HQ 1206 .I53 v.2

In women's experience

In Women's Experience

Volume II

In Women's Experience

Volume II

Edited by

Patricia L. Munhall, ARNP, EdD, PsyA, FAAN

**Associate Dean of Graduate Program
Director of the Center for Nursing Science
School of Nursing
Barry University
Miami, Florida**

National League for Nursing Press • New York
Pub. No. 14-2687

Library of Congress Catalog Card Number
94-188763

ISBN 0-88737-647-9

This book was set in Garamond by Publications Development Company, Crockett, Texas. The editor was Maryan Malone. The designer was Allan Graubard. The printer was Clarkwood Corp., Totowa, New Jersey. Cover design by Lauren Stevens.

Printed in the United States of America

Acknowledgments

*T*he women, without whom this volume would not be possible, are the ones who have shared their experiences. Revealing themselves to another has created this "mirror of words" and to all of them I express my deepest appreciation.

To the women, who searched for the meaning in the "mirror" and continue to be engaged in this on going composition, I extend my thanks. Cathy, Carolyn, Ellen, Patricia, Suzanne, Carol, Dula, Vickie, Joan, Sheila, and Jessie are to be acknowledged for their ongoing commitment to the understanding of the contextual meaning of women's be-ing. I am grateful to them also for the connectedness we share and the various forms in which it appears. We come and go in one anothers' lives, despite space, time and place, yet we are connected by a common bond to understand the meaning of women's (our) lives. This is a gift I treasure.

Another treasured gift is my editor, Allan Graubard, Director, NLN Press, who indeed is an advocate for women. His encouragement and enthusiasm for this project, as an ongoing composition, is an expression of his authenticity. I thank him, so very much, for all he has done to make this and other projects possible. Allan's faith and honesty have been the propelling forces in bringing forth to NLN my humble attempts. Behind every project is a senior editor who painstakingly brings the volume to fruition. I thank Nancy Jeffries for this as well as her talent, perseverance, and support.

So indeed I am grateful to many people. I am glad for this, because it demonstrates connectedness and attachments, examples of women's ways of experiencing be-ing.

P.L.M.

Prologue

*I*n the first volume of *In Women's Experience,* the prologue began with the acknowledged awareness of the uniqueness of women and their experiences. That prologue spoke to the need for women to be heard in the telling of their own stories. Through their stories we increasingly understand the meaning of being a woman. In the year hence, the need of course continues. So as in that last prologue let us see what is on *The New York Times* Best Sellers list that might advance such understanding.

Today is March 19, 1995. Going to that list, as I did last year, it appears that there is one book out of fifteen which discusses women. It was better last year. Anyway, the book is entitled "Sisters" by Carol Saline and is a book of 36 sets of sisters, romantically depicted in photographs and short narratives. I was going to buy the book for my sister, Donna, whose birthday is next week but I had this feeling of one large Hallmark card and decided that the experience of sisters was somehow more complex. I also am realizing that perhaps a chapter on that experience needs to be written, but alas, it is too late for this volume. However, to situate the context, let me mention some other books that are on the list—"I Want to Tell You" by O.J. Simpson, "Raging Heart" by Sheila Weller, a version of the O.J. and Nicole Simpson's marriage, and perhaps to exemplify our times "The Death of Common Sense" by Philip K. Howard. Books about the experiences of women are right up there with one on cats and another one on dogs.

Also in the last Prologue I mentioned an article in *The New York Times Magazine,* so I thought I might do that again and saved one from January 1, 1995. In that issue the feature was an article entitled "Lives Well Lived." You might wonder why I am going into all of this. Of course I am trying to make a point. It is rather simple. Women, in their various experiences, seem seldom understood and therefore are misunderstood. In a Prologue one tries to justify the importance of the work or book. So I believe we need to see what evidence, or lack thereof, there is in current literature that will advance the aim of better understanding the women whom Simone Beauvior calls "The Second Sex."

So back to the feature article, which is described as a compilation of individuals who died in 1994 and whom when "taken together, these forty lives embrace a spectrum of art, heart, intellect, and accomplishment—lives well lived, lives worth celebration" (p. 4). Eight of the lives are linked together as "Fathers of Invention," so of course they are male. Five men are linked together as "The Cartoonists." As I am now doing a quick quantitative check, I think I see four women on the list. Let me count the rest and add—that leaves twenty-three more men. Eight men plus five men plus twenty-three men equals thirty-six men. Now they were not all wonderful men in ways that are standardly virtuous but the point was their lives made a difference to the world.

When I first read this I thought, well, that is how Western history has been traditionally constructed. I then became more convinced as to the importance of women "talk:" how books like this and so many others can create and challenge the stubborn prevailing standard of power in our society. Yet we know it is 1995 and we have been at this effort for a long time. How foolish we would be though, if we were to become apathetic. In this volume, as in the first, the talk of women explodes with the importance and value of women's work and experience. The books and articles listed as references, the women's sections in book stores, the women's study programs in universities all validate how deep women's psyches go. The depth of their thoughts and concerns, the roles they play in shaping the context of lives and social institutions and the struggles which they encounter, often without a measure at all of support, deserve our understanding. Without understanding, myths, stereotypes and social

mores go unchallenged. Without understanding, we lack the base upon which to assist and help women and to alleviate pain, injustice, and misconceptions. Without understanding, women are left still to compare themselves to misleading theories and unrealistic expectations. Without understanding, women may not even realize that events society deems negative could be celebrated and vice versa. We need this understanding. It is critical to our being and to our validation and to help us find solutions and answers.

This period of time, I think, is critical in the "women's movement" because a new generation of women are now adults, without the historical perspective as to how they have the choices they have, what's all the fuss about anyway, and the seeming appearance that women are no longer considered marginal or unimportant. If that was indeed the case, surely more than four women would have made a difference, out of forty individuals, and the message, I think, is as clear as it was a generation ago.

Yes, I am making a case for this book and most books that call forth to us to understand the experience of women through their own telling. And that is what this book is about. In the first volume, women discussed their experiences of power, breast cancer, caring, menopause, mothercare, battered women, mothers' mourning, anger, chronic physical illness, and motherhood.

How many volumes would it take to deconstruct myths and misunderstandings? We are now on to the second volume with the hope of more to come. Because of the contingencies of human lives, Diane Cope, Sarah Steen Lauterbach, Geri Dickson, and Zane Robinson Wolfe are not part of this volume. I thank them for their contributions to the first volume and welcome some new contributors. One chapter is a cooperative work by Vickie Schoolcraft, Joan Davis, Sheila Hopkins, and Jessie Colin, all from South Florida. Suzanne Langner, I am glad to say, has joined our effort and she is from Philadelphia. Another Philadelphian joining the work is Patricia H. Becker. Previous contributors include the Northeast group, Carol P. Germain, Ellen Ehrlich, and Dula F. Pacquiao. From the South Florida area are Cathy Appleton, Carolyn Brown, and myself. So we add nine more experiences toward this one goal: coming to understand woman as person.

The women authors included here are creating real life narratives from attentiveness to women's stories, literature, art, film, and current issues and problems affecting women today. Each author has studied, reflected, felt, engaged, and worked towards a "mirror of words" to assist other women in their struggles, joys, and circumstances. The intermingling and interwoven experiences in this volume include, mid-life, competition, therapy, caring for self, being HIV positive, abused women and their children, women's secrets, grandmothering, and feeling different.

As I have heard from readers' responses to the first volume, there are many ways this kind of book can be helpful. Women feel less isolated in experience, women feel comfort in the sharing, women understand themselves and others better, and women find ways to help themselves through an experience because they say they understand the experience in a different way. Women gave the first book to other women when an experience described was thought to be helpful to another and, of course, to generate discussion. Women said they gave that book to men for the same reason. Men have told me that various experiences discussed helped them understand what their wife, mother, sister, or friend was living through.

None of the chapters are complete, in that they tell the whole story. Discussion adds other dimensions to the experience. Some discussions, again from the first volume, have resulted in my hearing from men, that often they experience some of the more generic topics in a similar manner. Also, women do not live their lives in chapters of experiences as articulated herein. Much is integrated into a whole. Still others do not experience what is being discussed but often know of others who do. And I am sure there are important dimensions not discussed because of the simple page limitations. When I scan the headings, I realize some of the topics are already full size books or could be such. The aim, however, remains: to further our understanding of women.

The authors of these chapters, whom I know personally, are wonderful women who care very much about the human condition and, in this book, the woman condition. They share of themselves and their work in order to understand. Once again I am struck by the spirit permeating their storytelling. *Indomitable* is the only word that compares—the strength of women, their

power, energy, determination alternating with doubts, tiredness, discouragement, despair, and circling around again, to try once more.

If books such as this can help other women make that circle, then this sharing makes a difference. This is my wish.

REFERENCES

Lives Well Lived. January 1, 1995. The New York Times Magazine.
Best Sellers. March 19, 1995. The New York Times, Book Review.

Preface

*T*his second volume of *In Women's Experience* is again guided by the philosophy of phenomenology. There are different interpretations of this philosophy, but the primary theme guiding this book resides in one question: What is the meaning of being human? Because the book is focused on women, the question must be rephrased: What is the meaning of being a woman? Researchers who ask such questions are dealing with extraordinary complexity. Paradoxically, the answers to these questions can be best found in everyday, concrete experience. Many phenomenologists reason that to understand what it is like to be a human being, we must seek to understand a human being in experience. That is where we find humans.

In this book, we say we wish to understand women through experience. This means that, in order to understand women, we find women through experience within a context of some sort. We simply cannot understand women by comparing them to some "thing" or by merely theorizing or conceptualizing. We must hear women speak of their experience if we are to understand their meanings and perceptions. Their descriptions and interpretations come from living in the everyday world—in a body; in time, space, and place; in a situated context.

A phenomenological perspective is one of enlargement. It makes us thoughtful of the consequential and inconsequential, the significant and the insignificant. This perspective questions the conclusions, assumptions, and the norms. Phenomenological reflection attempts to liberate us from what we believe we know

so well, from the way we take the world for granted. Phenomenology has the potential of emancipating us from our own presuppositions.

The essence of our interest in a particular experience is found in opening up and keeping open to all emerging possibilities, as they appear or as they are concealed.

To hear women speak, the authors in this volume have begun their work in silence. The question they are asking has taken up residence within them. In this way, they have remained open to different variations and to appearances whenever and wherever they appear. The major task is to construct (and, in this way, perhaps deconstruct) a possible interpretation of the nature of a human experience (in this book, a woman's experience). The major aim is understanding, and we aim toward understanding because we seek to answer that extraordinary question: What is the meaning of being? Of being a woman?

The researcher uses personal experience as a starting point, obtains experiential descriptions from women and from literature, reflects on essential themes, and synthesizes the material back into a whole—a narrative or a text. When studying women in experience, I began a journal; I noted what I saw and heard about the experience in films, clinical situations, interviews, contempory news broadcasts, at conferences, or during conversations. Once I turned my attention to it, I began to see the experience and find its essences everywhere. All became a kind of grid for phenomenology.

This kind of study is not linear nor is it method-driven. It is scientific and it asks that its investigators be creative, attentive listeners; that they reside with the material collected and live through it, that they reflect on what emerges and write about it. Self and others must understand what it means to be human in certain experiences, sometimes, and in some ways.

This book represents phenomenological study of post-modern women in their situated context. There is no pretense to generalize; that is not the purpose of the study. However, the notion of "resonance" should emerge. Does the description sound familiar or, if not familiar, possible for someone else? Differences occur in perception, depending on different situated contexts. Even then,

differences emerge, and that is fine. That is all part of our story and of understanding.

To be specific, each chapter of this volume is about women in experience. Readers might first read the text, which is written from a phenomenological perspective. For each chapter, a small section entitled "About the Study" will offer additional insight. Then there will be some references. Last, there is a short personal note, "About the Author," that may be of human interest. This, in its own way, is an attempt to eliminate distance between the reader and the text.

How does one arrange such chapters—in what order and with what intent to give meaning to such ordering? How can categorizing into sections be done when women do not live this way; when things simply happen?

As with the first volume, the chapters appear in the alphabetical order of the authors' last names. Each author challenges us by examining and revisiting normative commitments, biased interpretations, and unquestioned assumptions. Creating a "Mirror of Words" reflective of "Lives Well Lived" (*New York Times Magazine*, January 1, 1995).

PATRICIA L. MUNHALL

Miami, Florida
March 1995

Contents

Editor and Contributing Author

Patricia L. Munhall, ARNP, EdD, PsyA, FAAN
Professor and Associate Dean of Graduate Program
Director of Center for Nursing Research
Director of Primary Care Nursing Center
School of Nursing
Barry University
Miami, Florida

Contributing Authors

Cathy Appleton, PhD, ARNP, CS
Associate Professor
Florida Atlantic University
College of Nursing
Boca Raton, Florida

Patricia Hentz Becker, EdD, RN
Associate Professor
La Salle University
School of Nursing
Philadelphia, Pennsylvania

Carolyn L. Brown, PhD, RN
Associate Professor
Director, Nursing Administration Major
School of Nursing
Barry University
Miami, Florida

Jessie Colin, MSN, RN
Assistant Professor
School of Nursing
Barry University
Miami, Florida

Joan Davis, PhD, ARNP, C
Associate Professor
Director, Nursing Education Major
School of Nursing
Barry University
Miami, Florida

Ellen Ehrlich, MEd, EdD, RN
Associate Professor
UMDNJ
New Jersey's University of the Health Sciences
Newark, New Jersey

Carol P. Germain, EdD, FAAN
Chairperson, Science and Role Development Division
Associate Professor
School of Nursing
University of Pennsylvania
Philadelphia, Pennsylvania

Sheila Hopkins, MSN, ARNP
Assistant Professor
School of Nursing
Barry University
Miami, Florida

Suzanne R. Langner, PhD, CRNP
Director of Nursing Research
The Graduate Hospital
Philadelphia, Pennsylvania

Dula F. Pacquiao, EdD, RN
Associate Professor
Department of Nursing
Kean College
Union, New Jersey

Vickie Schoolcraft, PhD, RN
Professor and Associate Dean of Undergraduate Program
School of Nursing
Barry University
Miami, Florida

1

Midway: In Women's Experience

Cathy Appleton

A characteristic of phenomenological research is that the phenomenon begins with oneself. I noticed about a year ago that I appeared to be shifting in my life. Then came the little reminders and disclaimers. One little reminder came during my annual visit to the gynecologist, an activity I don't enjoy particularly, although I like the woman I see. We have wonderful conversations during my office visits. This day, she began to describe the changes she has noticed in me over the years. My initial reaction was, "This cannot be so. I'm too young." After each little reminder comes one of these little disclaimers.

Then, in my professional work, I began to experience changes in my energy level and productivity. I possess a sense of restlessness—that is my nature; yet I can't help thinking it's not confined only to my character. I'm spending more time thinking about what I *want* to do and *don't want* to do with the rest of my life. I

realize I'm getting tired of doing some of the things I do, and I'm ready to let go of them. I spend time reflecting, analyzing, and thinking about my life and how I'm going to live the rest of it. My friends say, "You're so young," yet, on occasion, I feel I've already lived a lifetime. I know that life is not only precious but short. My mother died when she was 67 years old, a tremendous reminder to me to live each day.

Recently, I bumped into a colleague at a Hallmark store, in the midst of holiday crowds and shopping. We stood between the long lines of people waiting to buy cards and gift wrap, and shared what was happening to us day-to-day. Because we work together at the same university, we have an appreciation for its life and culture. Before long, we were laughing hysterically at our shared anecdotes. Our laughter probably minimized the noise of the shoppers in the checkout area, and we may have obstructed the store's painstaking effort to create a holiday ambiance while remaining efficient and effective for customer traffic. I left feeling better than when I arrived; the day's events, before the encounter, had weighed heavily on my mind. I had received another little reminder that I love to have fun and, in whatever life I'm trying to create, I need to be happy most of the time.

I'm getting better at knowing what I want and in *giving* in my relationships with others. I realize how much my present friends mean to me, how essential friends are in my life. My friendships with women especially give me joy and comfort. Developing and sustaining these relationships, and others, have become increasingly important to me. I'm reminded through experience what I've always known intellectually: relational work is toward something—together. Even the relationship with myself is toward something—integrity.

I experience a working together in most of my relationships; when it is lacking, I'm willing to move away toward something rather than remain put. I know the greatest kindness I have to give, to myself and others, is truth. This realization reminds me that I no longer have time to waste—not that I did 20 years ago, but I am more acutely aware of it now. Sheehy (1993) refers to this as "midlife agitation" and suggests it stems from alterations in the sense of time, a realization of the foreshortening of time,

particularly in women in their 40s, who represent the "old age of youth" (pp. 221–222).

I'm not completely convinced that I'm experiencing "midlife agitation," but I'm learning what really matters to me and I'm getting better at making it my life.

I'LL BE THE JUDGE

Knowing me, being confident to trust myself, yet understanding growth, is a lifelong process.

The things you learn in maturity seldom involve information and skills. You learn to bear with the things you can't change. You learn to avoid self-pity. You learn not to burn up energy in anxiety. You learn that most people are neither for you nor against you but rather are thinking about themselves. You learn that no matter how much you try to please, some people are never going to like you—a notion that troubles at first but is eventually relaxing.

One of the most valuable things you learn is that ultimately you're the one who's responsible for you. You don't blame others. You don't blame circumstances. You take charge. (John Gardner, cited in Ansley, p. 69)

For women, midlife offers a greater sense of direction and power. This is not to say women do not find themselves pulled in a number of directions, nor is life devoid of uncertainty; rather, women see themselves as competent, capable, able to accomplish more, confident, wiser, more focused, patient, freer, and overridingly trustful of their own judgments. Realizing they *do* have choices, women in midlife take charge.

Specifically, these women believe they have a "more accurate" perspective—a better take—in midlife, about themselves and others. For Ava, getting herself and others in a "better or more realistic perspective" has served her well, an outlook she finds satisfying. Ava readily admits, "I'm more judgmental"; she has

learned to define and delineate issues of trust and reliability much better. "Knowing me" and going with what she knows contributed to Ava's choice to build on her professional education and experience and begin a business. Ava describes the "greater sense of power and competency" she experiences from being a businesswoman. She finds business, or the way she does business, "very fulfilling, empowering and powerful." Ava finds that the benefits of making choices suited to herself include: continually being challenged, which keeps her energized; a feeling of being fulfilled in her work; traveling and seeing the world; and an opportunity to make a tremendous contribution.

As women, we reconcile the conflicted or double messages received throughout the course of a lifetime. We learn to trust ourselves, and this assists us to acquire a "more realistic perspective." Coming to grips with oneself and life depicts a perspective from which these women judge, know what they want and, for that matter, what they don't want. Having a clear perception of their wants and the kinds of things that make life more comfortable seems to serve as an endless source of pleasure. Jackie describes it this way:

> *I'm pulled in a lot of directions, but they're directions I want to be pulled in. . . . work pulls, relationships pull, home pulls, but it's a different kind of pull. I'm pulled in directions that make me happy. It's a choice among a lot of things that I like. So, those things just give me a lot of pleasure right now.*

Often, being able to choose among "a lot of things that I like" occurs as an outcome of making a difficult decision. Choices women make in midlife tend to contribute to more satisfying relationships, work situations, and career developments. Women's life experiences and midlife maturity frequently help them gain a clearer sense of what they want to do and the courage needed to do it.

Sheehy (1981) writes about this courage in her book. One discovery she made about pathfinders particularly was their willingness to risk change. Sheehy found that "the people enjoying the highest well-being" described themselves as having had a major

change in their perspective, values, personal affiliations, or careers (p. 77). Establishing a huge handicap with regard to a willingness to risk change, Sheehy states that little exists in a woman's life to encourage a willingness to risk, and therefore embrace change. "Women have cleverly devised an unconscious mechanism that makes it possible for them not even to notice the need" (p. 82). Coping with "unacceptable" ideas or impulses by holding them inside, women try to attenuate, invalidate, or extract the distastefulness by turning "unacceptable ideas" into something more favorable (p. 82).

For women in midlife, risking change becomes the preferred choice when it affords happiness and well-being. Women find that "hanging in there" no longer works for them when it affects their health and happiness. Making the best of a bad situation, which most women describe as a value they "engendered," is no longer a satisfactory solution for them.

As Jackie told me about a recent midlife choice she made, "Leaving bad situations occurs after coming face-to-face with myself." Describing herself as a person who does not let go easily, Jackie realized she was in a place in her life that was not healthy for her. Trying to make the best of the situation was not making her happy, and she knew she needed to let go and move on. Describing the courage it took to leave, Jackie comments that she wouldn't have made this choice when she was younger.

Jackie describes letting go as "moving toward something different" and moving away from a part of her life she found noxious. She recognized and surfaced "this sick feeling in my gut" rather than choosing to hold on to the feeling and turn it into something more acceptable. Munhall (1994), in her study about anger, speaks of the "smoke screen" women create with their anger (p. 299) or with feelings unacceptable to them.

Munhall states that "women are so censored in the expression of their anger, and the anger is so repressed, that they do not leave situations that make them angry" (p. 298). Instead, they transform anger into pathology, wherein the transformation itself masquerades the real situation. When women don't make choices in their best interest and based on their own judgment, they create the phenomenon that Munhall (1994) refers to as "the cruelest paradox."

In midlife, women become more who they are, recognize what they want, and are willing to choose happiness rather than repression, and vitality instead of pathology. Becker (1991) once commented, "We grow neither better nor worse as we get old, but more like ourselves" (p. 156).

As we grow more like ourselves, our decisions to risk come only after great reflection, analysis, and thoughtfulness. Marian told me, "My primary relationship is with myself. I take a lot of time thinking about myself, how I need and want to be." Self-imposed expectations—life's "shoulds" and images of women—become distinguished from what gives us joy. The rewards of shedding the shoulds and images present opportunities to describe who we are as midlife women. This knowledge empowers us. We know to trust our own judgment. Although it takes "living this long," growing more like ourselves gives us a sense of peace and pleasure. Vanessa has this perspective:

Knowledge is wonderful. I can't even compare my self knowledge today to when I was younger. It's hard for me to remember what I knew about myself then. I just know that I'm much more comfortable. I know myself better. I know other people better. In that sense I think I've experienced enormous development. But yet, I don't know if my experience is typical. I think the fact that I was in therapy greatly enhanced my self-knowledge, and I would say I'm much happier . . . much more at peace with things I did. My relationships are better and I have a lot more confidence. I'm much more at peace with myself, and professionally I've succeeded to a point. I'm fortunate I'm in a profession where it's possible to continue to develop and fortunate to be in that position. It's a better stage in life. I feel good more often than I used to, and I derive pleasure from more things.

As Dorothy Canfield Fisher (1991) commented, "One of the many things nobody ever tells you about middle age is that it's such a nice change from being young" (p. 156). Letting go of images and expectations relieves pressure and stress for women. As Jackie notes, "It's taken me a long time to get there, but I've learned to trust my own process and I had to live this long to learn to trust myself."

Judging and having the courage to be the judge come when we learn from life's failures. "Looking at failures as tools for education" provides a sense of confidence to women in midlife. Ava says:

Failures are only failures if you don't learn from them; otherwise there are no failures in the world.

When somebody asked Thomas Edison, "Well, Mr. Edison, you've invented the light bulb, but how does it feel that you've failed 757,000 times?" He said, "Wonderful, Now I know 757,000 ways not to make a light bulb."

Sheehy (1981) believes that people who grow older successfully refuse to define themselves by their losses. As midlife adults, women describe taking charge of themselves and taking responsibility for their decisions. Like Edison and his light bulb, women learn 757,000 ways to become better judges of themselves and others.

Unlike the married women who were not involved in the "single scene," single women describe how they become better judges with regard to men. They talk of the kind of relationships they want with men. As a single woman, Vanessa finds her "standards for relationships with men are higher," yet "the pool of men is limited." In this sense, Vanessa experiences midlife as a "real disadvantage" for women who want meaningful relationships with men.

Knowledge also awakens our sensibilities to the realization that we grow more like ourselves even as we are growing older. While "knowledge is wonderful," this truth informs women, as they look back and forward, that what was will never be again, and what is is somehow the same but different.

IT'S NOT ONLY MY BODY THAT'S SHIFTING

Somehow it's the same but different, yet normal will never be the way it was.

"I don't feel any different than when I was 20 or 30 years old," Beatrice told me, and so did every woman in this study. Granted,

we talked about experiencing bodily shifts and changes, yet somehow these women "do not feel different." More about that later.

Most women feel the same as they did when they were younger, with minor variations in levels of energy. Some women have higher energy levels, others lower. What they describe as different for them in midlife is not so much how they feel, but the shifts that occur in relationships. For example, Eleanor describes the shift in her relationship with her aging mother:

> *The most difficult [thing] that I've had to deal with is accepting my mother as an old woman. She is in her 80s. Oh, I gave her such a hard time at times, although we are very close. When she stopped driving to my house in the beginning, I couldn't understand. "Why can't you drive over? You always used to." And if she says the same thing over and over to me, I say, "Ma, you told me that." I have to say to myself, "She's getting older. She's not 40." I used to think of her still in her 40s or 50s. I would have to tell myself that it's OK not for her to do the things she used to if she doesn't want to. And, it's OK for her to repeat herself. I find it has been most difficult to accept her aging, not mine.*

Also speaking about shifts in her relationship with her mother, Ava comments that her mother is in her 80s, and the relationship has gotten better. "As I get older, I just appreciate her more and more. I see more and more of myself in her." Beatrice, whose mother is 90, experiences a shift in responsibility: she cares for her mother, which enables her mother to live at home alone, although Beatrice admits, "It's a little tenuous." Spending hours with her mother every day takes a lot of Beatrice's time and energy, but her mother is healthy and mentally aware.

Participants who talk about the shifts in their relationships with their mothers also remark that their marriages seem to be shifting, too. Married women characterize their relationships with their husbands as intimate friendships. These marriages exist within the separateness of each partner's life: the women describe living lives that are distinctly separate from their husbands'. For example, Elizabeth and Veronica have full and active

professional lives. They are employed full-time and engaged in many professional activities outside of employment, yet their husbands are retired. Ava owns and operates a business that takes her all over the world, yet her husband primarily resides and works where they have made their home. Ava explains:

> *One thing I always knew—but it's certainly known more to me now at this particular time in my life—is that I think it's really important for women to have themselves and something that is for and of themselves. I think marriage is great, but it's not really enough.*

Interestingly, the women in this study convey their enjoyment about who they are and where they are in their lives. For them, this knowledge brings a feeling of appreciation, and yet they describe experiencing a sense of loss:

> *In some ways, I'd like to start all over, and the truth is, do things differently. I never had that feeling before. I look at all the things I could have done or might have done, and there's a sense of loss.*

Marian readily adds, "Oh well, I didn't do them. I did the things I *did* do, and that's the way it is."

"The way it is" conjures up a sense of loss about choices women were not aware of when they were younger. For example, many women in this study chose to have children, and having done so, cannot imagine what it would be like not to have them. Yet now, they are aware that this is a choice, and that many women choose not to have children and live happy, fulfilled lives. Marian admits, "I never knew I had an option to live my life any differently when I was younger. Today, I know that I did have options; I just didn't know it at the time, and I had some anger about not knowing it."

For some women, there is a sense of loss or anger, and perhaps a yearning to do it again a different way. But most women reconcile themselves to choices they made earlier in life. Women's midlife realizations contribute to living differently *in the present;*

"I need to live how I really want to now." For example, Marian
says:

> *When I was in my 20s, I had lots of energy, and I felt I had
> lots of time. I also didn't have some of my understandings
> about life that I now have. It was different. When I was
> younger, I was more inclined to spend my energy on getting
> things right and doing things perfectly. Now, I'm not so in-
> clined to do that. Like writing this article; I'm not trying to
> edit it to be perfect. Rather, I'm willing to work on editing
> so it will be clearer for people to read and understand. I'm
> doing the same thing, but I'm doing it for a different moti-
> vation. So the motivation has changed.*

Living how they "really want to now" makes women's lives dif-
ferent as their motivations change. But what else makes midlife
different? Overwhelmingly, women describe a newfound sense
of freedom—not only the freedom to be who they are, but the
freedom to make themselves happy and enjoy the way their re-
sponsibilities are shifting. Frequently, freedom was associated
with shifts in their relationships to their children. The mothers in
this group of participants, with the exception of one, describe
their children as grown and off on their own. Consequently, re-
sponsibilities in their lives have shifted away from raising chil-
dren and toward themselves, their spouses, and/or their parents.

Still active, and involved in as many projects and commitments
as when she was younger, Elizabeth comments, "Physically, I was
more involved with bringing up children." Her children went off
on their own, are doing their own things, and now it's just Eliza-
beth and her husband:

> *It's just that I have the freedom now and the responsibili-
> ties to myself and to my husband. So there's a tremendous
> amount of freedom, of not worrying on a day-to-day basis
> about other responsibilities, that makes this time of my life
> very meaningful. We can do whatever we want to do with-
> out making arrangements for children or other things. It's
> just what we want to do, and we don't have to answer to
> anybody except ourselves.*

Most of the children of the other midlife moms are grown and launched, and a few moms are preparing to launch them. Will a void exist in their lives, as presented in the literature, when their adult children leave the nest?

To the contrary, these women have found the freedom from "raising children" satisfying, a time of life that brings excitement. The women whose children are still home did not describe any despair about what they would do with their lives when the children leave. Instead, they are ready to launch them and looking forward to their future years and to what it would mean to have the children out of the nest and on their own. Women express a sheer delight and pride in their grown children and the experience of watching them develop and flourish. Interestingly, a contrast exists between these women's midlife experience and that of mothers described as experiencing the "empty nest syndrome."

Women with and without children describe excitement for their prospects in midlife. Eleanor looks for freedom and significance:

What's exciting, for me, is experiencing more of a sense of freedom. I don't have to do the things that I don't really want to do. I don't have to do all the work. I can delegate and pay for it. I don't have to do things for the challenge any more. Now, I do things for the significance in life, for its being meaningful and to get fulfillment in life.

Not only does fulfillment come with shifting relationships and responsibilities, but in knowing that normal will never be the way it was. The way it was was OK, but "I like where I am now better" is perhaps an indication of growth in midlife. Jackie narrates the effect of her decision:

I was in midlife when I started doctoral study. I had gone as far as I could with being a housewife and [doing] the things that you do when you're raising kids. I needed to do something for me. When I went to school for doctoral study, there was a fantasy that we all labored under in our family, that when I finished we'd go back the way we were, where I did a whole host of things. After graduation, I was

sitting in the living room and my husband was saying,
"Now we can get back to normal." I said to him, "Normal
will never be the way it was."... [T]hat clarity had come
to me.

Clarity, wisdom, and competence underpin these women's
self-concept; they describe the skillful decision making they ex-
perience as they encounter life's shifts and turns. Brown (1994)
describes the same experience in her study of power for women
in midlife, particularly when she writes, "At midlife, women see
more clearly, often with great compassion for themselves, for
other women, and for men" (pp. 80–81). Brown suggests that
awareness empowers women to choose from a position of know-
ing that prepares them to live the second half of their lives.

If, as women, we grow more like ourselves in midlife, then
what becomes different stems from the awareness we have of
who we are. Therefore, knowing who we are is different in
midlife. According to Belenky, Clinchy, Goldberger, and Tarule
(1986), "when truth is seen as a process of construction in which
the knower participates, a passion for learning is unleashed"
(p. 140). This knowledge of constructing one's life brings clar-
ity—the kind that enables women to make decisions that make
them happy.

Heilbrun (1988) refers to this knowledge as power and says,
"Power is the ability to take one's place in whatever discourse is
essential to action and the right to have one's part matter"
(p. 18). Brown (1994) found power was created through relation-
ships in women's lives. Possibly, the shifts women describe in re-
lation to themselves and to others reveal their sense of power to
construct their lives and live them more fully.

AS LONG AS I DON'T LOOK IN THE MIRROR

Feeling more fully alive, yet reminded I'm getting older.

Looking through my eyes I don't see myself aging, only
when I'm addressed as "Ma'am" or some other indication
that I'm aging. I don't know whether that's me, if that's
unique, or if everyone feels that way. I feel more fully alive

now—probably just because my life is so much more fuller.
I can do more. I've experienced so much more.

In these words, Beatrice characterizes the experience of women in the study who spoke about feeling more fully alive, yet being reminded they're getting older. Feeling more fully alive is not devoid of becoming exhausted or tired at times, or attempting to do more than perhaps can be comfortably accomplished. It simply means women experience a spiritedness, a passion for living that distinguishes midlife. Women also relate feeling more sexual.

An irony exists for women. Unless someone addresses them as "Madam," or they look in a mirror, they go about living as exuberantly as before midlife. Ava uses this strategy:

As long as I don't look in the mirror, I am not in midlife. I don't know that I'm in midlife as long as I don't look at my body and my face too closely in the mirror. I'm still 32 years old, which was an exceptionally good year for me. I know in my head that I'm in midlife. For me emotionally, it's not difficult as long as I don't think of myself chronologically. When I think of myself chronologically, I get slightly depressed because I know I'm on the back half. But I've always kept busy. I like keeping busy and I have a tremendous amount of energy.

Feeling more fully alive coexists with undergoing the realization of change—not the kind of changes described heretofore, but the kind of bodily changes that occur for women in midlife, the day-to-day reminders of chronological age. Marian refers to them as "the things that suck." Usually, "the things that suck" had to do with experience related to these changes:

One of the things that sucks about midlife is the fact that my body is wearing out way before I am ready for it. I would love to have a conversation with God and just tell God that I think the design sucks. I mean, if we have to live here for 80 or 90 years, then the body should last better than it does, I'm having all these awarenesses and learning all this stuff that I would like to implement, and

my energy level is waning instead of getting bigger. And when I had all that energy, I was dumb. The other day I was talking to my friend, who has a Sharpei puppy. She was telling me the dog has all this skin that's scrunched up. When he's little he looks so cute that way with scrunched up skin, and when he gets big, the skin is nice and sleek. Well, why don't we start out that way with scrunched-up skin and then we can grow into it instead of skin that gets all baggy and shaggy at the end? It's ass backwards. Instead of being all smooth and pink when [we're] born, we need to have wrinkles.

Skin, hair, vision, and body shape are what many participants, like Veronica, speak of in terms of recognizing their aging:

I really feel, healthwise, real good. I tint my hair because I don't want gray hair showing. So I frost my hair. I don't like getting wrinkles. My body changed. I notice my skin is not as smooth like it was, even if I exercise. I notice these brown spots on my hands. I don't like them. I'm thinking even of getting that one off. I noticed my hands are getting all wrinkled more than before. And so, yes, I'm aging. I work hard to keep my neck from getting too wrinkled. I'm doing all these neck exercises. I don't like wrinkles.

Veronica told me that her body seemed "to get bigger, more fuller," but she was taking hormones. Others described changes related directly to menopause, and some stated they really didn't notice menopause except for the change in menses. Others claimed they felt liberated from the ability to reproduce, and a few said they were looking forward to menopause coming and going.

"Everyone wants to be the person she was before, but our bodies are signaling us otherwise" (Sheehy, 1933, p. 129). In her study about menopause, Sheehy suggests that women can no longer put the same high demands on their bodies. Particularly in times of unexpected stress, women "cannot continue indefinitely being the same person as your younger self." Elizabeth had this experience:

I just took down the picture [frame] behind my filing cabinet . . . , and it was all the pictures from my youngest daughter's wedding 12 years ago. I had a picture of me and my husband. I'm wearing a lovely garden dress and I said to someone, "I look so much younger in that picture." Twelve years ago. You know, there's a frustration with myself for not taking enough time to physically focus in on the needs that I should, the way I should respond to my bodily needs.

Elizabeth speaks of feeling "a little more aches and pains" and "not responding to them." Pushing herself a lot physically, Elizabeth conveys that she doesn't feel any different than she felt in her 40s, but she is reminded that indeed she is older and needs to care for herself more than before.

"We must make alliance with changing bodies and negotiate with our vanity. The task now is to find a new future self in whom we can invest our trust and enthusiasm" (Sheehy, 1993, p. 222). And for the most part, these women are doing just that. Veronica says she's facing the idea of midlife, even though she saw herself as forever young to some extent, because her family has experienced tremendous longevity.

Women admit that the concept of midlife creates a sense of depression. "Knowing that I'm on the back half, I get slightly depressed," was the collective comment. Sheehy (1981) calls this time the "Youth of Second Adulthood" (p. 222). For these women, the thought of this "youth" still has fleeting moments of "This is depressing." Recognizing that one has changed always involves loss, and subsequently, a feeling of depression, but not in the sense that it's all downhill from here. To the contrary, these women experience midlife as feeling more fully alive, and they talk optimistically about their future. How does optimism about the future coexist with these women's description of "getting slightly depressed" about the notion of midlife?

Some say, "The realization that I've reached this point in life is depressing, but then I don't have time to focus on it." Others claim the concept of midlife provides a lens from which to view the past and the future. This lens tends to hone in on losses in the past, thereby providing a realization that the future is time-limited.

Coupled with the little reminders of the process of aging, reality does have a way of being depressing. However, women say they do not dwell on this knowledge in a way that inhibits or restricts them. Instead, they seem to seize the time that remains and become more fully engaged in life.

As an example, women become more fully involved in their friendships with other women. Particularly, old friendships become increasingly important to women in midlife, even as they serve as a gentle reminder of aging. Eleanor told me that old, old friendships have become very significant to her during the past five years. She spoke of friends she has had since the second grade; in particular, she spoke of a friend currently visiting from out of town:

> *My best friend from school is visiting right now. She and I were so close in school, and that was over 30 years ago. She and I are so different. We don't even see the world the same. We have different values, and even though we're so different, that bond is still there. I love her. She's like family. So right now I'm trying to make arrangements to go out with her and her husband because they are here for the week visiting. . . . my old friendships are very important.*

Jackie experiences "a greater depth of relationship" with people who have been friends since young adult life. These friendships exemplify the fact that "we really know one another in a different kind of way." Jackie told me about visiting with a friend and her husband after not seeing one another for over a year. "[We didn't] miss a beat. We simply picked up where we left off. We have a great depth of understanding." These friendships seem to endure gaps, and when contact does occur, Jackie says, they pick up where they left off:

> *These are old comfortable relationships. The kind you can't have when you're 20 or 30 years old because you haven't developed them. I have probably fewer really close relationships that have withstood long time, but those are very meaningful to me.*

TICK-TOCK, TICK-TOCK, THERE ISN'T AS MUCH TIME ON THE CLOCK

Delighting in life's accomplishments, but there's so much left to do.

Feeling that they don't have as much time as they used to, women describe how their sense of time is compressed and their days are shorter. Because there isn't enough time to do as much as they would like, they pack each day full. Jackie, aware that she cannot be active in every area she thinks is important, says, "So I pick and choose." Ava has a sense of wanting to contribute to making the world a better place for others, yet time is limited:

> *I feel like my work as a businesswoman is one of the things that drives me. I want to touch as many lives as I possibly can, and in a positive and refreshing way. I'm always looking at my impact on the world, to try and make it a better place. The business that I've chosen allows me to touch other people's lives in a very positive way. I know that those people's lives that I touch will go on to touch other people's lives in a positive way, and that makes me feel fabulous. And when I die, I will have known and lived a good life.*

Delighting in life's accomplishments, yet expressing a desire to continue to contribute to their communities, families, and professions, these women want to remain active through late life.

Jackie told me that midlife has raised many questions for her. She realizes that she's "coming to a closing life," referring to her life as she knows it now. Jackie asks herself, "What do I want my life to be, to look like and feel like as I move ahead? What do I want my later years to hold for me? What do I want to be doing? Where do I want to do it?"

For Elizabeth, midlife is "defined in activities versus years, and by what a person wants to do with the life that is left." She has much she wants to do with her life. Similar to Jackie, Elizabeth also raises questions to which she gives a great deal of thought: "How do you get to a point of knowing when it's OK to slow

down or when you want to slow down? How does one move from one kind of life to another? Does there have to be this movement or not?"

Questioning one's future may occur throughout the course of a life, but in midlife these women explore how they want to continue to make a contribution. Interestingly, they live these challenges and simultaneously make a transition into their later years. Most women say they never want to "retire completely," and others describe how they have "paced themselves." Sheehy (1981) says the "possibilities for developing and extending ourselves in these stages are more various and liberating than at any earlier period" (p. 227). For example, Beatrice has slowed down; not that she's less productive or engaged, but her rhythm or pace in life has changed:

> *I just can't work the way I used to. I think I worked very hard when I was young because I went to school and raised a family. Now, when 7 or 8 o'clock rolls around, I'm tired, and I don't feel like working all evening. When I was younger, I would get up early, work all day, make dinner, put the kids to bed and then work all evening into the night. Now I don't do that. I pace myself more.*

Eleanor gauges her activities by her goals, which she feels she is constantly reevaluating in midlife. Like Beatrice, Eleanor talks about not pushing herself as hard as she used to when she was younger, yet remaining actively engaged and productive in her profession. What guides Eleanor's goals and contributions in midlife is the meaning they hold for her. She remarks, "I still want to work hard, so I still have a lot of goals, but now I choose for the fulfillment in life, the meaningfulness to me."

Veronica talks about "having a purpose in life [and] sharing that with others." She would "like to work for a long time and participate in life" and her profession. As for Ava:

> *I don't ever plan to retire. I've learned that retirement is deadly for people. I always felt that my children kept me*

young. I feel my professional involvements and my accomplishments in the world also keep me young. They have energized me. I feel my energy drives it, but then I receive energy from it.

Speaking of "always wanting to accomplish more than I could ever expect to have the time for," Ava says she has the energy but not the time.

Marian comments, "I always feel like I don't have enough time to do everything I want to do. I feel like time is running out." This gives Marian a sense of urgency to keep doing the things she wants before she runs out of time and energy. Reflecting on a midlife realization that the clock continues to tick, yet they have so much left to do, and on the losses they experience in midlife, specifically the death of family members and friends, women express an acute awareness that chances come and go and may not come again:

I keep picturing an hourglass with the time just running. You can't stop it. It just keeps going. It races on as I try to catch up with it. I have more ideas than I'll ever have time. While I have that urgency, I still have the idea that there is time to do some things in my life. I tell myself, "This is it, no fooling around. I better really do it this time because I may not get another chance."

Realizing life "is not a dress rehearsal," Marian now places her energy in the middle of activities she wants to accomplish. For example, she initiated and completed two academic degrees, like many of the women in this study who pursued academic goals in midlife. Marian spends her time investing in her future; she's about to undertake a business venture as her way of contributing during her later years.

The clock may be ticking for Marian and the others, but they look forward to doing something for which they will work arduously in midlife, something they will have during their later years.

PATHFINDING AND TRAILBLAZING

As they construct an experience of midlife, women in this study seem to define and create their lives in ways that have yet to exist for them. Sheehy (1981) suggests a way to think about what midlife is like for women: a strong alignment of our inner convictions with our outer presentation. This process may place women between two selves: the woman I was and the woman I am now, which is the woman I am becoming. The woman I am becoming feels more confident to trust herself; she is willing to take risks and create a life that suits her. Permeating women's midlife experience is a need to be who they are and say what they believe— "with compassion," Marian adds. Confidence is characteristic of midlife maturity. It flows in and from experience, and it accentuates knowledge and wisdom.

Women in midlife describe *energy,* to pursue what is important to them; *selectivity,* to walk away from what is not; and *wisdom,* to know the difference. Ava says, "I'm more grown up." Being "more grown up" may be informed by the changing roles of women and, specifically, by the way these women have lived their lives. These women have always had careers; they still do. Living the life of the women Friedan studied—women who moved beyond the "feminine mystique" or who combined a profession with marriage and motherhood (Friedan, 1993)—these women have been even more distinctive. Not only have they qualified for a profession or pursued a serious involvement outside the home, but they have had lifelong careers.

Contrasted with the "empty nesters" of the 1950s, midlife women of the 1990s relate an exciting newfound freedom that comes with midlife: the freedom to choose happiness, pursue academic or business ventures, travel, live apart from one's spouse, slow down or heat up. Many of the myths about women in midlife, and aging in general, have not held true for these women. For example, they have not experienced midlife as synonymous with menopause. Menopause in the past has characterized the essence of midlife for women. If menopause did occur, these women expressed feeling liberated by the experience.

In general, they feel much as they did when they were younger, even though their bodies are changing. More important have

been the losses that become apparent during these times of transition and the effect this awareness has on a view of midlife.

In describing their sense of loss, these women said they were "slightly depressed" but they didn't dwell in depression; rather, it seemed to energize their lives. This study of midlife like that of Friedan's (1993) on late-life experiences, and those of others, shed light on what we believe about these experiences, what we can expect, and how the changing roles of women possibly influence what midlife is like for women today.

One constant for women in midlife today seems to be the significance and comfort of greater "depths of relationship" with lifelong friends. Midlife also offers women the pleasure of knowing other women in a meaningful way. Women share with each other and create mutual understanding that is a source of great joy and satisfaction.

Living full lives and paying little heed to their experience of aging (unless someone or something brings it to their attention), these women feel spirited and less complacent about midlife. Having clarified their focus, they are gearing up for the next half and planning for how they would like it to be.

A key to how they would like it to be is their own continued contribution toward making the world a better place for others. However, they describe a different approach, not the one they used in the first half of their lives. Now, women do it better: they take care of themselves first, and direct their expertise in a way they believe makes a difference.

By many accounts, midlife for women involves pathfinding and trailblazing. Pathfinding can best be described as the experience of traveling a particular path in life, recognizing that path by its markings, and realizing where it leads and where it cannot take us. Reaching a crossroads, we must make a choice. We can't turn back, but the path we have been following turns sharply and merges with the crosswise thoroughfare. Our journey into the future must go straight forward, in the direction we have been traveling. We stop, pause, reflect, think about our travel destination, and survey the unmarked terrain. We're excited and saddened, confident and questioning, energized and paced as we choose trailblazing. We know our destination lies straight ahead, but we are uncertain about the journey. Our certainty about ourselves is

our beacon toward our destination; our uncertainty about the journey makes us blaze our own careful, thoughtful trail.

Heilbrun (1988) says:

> *I do not believe that death should be allowed to find us seated comfortably in our tenured positions. Instead, we should make use of our security, our seniority, to take risks, to make noise, to be courageous, to become unpopular. (p. 131)*

Women in this study are taking risks and making noise. Not only are they becoming "more chronologically gifted," but, in many respects, they are carving out a new experience of midlife for women.

CONCLUSION

The findings of this study offer important information about what midlife is like for women, and the implications for women's health and for clinical practice are significant. The midlife experience for women is one of trusting themselves and confidently exercising their judgment; of knowing life will never be the way it was and living differently now; of living their aging and feeling more fully alive; and of delighting in life's accomplishments, but having so much left to do. These essential themes portray life processes and patterns that reflect and affect health.

The implications for women's education and health care intervention involve understanding what midlife is like for women, making women's experience known, and enhancing the processes and patterns that women describe as liberating. The experiences of the women studied illuminate their self-concept and lifestyle—phenomena critical to individual and collective well-being.

APPENDIX

Phenomenological Inquiry and Method

In this study, I used the methodological structure of human science research, as explicated by van Manen (1990), to understand

what midlife is like for women. Van Manen asserts that hermeneutic phenomenological research is a dynamic interplay among six research activities:

1. Turning to a phenomenon of serious interest and commitment.
2. Investigating the phenomenon as it is lived, rather than as it is theorized or conceptualized.
3. Reflecting on the essential themes that characterize the phenomenon.
4. Writing and rewriting to describe the phenomenon as it is present in the lived experience.
5. Sustaining a pedagogical relation to the phenomenon.
6. Balancing the research context by considering parts and whole.

As methodology, phenomenology aims at the nature of the meaning of everyday experience. Consequently, phenomenological inquiry seeks a deeper understanding of a particular phenomenon by researching lived experience.

In publicizing this study, I informed women by word of mouth. Eight women responded and consented to participate in tape-recorded interviews. I asked each participant: "What is midlife like in your experience as a woman?" The interviews lasted approximately 90–120 minutes, and the tapes were transcribed into text.

Through reading and rereading the texts, and reflecting on these women's descriptions of midlife, I analyzed and began to explicate what constitutes the nature of midlife in women's experience. Thinking deeply about the individual and collective narrative descriptions given by all of these women assisted me to know essential, emerging themes: "I'll be the judge"; "It's not only my body that's shifting"; "As long as I don't look in the mirror, . . ."; and "Tick-tock, tick-tock, there isn't as much time on the clock."

The chapter was organized around the essential themes of the phenomenon, after initially interpreting the nature of the phenomenon. "Bringing to speech" women's experience of midlife occurred through writing and rewriting (van Manen, 1990, p. 32).

By maintaining an orientation to the research question, I engaged in what van Manen (1984) refers to as a "dialectical going back and forth" among the levels of questioning (p. 68). This activity sensitizes the researcher to the language. In an effort to preserve the language of these women, I varied the examples throughout the chapter.

The study of human experience—what it means or the nature of experience as it is lived—is the concern of the phenomenologist, who, as a researcher, investigates experience as it *is* rather than as it is conceptualized. Van Manen (1990) suggests the following questions be asked of the entire phenomenological research study: "Is the study properly grounded in a laying open of the question? Are the current forms of knowledge examined for what they may contribute to the question? Has it been shown how some of these knowledge forms (theories, concepts) are glosses that overlay our understanding of the phenomenon?" (p. 34). I'll let you be the judge.

REFERENCES

Anglund, J. W. (1984). *Memories of the heart.* New York: Random House.

Ansley, H. G. *Life's finishing school: What now, what next.* Conscious Living/Conscious Dying: A project of the Institute of Noetic Sciences.

Becker, M. L. (1991). *The quotable woman.* Philadelphia: Running Press.

Belenky, M., Clinchy, B., Goldberger, N., & Tarule, J. (1986). *Women's ways of knowing: The development of self, voice and mind.* New York: Basic Books.

Brown, C. (1994). Power for midlife women: Written on the breeze. In P. Munhall (Ed.), *In women's experience* (pp. 43–89). New York: National League for Nursing Press.

Fisher, D. C. (1991). *The quotable woman.* Philadelphia: Running Press.

Friedan, B. (1993). *The fountain of age.* New York: Simon & Schuster.

Heilbrun, C. (1988). *Writing a woman's life.* New York: Ballantine Books.

Munhall, P. (1994). The transformation of anger into pathology. In P. Munhall (Ed.), *In women's experience* (pp. 295–322). New York: National League for Nursing Press.

Sheehy, G. (1981). *Pathfinders.* New York: Morrow.

Sheehy, G. (1993). *Menopause: The silent passage.* New York: Simon & Schuster.

van Manen, M. (1984). Practicing phenomenological writing. *Phenomenology and Pedagogy, 5*(3), 230–241.

van Manen, M. (1990). *Researching lived experience: Human science for an action-sensitive pedagogy.* Albany, NY: SUNY Press.

ABOUT THE AUTHOR

I am the Interim Graduate Program Director at Florida Atlantic University. Since joining the faculty in 1981, I am one of the pioneering members of College of Nursing and integrally involved in the development of a curriculum that emphasizes the significant influence that nurses have when practicing nursing from a perspective of it as an art.

The majority of my research is an exploration of nursing as it is practiced and taught. My phenomenological research on the art of nursing explicated what constitutes nursing as art. The major implication of this work is that when nursing is an art, it gives caring a new meaning of liberating help. The art of nursing goes beyond the notion of aesthetic practice. I regard the essence of the art of nursing as an ontology, epistemology, axiology, and praxis gestalt. My research offers a paradigm for originating nursing.

Currently, I live in Delray Beach, Florida, with my husband Bud Siddall. I grew up in Delanco, a small town situated in southern New Jersey and went on to receive my bachelor's degree in nursing from Trenton State College. My master's degree in nursing was from the University of California, Los Angeles, and my doctorate from the University of Colorado Health Sciences Center.

In addition to my research and teaching at the university, I have broad-based practice experiences in nursing. I am licensed as an advanced nurse practitioner and certified by the ANCC as a Clinical Nurse Specialist.

Out of Silence:
Discovering and Creating Self

Patricia Hentz Becker

CREATING SELF: LIFE'S JOURNEY

*T*he process of creating self is an ongoing process that involves a continuous struggle between holding on to the familiar and moving toward the possible. The need for stability and the need for change create a healthy tension that prevents stagnation and enhances personal growth. All too often, women describe themselves as feeling stuck, being in a rut, or having a general sense of stagnation. However, change is not just something that happens; it involves choice and action.

What has been remarkable in working with women has been the observation that there is always a potential for new beginnings and even for starting where one has left off. Reflections

on one's history and self-understanding are critical to the process of moving on. Just as a house has a foundation on which we can creatively build, so does self have a foundation with similar potential.

Too many women live in sadness and regret. Loss and sadness need their time, but moving on is the only way to go. There is always the potential for new beginnings, growth, and finding and creating self. Nadine Stair (1992), at age 85, invites us to enjoy life:

Afterword: If I Had My Life to Live Over . . .

I'd dare to make more mistakes next time.
I'd relax.
I'd limber up.
I would be sillier than I have been this trip.
I would take fewer things seriously.
I would take more chances.
I would take more trips. I would climb more mountains, swim more rivers.
I would eat more ice cream and less beans.
I would perhaps have more actual troubles, but I'd have fewer imaginary ones. . . .
You see, I'm one of those people who live seriously and sanely hour after hour, day after day.
Oh, I've had my moments. And if I had it to do it over again, I'd have more of them.
In fact, I'd try to have nothing else, just moments, one after another, instead of living so many years ahead of each day.
I've been one of those persons who never goes anywhere without a thermometer, a hot water bottle, a raincoat and a parachute.
If I had to do it again, I would travel lighter than I have.
If I had to live my life over, I would start barefoot earlier in the spring and stay that way later in fall.
I would go to more dances.
I would ride more merry-go-rounds.
I would pick more daisies. (p. 1)

BEING TRUE TO SELF

Self-understanding is critical for making meaningful life choices. Understanding one's history and reflecting on life experiences are foundations for self-understanding. Integrity of self is maintained when life choices are true or authentic. Self-awareness is a necessary condition for making authentic life choices. Without it, getting lost is very likely. Life choices are not simply personal preferences; they are also influenced by the social world and the expectations of others. As reflected in women's stories, the "personal self" and the "social self" are often at odds. Integrity of the personal self is critical to the process of creating self. Maintaining a commitment to self and to personal integrity leads to what I describe as *authentic self.* Figure 1 depicts the construct of authentic self.

Authentic self is the ability to define self based on personal values and commitments rather than on what is seen through the eyes of society. Authentic self can be described as an inside-out approach to the world. It is the ability to stand apart from the culture and view self within a social context but not as defined by the culture. It implies a clear awareness of self and a valuing of self, priorities, commitments, choices, perceptions, and integrity.

When the social world plays a major role in defining self, women run the risk of losing sight of their values and commitments. The result is what I describe as *silent self.* Figure 2 is a model of the process of silent self. An outside-in approach is used, whereby choices and life paths are determined by the expectations, opinions, and needs of others. To create a personally meaningful life, women need to come out of silence.

Many women lose themselves when they follow life paths determined by others, yet, interviews revealed that many women were unaware that they had lost "self." The degree of loss varied. Some women spoke of how they "used to be" and how they missed that part of themselves. After reflecting on their lives, these women came to see what they had lost and where they had gotten off track. One woman noted, "I had to backtrack quite a bit to get my life moving in the right direction."

One woman described herself as the corporate wife, a role she thought she would never experience. She hated pretending to be

Figure 1 Authentic Self—Inside-Out Approach

interested in her husband's colleagues' conversations. Her husband often reminded her how important it was to make a good impression. Another woman stated how she would get "lost in my work," a way of temporarily leaving the world she was in, a world that required her to be silent. She stated: "I find myself in my work. It is my world. The rest of my time is spent meeting everyone else's needs."

The corporate wife's experience illustrates how women can be defined in the social world and how they often get lost when they are subjected to the pressure of social expectations. The woman who refers to herself as getting lost in her work may have found the only place where she can be authentic, and one of the few places where she isn't silent. Meeting everyone else's needs

Figure 2 Silent Self—Outside-In Approach

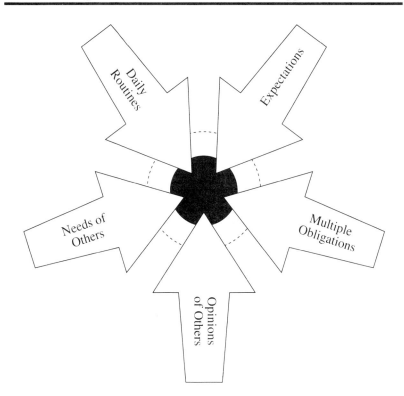

leaves little time for self. Both of these women could see the aspects of life that were meaningful, and they were struggling to maintain them. Both are at risk of losing self; self-awareness is key to finding one's way.

The loss of self can be quite profound for some women. As voiced by a 31-year-old lawyer, "I don't know who I am or who I want to be. My father always wanted me to be a lawyer, so I am a lawyer, but I am not happy." This woman was hospitalized for depression. As a child, her path had been determined for her, and gaining approval from her family was a key factor in the path she eventually took. Authentic self had been silent for so long that she did not know where to begin to look for it. We started her journey by going back to her childhood and discovering when

she went off track. Reflecting on past experiences helped her understand self. What was evident with this woman, as with so many other women, was that she had become stuck or fixed in a life path even though she was very unhappy with where the path was taking her. She was creating and recreating a social reality, and, like many other women, she could not see any way out. One woman described it as being lost in a "fog," unable to see more than a few feet in front of her.

As mentioned earlier, change requires energy and courage. Many women continue to hold on "to continuity even though there is an awareness that it is very flawed" (Bateson, 1989, p. 8).

The process of finding and creating self requires reflection on past experiences, to help women understand how they have been created. However, many women expressed a more urgent need to move on. One woman who had been abused as a child stated angrily, "Everyone tells me that I have to understand my past, my history, but it was such a terrible experience. I am just depressed when I think about it. I would rather just forget about it. I don't know why I have to relive it." This woman was able to move on when she realized that she was not expected to relive it but only to understand it. Creation of the possible is based on understanding reality, not on recreating that reality. Old patterns are life paths that are hard to move away from. They become even harder to leave behind when they are outside one's awareness. Every life path has a beginning. Once a woman knows where she has been, and where she is, she gains a better idea of where she can go. Paraphrasing a common colloquialism, "Do *I* know where I'm coming from?" Understanding self and others requires an awareness of where one has been, one's history.

Self-understanding and "insight" are critical for making meaningful life choices. "Phenomenology aims at gaining a deeper understanding of the nature of meaning of our everyday experiences. . . . Consciousness is the only access human beings have to the world. . . . A person cannot reflect on lived experience while living through the experience . . . thus, phenomenological reflection is not introspective but retrospective" (van Manen, 1990, p. 60). All our experiences and the meaning of these experiences set the foundation for who we are and the paths for self-development. Without them, authentic self is not possible.

BEING PULLED IN SEVERAL DIRECTIONS: THE SOCIAL SELF

How many hats can one woman wear? Some women wear more than others, but do all the hats fit? When one has to play roles that are not true to self, what is the impact on self? Women complained to me that there was little time to pursue meaningful activities because they felt pulled in so many different directions. Lindbergh (1978) cites William James, who described the phenomenon using the German word *Zierrissenheit,* meaning, literally, "torn-to-pieces-hood." A woman "cannot be perpetually in 'Zierrissenheit.' She will be shattered into a thousand pieces" (Lindbergh, 1978, p. 56). Some women did not describe their lives as being "lost," but they had a sense that life was passing them by. These were very busy women whose lives were filled, but they felt their lives were not full. Their feeling of being pulled in too many directions prevented movement in any one direction. One woman recounted how everyone wants a piece of her and there are no pieces left for herself. Another woman talked about how happy she was now that she was back in school, but how frustrated she was because there was no time for her studies. She described herself as a Girl Scout Cookie mother, a volunteer at her children's school, a wife, a Registered Nurse, and now, a student back in school. Some women found it was sometimes easier to keep moving than to slow down or stop. One woman described her life as being out of her control, like a roller-coaster ride, but she could not know or see how to get off. To borrow from physics, an object in motion tends to stay in motion. Choosing to slow down or redirect oneself requires a lot of energy. Many women must work through the guilt they feel when they give up some of their self-assigned activities.

WHO AM I?

Creating self and gaining self-understanding are ongoing processes that exist within a social world. One theory, symbolic interactionalism, seems to account for this phenomenon. The theory rests on three major components: "the self, the work and social action" (Bowers, 1988, p. 36), with the self composed of the "I" and the

"Me" (Mead, 1934). The Me is the object of self-reflection; the I acts as the reflector. Self-growth and the promotion of authentic self require maintaining a sense of consistency and meaningfulness in the organization of the multiple Me's. It may then be too simplistic to say that a woman who accepts too many roles loses her sense of self. If her roles are in harmony, they can foster meaning in her life rather than pull her in several conflicting directions. I was often asked how I could go to school, work, and raise a family. I would reply, "I don't think I could have survived doctoral study without my children; they helped me feel grounded." While I was writing my dissertations my two-year-old daughter was often at my side. When I was typing and feeling quite scholarly, my daughter would interrupt me with a request to have Barbie's clothes changed. I couldn't be in two places at once, but I understood that I could satisfy my daughter's request with only a brief interruption to my work. More importantly, I valued my daughter's request because it reminded me that I was a mother as well as a student. These two Me's are essential parts of my self; each provides meaning and purpose and is true to my authentic self. For me, the key was to not allow others to define who I was or who I could or should be. I did not want to lose any of the essential parts of self, or have them become silent.

SOCIAL EXPECTATIONS: GETTING LOST

Loss of self does not mean that part of self ceases to exist; rather, it is not within our view. As one woman stated: "I looked in the mirror and I did not like what I saw. I don't know what happened, but the person I saw was not who I wanted to be and I knew things had to change."

Another way one loses self is through a process of self-concealing: there is an aspect of self that is not acceptable to others. The phrase "I don't feel like I can really be myself . . ." is an expression of the concealing process. Many women go to great lengths to conceal aspects of self that friends and family may not approve. Part of self may even be out of one's own view. In such situations, one may block out aspects of authentic self and focus instead on socially acceptable aspects of self, because the social

constraints are so great that parts of self cannot survive. One woman, who had been abused as a child and during her marriage, stated, "I did not wear glasses until I was 30 years old. I did not realize I couldn't see. I now know that I did not want to see the world and I did not want it to see me. A friend took me to get glasses and convinced me to go back to school. Up to that point, I was the type of person who was always helping everyone but no one helped me. Luckily, one friend pointed me in the right direction and was very helpful and supportive. I then realized I needed to make changes in my life. That was the beginning of my life changes, including a divorce from an abusive husband. I've come a long way and I know I'm going to have a great life." For her, moving on and creating possibilities required seeing and understanding, and then having the courage and energy to change.

SOCIAL ROLES AND EXTERNAL STANDARDS

Gilligan (1989) described women as developing identity within a web of relationships. Through their relationships, women define self. However, although relationships are critical for identity development, women need to find self in the context of these relationships rather than as defined by the relationships. An understanding of relationships provides insight to the life paths one chooses. The process of conforming to social roles and external standards is not usually a conscious choice. No one hands us a list of expectations and says, "This is what society, your family, and your friends expect of you." The cues are so subtle and familiar that they often go undetected. One woman commented how everyone used to call her "a saint," and how good that made her feel. Friends could count on her to be there for them. After thinking about what it meant to be a saint, she realized that saints did not have really fun lives. She decided to change her image.

When paths are not grounded in authentic self, there is the risk of fragmentation and silencing of self. There is nothing wrong with a busy life, but there is a difference between a very busy life and a fragmented life. As stated by Lindbergh, "What a circus act we women perform every day of our lives. It puts the trapeze

artist to shame. . . . It leads not to unification but to fragmenta-
tion" (1978, p. 26). Silence is common among women who spend
their lives meeting the expectations of others and seeking self-
validation from the external world. Self-awareness is the ability to
know how and why one makes choices and commitments. Main-
taining one's voice and creating a meaningful life require a com-
mitment to valuing self and to making choices that maintain
personal integrity alongside one's social responsibility. It means
being neither selfish nor selfless.

INTERACTING IN THE WORLD

Life becomes habit whereby we create and recreate self in social
interaction (Dewey, 1938). Only with reflection on experience
can one uncover the meaning of experiences and the impact they
have on self. Many women have remarked on how they found
themselves in lives they had never imagined and would never
have chosen. Other women, unsatisfied with their lives, knew a
change was needed but did not know what direction to take. One
woman spoke of how she tried to convince herself that she was
happy. She stated: "Everyone thought my life was great. I pre-
tended it was but I was living a lie. I could not be myself. After a
while I had a hard time sleeping and realized that I could not pre-
tend any longer no matter what my family and friends thought."
 Social expectations, coupled with a need for social approval,
narrow the paths for personal growth and discovery. Over time,
pieces of self are set aside; they become covered with dust or
even forgotten. The habits of daily life and the demands of our
world keep us distracted and distance us from self. One woman
recalled: "I was unaware of how my life had evolved and had just
become accustomed to my role. When I look back at it now, I
don't know how I lived like that. A friend asked me how I was
doing, to which I replied, 'I'm surviving.' My friend's response
was, 'Isn't it a shame that a 36-year-old woman describes her life
as just surviving.' That statement made me open my eyes and look
at where my life was going and where it was heading." The words
we use to describe experiences help us understand the meaning

of those experiences. In listening to our voice, the silence can be broken and conscious awareness and awakening can begin. As stated by van Manen, "It is sometimes surprising how didactic language itself is if we allow ourselves to be attentive to even the most common of expressions associated with the phenomenon we wish to pursue" (1990, p. 60). What does it mean to survive, and how have life choices made one's existence into a struggle?

It is important to understand how we are seen by others. One woman talked about the pressure she felt from business associates and friends when she decided to stay home and raise her daughter. She faced queries like: "How can you give up your career?" and "Why are you giving up everything you worked so hard for?" Now in her mid-30s, she had a little girl after five years of infertility treatment. Her choice to be with her daughter was a commitment she was unwilling to compromise. For this woman, being self-aware, valuing self, and having a clear sense of commitment made the choice possible despite the social pressures.

AWAKENINGS

A consistent theme for women who have begun the process of finding and creating self is "seeing." Woman used phrases like "a rude awakening," "looked in the mirror and was shocked at what I saw," and "an eye-opening experience." Other women stated they did not want to see, and some said they could not see their lives ever being different.

The process of "seeing" varied among women. For some, a life crisis brought about a rude awakening. For others, the awakening seemed more gradual. They had periodic glimpses of their true situation but not quite at the level of full consciousness. One woman described a vivid image: she "saw" herself drowning, and the need to make life changes was her only means of survival.

Often, women were too close to see. One woman described how she was talking to a close friend about the communication problems she was having with her husband. She said to her friend, "I try to get him to discuss the financial problems and how we

can solve them. He just keeps saying, 'I don't have a magic wand.' The friend replied: 'Yes he does, he has you.' What an eye opener!" Someone outside of the situation could more clearly see what was going on.

Seeing requires full awareness, which includes thinking and feeling. As rational beings, we often try to fast-forward through emotional moments and intellectualize our way out of a situation. One woman told how a good friend of hers, a psychiatric nurse, used to always say to her, "How does that make you feel?" She hated when he did that, but she realized that there needs to be more than a cognitive awareness. Emotional awareness is also central in the reflection process.

THE RISK OF LOSING SELF: PSYCHOLOGICAL DEVELOPMENT OF GIRLS

The process of losing self has been identified by Gilligan in her study of the psychological development of girls. "Eleven-year-olds are not for sale" (Gilligan, 1990, p. 23); they have a sense of integrity and confidence in what they know and see. However, entering the teenage years, girls often experience what Gilligan describes as "going underground." Girls stop knowing what they know, and they begin a process of separating from self. Instead of defining and creating self in a world of relationships, girls begin to define self and see self through the eyes of others. For some, a struggle begins between conformity and creativity. Some women's voices echo this struggle as they reflect on missing out on opportunities. Other women feel that they do not know who they are (Belenky, Clinchy, Goldberger, & Tarule, 1986; Brown & Gilligan, 1992; Gilligan, Lyons, & Hammer, 1989).

Women who have become aware of "going underground" speak of needing to backtrack, begin anew, and rediscover. They see the awakening as a turning point in their lives. One woman said she felt she had lost herself in her early adolescence and needed to go through the phases she had missed. At age 35, she saw herself at about age 17. She predicted that it would not take her long to catch up, but she needed to experience those missing pieces of her life.

BEING LOST: THE WORLD OF ANOREXIA

Some of the clearest examples of being lost and silent can be seen in women who are anorexic. Patterns of social interaction reflect a strong desire to gain approval. Approval-seeking behavior intensifies one's sensitivity to the opinions and expectations of others and increases the risk for developing a silent self. This external validation of self keeps women trapped in a state of vigilance, always looking at how others see them. Life moves out of their control, and only the physical self remains in their control. The attention (both positive and negative) they receive from the world becomes more and more focused around issues of weight, and soon the world of anorexia is all they have left.

DISCOVERING AND CREATING SELF: COURAGE AND ENERGY

I have worked with women, helping them to uncover the essence of self, to rediscover lost pieces, and then to begin the process of creating meaningful life experiences. "Moving on" and "getting unstuck" were common phrases used by these women. Not knowing what to expect was also a common theme, although the women realized that the journey was not going to be easy. Getting unstuck required a tolerance for uncertainty along with a willingness to take risks and make mistakes along the way. Some women just kept waiting. They wanted to make sure they made the right decision and followed the right path. Fear kept them stuck.

The courage to explore life was one of the keys. For some, this choice was too difficult and too scary, and/or required too much energy; for others, once the journey had begun they saw no turning back or giving up self again. As one woman commented: "It has been hard staying on track and caring for myself. I often feel I am being pulled in so many directions but I cannot lose my focus. If I get off track, I try not to stay off track for long." Another woman stated: "No more secrets. I am honest and open. I'm not going to let anything stop me. . . . I know my priorities now and my commitments, and I look forward to a great life." This

move to authentic self should not be misinterpreted as selfish or narcissistic. Commitments and priorities and choices are socially grounded. Reflection on choices involves an awareness of and sensitivity to the world, to social interactions, and therefore to one's responsibilities. Being responsible in the paths one chooses is illustrated in this woman's story:

> *I had the chance to pursue my lifelong dream of going to medical school. I was accepted, I started classes, and I was doing great. I then saw the tremendous burden it was placing on my mother and my children. I knew I could not continue.*

Just as the process of self-awareness is ongoing, so too is the process of becoming. Many women speak of the courage to move on and to change one's life. One woman who had gone through a divorce spoke about friends' telling her she was brave. She explained that many of her friends were unhappy in their marriages but found it too difficult to leave. This woman knew her integrity was in jeopardy. She said: "When my husband asked me if I was leaving him for someone else, I replied, 'Yes, me.' I knew I could not survive in that marriage and I couldn't lose any more of myself. My integrity was at stake. I was willing to lose the house, and for a long time even tried to convince myself that the material things were enough . . . but they weren't. I used to say to myself, 'I need to keep the marriage for the sake of the children,' but I realized the price was too high. It meant giving up myself."

How much risk should one take? There is a healthy amount of caution and then there is caution to the point of being immobilized. I advise women to learn how to fall and learn to get up. Falling down is a natural process but it is critical to learn how to get back on one's feet. What women often forget is that they can also ask for a hand.

TIMING

There is something to be said about being in the right place at the right time. Women often refer to timing as a critical element in

their life choices. One woman spoke about her decision to leave her alcoholic husband: "I couldn't waste any more time; I needed to get on with my life." Many women who found themselves stuck indicated that they were looking for the right time to make major life changes.

This theme also emerged in a class that incorporates learning to care for the self. The class is offered to Registered Nurses returning for a degree in nursing. "Learning to care for the self is an innovative teaching strategy used in the clinical course, *Nursing Human Systems Under Stress,* at La Salle University. The aim has been to increase the understanding of the needs of the self, and the relationship to caring for others. Through the experience of learning to care for the self, students enhance control and power over their own lives and caring practice" (Lauterbach & Becker, in press). Students have often remarked that this course came just at the right time in their lives and helped them make necessary life changes. Years later, some former students have remarked that they effected major life changes and found the course a turning point in their lives. One student wrote: "I have spent most of my life taking care of everyone else, and now, I really feel the need to spend as much time learning how to recognize and take care of my own needs, desires, and dreams." With the use of journaling, many students begin to see their lives more clearly. A typical assessment was: "The journal opened my eyes to how I coped and opened the door to view different ways of coping."

MAKING A COMMITMENT TO SELF

To find self implies something is missing or misplaced. It can also mean that a "part of self was set aside" and the trick is to figure out where it is. What has become apparent in working with women is that many women set aside pieces of themselves and have almost forgotten those pieces existed. For some, forgetting was easier than mourning the loss. As one woman commented, "I don't have time to think about it; but if I did, I'm sure I would get depressed." My work with women has involved helping them make a commitment to self. One woman revealed, "I used to be a

good little girl, a people pleaser, but I wasn't happy. I didn't feel like I was really living. I felt myself slipping away."

Once women make a commitment to self, they are driven to maintain the essential pieces of self and to choose how they are becoming. Making a commitment often comes as a result of a life crisis, such as the death of a loved one, or a divorce. Life transitions were also common turning points for women. One woman discussed how she had always prided herself in maintaining her health and appearance. After the birth of her daughter, she realized she had let this part of herself go and decided to recapture that part of self.

REFLECTION AS AN ONGOING PROCESS

The process of finding and creating self is ongoing and requires an openness to the possible. A phrase I recently heard (and love) is "Believing is seeing." As women make the commitment to self and to belief in self, they are able to open themselves up to possibilities, to what can be. Seeing the social constraints and barriers helps one find ways around them. No one said it would be easy; it can be very painful and frustrating, which is why courage and energy are components of the process. At times, it seems easier *not* to move on, and some women found they needed to rest before making major life decisions. The ever-present tension between stability and change, continuity and the possible, makes them part of the challenge in creating self. Timing is one key: is it better to wait or to move on? Stability and change both play significant roles in the process of becoming.

REFLECTION ON EXPERIENCE

Becoming is more than a state of mind; it is a process that occurs within a social world. One can try to prepare for certain experiences, but, to learn and move on, one needs experience. How often do parents try to convince their children of something they learned from their own experience, only to be reminded that we

all have to make our own mistakes and learn from our own experiences. The concept experience is critical in the process of discovering and creating self. I am reminded how critical learning from experience is when I think about a story told by Dewey (1975). There was a school that taught students how to swim without going into the water. Carefully, the mechanics of swimming were practiced and the principles behind the motions were explained. Students knew how to swim. However, when one of the students was asked what happened when he got into the water, he replied, "I sank." There is no substitute for experience. As one reflects on self and maintaining integrity, experiences need to be sought that reinforce integrity. In addition, life paths that silence self or tear away pieces of self need to be entered into carefully, with open eyes. Making a commitment to self is key to making choices and setting priorities. Lindbergh wrote, "What we fear is not so much that our energy may be leaking away through small outlets as that it may be going 'down the drain'" (1978, p. 46).

IT IS NEVER TOO LATE

There is always a potential for new beginnings, for starting where we left off and forging new paths. Believing is seeing. As women believe in their ability to create a meaningful life, the possibilities become visible.

ABOUT THE STUDY

Understanding one's history, and reflecting on experiences and their meaning are foundations for self-understanding. Both phenomenology and symbolic interactionalism are responsive to this process, whether for self-knowledge or as an impetus for research. Phenomenology offers important insights on how critical self-reflection and self-awareness are and how they act as foundations for making meaningful life choices. Phenomenology also offers a framework for understanding how women derive meaning

from life experiences and create a sense of self. Symbolic interactionalism facilitates understanding how social interactions impact on the process of discovering and creating self, specifically in terms of our collective expectations.

Being able to see authentic self offers women a foundation for recapturing aspects of self that they have lost. Life choices that reflect authentic self prevent fragmentation—in essence, a scattering and disorganization of self. When choices do not reflect authentic self, women risk losing much more than they might wish. They risk becoming silent.

My research on women's experience has evolved over the past eight years and has included interviews with women who have made major life transitions, women with eating disorders, and working nurses interested in the phenomenon of human systems under stress. I have done much of this research with my good friend and colleague Selen Lauterbach, who also teaches the course "Human Systems under Stress." In this course, learning to care for self has been a major component. Its underlying philosophy is that understanding and caring for self is essential to understanding and caring for others.

A common theme in women's stories was getting lost or losing a sense of self. Women described how they felt their lives had gotten off track, they were pulled in many directions, and they found it difficult to maintain a sense of self. Choosing meaningful paths took a lot of energy, and there were many obstacles along the paths they had chosen. Timing, another critical theme, involved being in the right place at the right time, and knowing when to move on. Meaningful paths meant hard work because they were not usually the easiest possible paths. Staying in a rut was sometimes easier than getting out. The required conditions for creating self were: awareness of authentic self, commitment to self, and energy and courage.

I would like to thank my undergraduate students who enrolled in the course "Human Systems under Stress." They were part of an ongoing dialogue that made this chapter possible. I would also like to thank three graduate students who participated in data collection and many hours of dialogue: Catherine Haldworth, Sheila Krasnansky, and Mary Ellen Miller.

REFERENCES

Bateson, M. C. (1989). *Composing a life.* New York: Plume.

Belenky, M. F., Clinchy, B. M., Goldberger, N. R., & Tarule, J. M. (1986). *Women's ways of knowing.* New York: Collier Books.

Bowers, B. J. (1988). Grounded theory. In B. Starter (Ed.), *Paths to knowledge: Innovative research methods for nursing.* New York: National League for Nursing Press.

Brown, C., & Gilligan, C. (1992). *Meeting at the crossroads.* Cambridge, MA: Harvard University Press.

Dewey, J. (1938). *Experience and education.* New York: Collier Books.

Dewey, J. (1975). *Moral principles in education.* Southern Illinois University at Carbondale: Arcturus Books.

Gilligan, C. (1990, January 7). Confident at 11, confused at 16. In F. Prose, pp. 22–25, 37, 38, 40, 45, 46, 50, 54. *New York Times Magazine.*

Gilligan, C., Lyons, N. P., & Hammer, T. J. (1989). *Making connections.* Troy, NY: Emma Willard School.

Lauterbach, S. S., & Becker, P. H. (in press). Learning to care for self: Using reflection as a prelude to understanding. *Holistic Nursing Practice.*

Lindbergh, A. M. (1978). *Gift from the sea.* New York: Vintage Books. (Original work published 1955.)

Mead, G. H. (1934). *Mind, self and society.* Chicago: University of Chicago Press.

Stair, N. (1992). If I had my life to live over. In S. H. Martz (Ed.), *If I had my life to live over, I would pick more daisies.* Watsonville, CA: Papier-Maché Press.

van Manen, M. (1990). *Researching lived experience.* Albany, NY: SUNY Press.

ABOUT THE AUTHOR

My daughter, Kaitlyn, is now 7, and my two sons, Kevin and Eric, are 20 and 13. This chapter is for them; may they never be silent. Of the multiple Me's, I cherish most being the mother of three wonderful children.

This chapter stems from my own work with women, from interviews with women who have made major life transitions, and from my continuing work with my good friend and colleague Selen Lauterbach. A major part of the data has come from working nurses enrolled in the course "Human Systems under Stress." My role as teacher has been to facilitate the process of critical reflection.

At age 41, I have come a long way and have gotten lost several times. I have even been silent at times, even though it is very contrary to my nature. I finished my doctorate from Teachers College, Columbia University, in 1991. Kaitlyn was my doctoral baby. Teachers College was a wonderful path.

I know where I am and where I've been, but I'm not certain of which paths I'll take in the future. I do know that I will try to enjoy each path I'm on, try not to get into a rut, and, when the paths get a bit too difficult, I will be much more willing to ask for a hand or directions. I am lucky to have good friends.

Of the many Me's, being a teacher has been most rewarding. I never saw myself as an educator, but I cannot imagine any other path for me. I look forward to the adventures to come, and, with a brand new pair of hiking boots, my Christmas gift from my children, I'm ready.

3

Losing at Winning: Competition in Women's Experience

Carolyn L. Brown

COMPETITION is about pain and power and people and perversion and pettiness, and about winning and losing YOURSELF and, at times it seems, YOUR MIND! The women who participated in this study told me extremely moving stories about how they experienced competition in their everyday lives. Most of the stories were sad, with just a little gladness for good measure. A few were humorous.

After hours and weeks and months and a lifetime of living and breathing the air of our competition-based society, and more months engaged in reflective work about the phenomenon, I now know that, overall, for women, competition means mostly loss. Even when they win, women lose. Following that rather blatant and paradoxical statement, please join me in entering into the

lives of women as they tell of how they experienced competition. These women helped me to realize that all of my upbringing, all of my socialization and education leading me to where I am now, was based in wrong assumptions about competition—a scary thought for someone who has lived and worked as long as I have.

OPENING THE DOORS TO AWARENESS

One woman told this story about competition during her early high school years. She spoke in a low, reflective voice:

Donna: One experience I vividly remember is when I was a cheerleader in high school, a Junior Varsity Cheerleader. I was captain of the cheering squad, and when I tried out for varsity cheerleading, I didn't make the team. And nobody knew why. Nobody could figure out why. And I found out later the reason was because there were some girls that were prettier than I was. You know, they weren't good cheerleaders, but they were better looking and they made the squad. It was the girls' coach who chose the team members and she was friends with the parents of these girls, and whatever. . . . It was a very devastating experience for me as far as competition because it was unfair; and it was very disappointing for me because I, along with every body else, was sure that I was going to make this team. The captain of the junior varsity squad always made the team. And I didn't. That's what was so devastating about it. I remember it vividly, I really do . . . [said softly, with some puzzlement]. That's probably my first real memory as a young—almost a young-adult, of competition.

Author: How old were you then?

Donna: I would have been 15 or 16. I would have been entering my junior year in high school. When I think of competition, I still remember that experience. That was a very hard lesson to learn. But that was a very realistic lesson to learn.

Snapshot

Envision a group of teenagers at tryouts for the varsity cheer-leading squad. All are carefully groomed; their tension shows in their forced laughter. Not everyone will be chosen. Each has carefully rehearsed her individual routine, and knows the squad routines by heart. In each heart lies hope, and the captain of the junior varsity squad has only small doubts about being selected. After all, every past JV captain has made the varsity squad. The tryouts go smoothly, the routine is as perfect as it can be. Everyone goes home to await the posting of the names of the girls who made the team. When the list goes up, they crowd around it, fearful yet eager. Who has won the coveted places? The JV captain, sure of her place on the list, reads more casually and confidently. Then she quickly reads it again because she did not immediately see her name. Surely she has read it too swiftly! Her name *MUST* be there. She reads the list again and again, her heart sinking into the heaviness of her body as she reads. Finally, with tears at the back of her lids, she realizes her name is not there. She feels sick and can hardly breathe. Then, with a glimmer of hope, she thinks, there must be some mistake! Soon she learns there has been no mistake. She has not been chosen. She sleepwalks through classes, thinking WHY? WHAT HAPPENED HERE? Friends support her, telling her they do not understand: she had been an outstanding team captain and had performed faultlessly during the competition. In her mind, she plays the tape of the tryouts over and over again, but no answer pops forth. Into the fiber of her being creeps the realization, "I'm not pretty enough. I'm not good enough to make the team because I'm not pretty enough." The written rules talk about talent, skill, and ability, but the real rules say you need to be pretty enough and know the right people. It's *not fair*, but there is nothing she can do. She feels helpless, angry, and betrayed by the trusted coach and the structures that set her up to believe she had a chance. She had the skill and the ability, but they weren't enough. They didn't even put her among the front-runners for making the team. She has quickly learned that, in a competitive society, the rules aren't always what they seem, and success does not depend on rational processes. In fact, much of the basis for making decisions stays hidden, leaving contenders on a dangerous playing field where rules reside in shadows rather than substance.

There is something wrong with this picture.

Author: What was the lesson in that?

Donna: [thoughtfully] It [success] wasn't really based on talent and what you were capable of doing. The lesson in that is that life isn't fair. I mean, that was an example . . . a perfect example of life not being fair. That you can't really depend upon yourself, even though you may know you're capable of something. It's always going to be something political or . . . there may be forces you can't control that will determine the outcome of any competition you're involved in. And that goes on regularly in life.

In Donna's story is the whole story of competition.

Sadly, this story is repeated, in many forms, through the voices of women who tell how they experience competition in their everyday lives.

DEFINING THE SELF IN RELATION TO COMPETITION: AM I A COMPETITIVE PERSON? (SURELY NOT)

Women struggle to define themselves in relation to living competition. With a few exceptions, I believe the women in this study preferred to shift their knowing of competition in their lives into the shadowlands of suppressed awareness. From this place, knowledge is retrievable, but not too often or too clearly because competition does not fit easily with how women see themselves or other women. Even in the shadowlands, competition thrives, rearing its head with an ugly snarl when a women is in pain through experiencing it. When awareness comes, women construct their images of themselves, and from this place flows the essence of who they are and will become. In fairness, some women accept competition as part of themselves. It sits easily and forthrightly in their lives, and they are at peace with themselves. But these women did not seem to be the norm.

As women talked about competition in their everyday lives, their statements often resembled Donna's:

I'm not an aggressive, assertive person at all, and I'm not fiercely competitive. I can be competitive if I really want something, but it's not a driving force in me. I mean, I've never felt that competition is a major area in my life. I've never felt that, wherever I was, I had to outdo this or that person in order to get ahead or be successful.

Marcia's statement followed the same thread as Donna's. She stated at the very beginning of our interview:

Well, competition is kind of an interesting word because I don't really see myself as a competitive person. I've played a lot of sports, and in competing, and trying to achieve the same goal, and wanting to be ahead of the game, or really achieve that goal, in that sense I deal in competition. [Then, more softly and reflectively] I don't really care for that word.

Marcia went on to discuss her uneasiness with competition in her life. Bonnie, who acknowledged that she was competitive and was at peace with this aspect of her nature, recognized, "Women don't define themselves as competitive. It's not something that's really valued with women, and so I don't think I've ever thought too much about it, though I hate to lose. And so I probably would deny to most people that I'm competitive. But I know that's really untrue." She went on to state, highlighting her need to be competitive to avoid losing, "I couldn't even play bridge and lose quarters [acknowledging the supposed trivial nature of losing a few pennies]. I had to GET GOOD at bridge." In a way, she was laughing at herself while still acknowledging the important role competition and winning played in her life. For Bonnie, like many women who tried to define competition for themselves, competition is about winning and losing, and about achieving.

Connie's experience of competition starts with awareness. When Connie thought about competition in her life, she realized that she became aware of being in a competitive situation by how she felt. Often, when she realizes she is in a competitive situation, she chooses not to compete, but first comes the recognition.

[Realization comes through] vibes that I'm getting from somewhere, so I know, when I sense it from someone else, there is a competitiveness. Or perhaps there is a sense of striving for the same thing—which, I guess, is what I believe that competition is. When one or two other people perhaps have the same goals, or want the same thing . . . I experience it through something that is happening

Participants then feel they must develop the situation as competition. They believe that only one person can attain the goal, at least in conventional wisdom, and so they play out the situation as win–lose. Deliberately, but not necessarily consciously, they act to outshine or outdo someone else.

Diane feels her competitive nature when she plays tennis or drives on the freeway:

The only time that I'm really aware of competition is when I play tennis. I experience it there and I guess I judge it as being bad; but at the same time, I know that being competitive helps me to pay attention to the game, and to try to play well.

Later in the interview, and laughing gleefully, she admitted:

Driving in the car! Oh, that's always a good one. I find myself just automatically competing with the car next to me. That kind of shit! And I say to myself, "WHAT are you doing THIS for?? You don't NEED to do that!" I like to drive fast, but there are times when I am aware that somebody's gonna get ahead of me, and I have to talk to myself and say, "It's REALLY OK if that person gets ahead of you." And then I laugh at the person that had to get ahead of me.

Stacie countermanded her earlier statement that she didn't have anything to say about competition:

After I gave it a lot of thought, I even talked to a friend about it, and said, "Would you think of me as competitive . . . ? What would you think about that?" So we had

some interesting discussions, but the more I thought about it, the more I thought, "Well, maybe I am just a tad bit competitive." So we were talking about, well, does it mean you have to win everything . . . or what did it mean? . . . So maybe it is whether or not you thought you had to win, or come in first, versus just feel competitive with yourself and try to do better.

Bonnie recognized that, although she was competitive at work, she was really competing against herself, because there was no one to compete with. She was already doing better than others, so she was really trying to improve on her own record.

Part of women's experience entailed coming to terms with themselves as competitive persons. How did they know competition and were they or were they not competitive? How did they feel about that? Bonnie was clearly comfortable with her own competitiveness, but the rest were uneasy to have competition as part of their identities. They disclaimed by saying they did not see themselves as competitive. When they did recognize competition as part of themselves, they tried to justify or make light of it.

PUZZLING IT OUT:
WHAT IS COMPETITION ANYWAY?

Like most of society, women defined competition in terms of blind acceptance. Competition was viewed as necessary, even helpful in a number of ways. Sandy commented:

I find competition a very interesting word and I recognize that competition is valuable. . . . If I were to define competition, I'm not exactly sure how I could define it. I see it as a paradox. There's a necessity to compete for quality, but I guess it depends upon how people are driven. I would say that if you get something over someone else, then you've gained and they've lost. I don't know if there's always a win–win. Maybe if someone wants something that you have, then they compete with you. But at the same time, there is a necessity to do that for the purpose of making

those improvements, when you try to be like somebody.
Maybe the traditional way of looking at competition is, you
see somebody else and you want to exceed their level of
quality, scholarship, outfit [clothing].

She went on to say:

I think that I probably have spent a lot of time in my life
competing against my own journeys. I'm always engaged
in the process of wanting to improve or learn more or go
deeper into myself.

Like Sandy, as women reflected on competition, they displayed
some confusion and uneasiness about the role competition plays
in everyday life. The type of competition that sat most easily was
competition with oneself in order to exceed one's own past per-
formance. No harm came to another in this type of competition.
The worst that could happen was a failure to measure up to one's
own expectations of self.

Diane, who thought of tennis when she thought of competi-
tion, expressed her ambivalence by saying, "I guess I have con-
flicting feelings about competition as being good and bad."

Bonnie found that competition for her frequently involved
competing against herself. "It's games I play with myself some-
times . . . I'm not sure who I'm competing against. I have to have
some type of challenge . . . which I think is a form of competi-
tiveness." For Bonnie, competition with herself most often in-
volved exceeding a past performance. "It's sort of like getting
better at it the next time than you did this time . . . and it isn't for
the rewards or awards, it's just me. It makes me feel good because
I don't tell anybody. It's competition with myself. It's comparing,
too, because we all know each other's statistics, but we don't talk
about it. We just know."

Team sports appeared often as a metaphor for competition.
Somehow, team sports were acceptable competition, because
they followed rules of fair play in the drive to win. Using the team
metaphor of appropriate competition, Marcia differentiated be-
tween a team player and one out for individual gain. She believed
working for individual gain sabotaged team efforts. "Even though

they may say they're a team player, [they are not because] they're the ones that want to shoot the ball all the time and not hand it off to the [player] under the basket."

Connie did not particularly like team sports, such as football. "I like sports, but the kind of sports I engage in are . . . not putting person to person against each other for the ultimate win. . . . I like activity that is interesting to watch, but I don't watch to see people win." Rather, she watches to see the skill and grace that the athletes exhibit. She went on to describe the experience of winning in the context of team and individual efforts:

> *As a student in high school, I was in gymnastics and we entered competitions. It is a context that builds, in conventional wisdom, "character." And perhaps it does [said thoughtfully]. And it can all be in fun. But I don't think that my experience of competing was one of fun. In organized sports, it was stressful because the aim in that was to win the game, or the competition, or whatever. . . . There's a winner and a loser and you want to come out the winner.*

In situations where there was a winner and a loser, she saw the pain involved because SOMEONE or SOME GROUP must lose.

When Marcia spoke of competition in the context of a team effort within an organization, she spoke of the importance of focusing on the goal rather than on who achieved it. Something was to be accomplished and whether or not she or her team was responsible for goal attainment, the organization achieved its aim.

> *. . . I did play sports, and different team members can be in different positions in order to achieve the goal, without [just one] individual achieving that goal. So, that's how we're successful in basketball. . . . As long as the goal continues to get achieved— . . . most times, good ideas are supportive of goals that really benefit all—it's not just one person's idea.*

She reminds people that "a multitude of people" in the organization have the same drive, and ideas, and convictions. Thus, achievement of goals needs to be a team effort, and individuals

Snapshot on Two Levels

Envision a basketball game. Two teams take the floor. They are fairly evenly matched. Names on the back of the shirts are MANAGED CARE and NATIONAL HEALTH INSURANCE. The centers are poised and the ball goes into play. At stake is the district championship. At stake for some players is a college scholarship. For the crowd, the prospect of a trophy for the school and being number one in the state, perhaps even in the nation, awaits on the horizon. The stakes are big. Lots of dollars, within an environment of scarcity. Both teams want to WIN the game, because for THIS game, survival as a team is at stake. How hard will the players play, what chances will they take, and what will the outcome be? The competition becomes more and more fierce, with the players becoming hot and sweaty. Several of the players have made it to this game because their training was paid for by a backer. These players know that if they do not do well and play the game as the backers and trainers wish, they will lose their monetary support to another player. At stake are dollars, jobs, glory, contracts to provide services for large numbers of companies employing large numbers of people. Individuals can become stars!

How many winners can the game support? In basketball, one team will emerge victorious. In health care, can more than one hospital, more than one managed care group get the same contract to serve the same population? The fewer the potential winners, the fiercer the competition. Despite the rules governing the competition, which state that the play for the goal must be fair, the stakes determine how fairly the game will be played. Referees cannot watch all players at once. When the prize is coveted, and only one team can win, and when chances of being caught are slim, a toe snakes forward to trip up the center forward as she rushes to make a basket, (or a computer key is touched to alter a dollar figure), because the goal is worth the risk, and the goal might not be achieved without the unfair edge.

Besides, players cannot trust that the other team, or the other center forward, will play fairly, so if we do not (drop the atom bomb) the other side will, and we (I) want to survive. So we justify sacrificing moral imperatives to win. The center forward goes down in a heap, ankle twisted, perhaps broken, and her team loses. Her teammates, with heads bowed and eyes filled with tears, leave the court after giving the formula cheer for the

Snapshot on Two Levels *(continued)*

victorious team. They are losers. In the heart of the guilty tripper lies the heavy knowledge that she has harmed another. The WIN may be undeserved, but she couldn't risk playing fairly. The stakes were too high. And the woman who was misdiagnosed, because to save a few dollars, she was sent home without adequate testing. She didn't fit into the requisite 15-minute diagnostic spot, so she may lose her life so that the competing health care organizations can win the race for DOLLARS.

There is something wrong with this picture.

should not feel distressed about not being recognized. The institution (team) moves forward. As I thought about this, I realized that the team metaphor can be enacted in organizations as long as the rewards are fairly distributed. Do rewards come to individuals, or to the teams? How many players compete according to the unstated rules of the game, seeking individual recognition?

Thus movement toward attaining something, or winning, forms the cornerstone of competition. Scarcity permeates the definition by creating a strong desire for the goal. By definition, someone or some team will achieve the desired win (or goal) and someone or some team will not. Examining competition in the context of organizations, I came to realize that women play out the scenario of helping the organization to compete in the wider organizational, societal, and global contexts. However, at the root of the definition, one still finds WINNING and LOSING. Competition exists at all levels of society.

WHAT'S WRONG WITH THIS PICTURE?
THE DARK SIDE OF COMPETITION

When most of us think of competition, we think of winning and we associate it with a sense of joy and exhilaration. Winning the lottery means the winner has money for whatever he or she might need and want. Yet millions of people who spend much needed resources on lottery tickets *lose* in the hope of a big win. Winning the Superbowl means the champions are the number-one team.

But all the other teams that made the playoffs are now *losers,* and many players and fans coast to coast are deflated. In the drive to win, some players have been injured and may never play again. Jill Kinlin's story, in the film, *The Other Side of the Mountain,* attests to the tremendous risk to self that accompanies a deeply embedded drive to win. When Jill met a competitor who, she feared, might be superior to her skill in skiing, her drive to win was so strong that she disregarded her coach's instructions to be cautious at a dangerous part of the course, and took it too fast. As a result, she flew over a precipice and tumbled down the mountain like a broken toy. The cost? Becoming a paraplegic with little or no use of her hands. She was a REAL LOSER!

Winning the gold cup, in anything—is it worth the hours of hard work and the effort at fine tuning? Many competitors are very good, but not good enough to shave off a millisecond, or bunt the ball just inside the base line, or place the kick just high enough, or predict a bear market, or have just the right sense of curriculum to know how many students will enroll, or estimate how many doctors will bring how many Medicare dollars for condition X, and so on. We seek to win by striving for perfection. And we are all LOSERS, LOSERS, LOSERS. "He's a loser." "She's a REAL loser." "That school is a real loser." "That hospital is a loser." Those are horrible summations. No one wants to be a loser, so the dark side of competition encompasses the reality that many people will do almost anything, and some people will do anything, to be winners. There are only two alternatives. If you are not a winner, you must surely BE A LOSER! You don't just *lose.* You ARE a loser. You become your losses, you are defined by your losses. That is the dark side of competition for many women, and it doesn't feel good.

Fierce and Vicious

When women talked about competition, the words *fierce* and *vicious* kept popping up. Competition within rules of fair play seemed to be acceptable, but pernicious, cutthroat competition, where people get hurt, concerned women. Donna stated:

> *Competition can be healthy if there's mutual respect on both sides, but some don't have that factor.... Because there's*

really no regard for the other side or what happens, as long as they win. The means justify the end.

Donna spoke about her discomfort with the viciousness of competition in work settings. Staying out of vicious drives to ascend in the organizational hierarchy was important to her.

It's how you view competition when you go for a job interview. You are competing with someone else for a position. . . . I certainly don't feel that competition in that regard has affected me in [the same degree] as a man, because I am in a field involving more women. I've not been super-goal-oriented in moving up into administration at this point in my life. While I was raising my family, those were not my objectives. So, I've not been in that circle of viciousness [where] you might view other people [embracing] in order to jockey into a position.

In the rest of her statement, the idea of competition having rules of fairness came through. We were talking about her discomfort with vicious competition and the importance of staying out of such situations.

. . . I'm uncomfortable with them. I'm VERY uncomfortable with them, and I'm basically a very honest person. Probably too honest. I play the game to a degree because I think all of us have to play "the game" to a certain degree in order to live in the type of world we live in, to get along. . . .

What was her perception of fierce competition?

Fierce, to me, in talking about competition, would be insensitivity to other's feelings or needs, ruthless, calculated, very fierce.

In her account, competitors have little regard for each other. The process of winning becomes subsumed by the importance of winning, or achieving the goal. Self-ascending takes precedence, with little regard for the cost to either party.

Sandy spoke about the fierce competition in education, specifically, about teaching at another university:

What's going on at the school is like a competition. It's so FIERCE. So it's like trying to provide for them [students] a safe haven that they didn't have to compete. We could work together.... That's what they were accustomed to [competition].

She sought to provide respite where the self and each student's creative spirit could grow, a place safe from harmful competition. In fierceness resides the idea of doing injury to another. Visions of battle, weapons, wounds, and drawing blood in direct combat arise when I hear the words "vicious competition."

Loss of Joy in Another's Success (Jealousy)

Jealousy loomed on the horizons of women's stories of competition. It was defined as not being truly happy for another's success when the goal was one you desired for yourself. Jealousy seemed to emerge from a sense of scarcity. Both contenders could not have the coveted prize, and both desired it. When one gets the prize, or when one is successful and the other fears she might not be successful, jealousy emerges. Connie reflected about competition and jealousy:

I know there is a genuine sense of joy that I experience in the accomplishments that I have made, or that colleagues or family members have made. There is a genuineness of happiness that is unrelated to the person that's expressing it.... It makes me think it's competition when someone is not able to be genuinely joyful about someone else's successes.... I wonder about what is at the essence of that, and I usually feel that this is jealousy *[said in a whisper].*

When asked to describe this experience further, she went on:

I have experienced the situation with particular accomplishments that are expected as part of professional

responsibility.... With some individuals in that context, I
have experienced a sense of being helped, of support, a
sense of... "That's wonderful!"... I have also experienced
with other individuals a sense of lack of joy, recognition,
or positive feedback for those accomplishments.

Sandy spoke about how she felt when a colleague was success-
ful. Competition, in many ways, blights the fullness of joy in an-
other's success.

You might have a pang there because you didn't get into a
journal. I feel bad momentarily, but I'm not going to let it
eat me alive. I'm not going to let it destroy a friendship.
I'm not going to trample on somebody because of it.

Competition, when the goal can be achieved by only one, de-
stroys the joy possible in another's success, because one's own
loss tempers the experience with one's own diminished sense of
self. The other person's success creates a LOSER.

Minimizing Another Person

Another way competition becomes manifest is through the need
to minimize another person or his or her contributions. Connie
observed:

Lack of recognizing the individual in a group situation, or
deliberately minimizing the person—I think that is proba-
bly an experience of competition. Minimizing a person's
contribution, the persons, who they are, what they've done.
It's an overlooking. And I don't mean it's just in the context
of colleagues.... It's in the context of personal relation-
ships, friendships, anything like that. I think those behav-
iors are... [softly, almost in a whisper] disempowering.

Minimizing another diminishes the being of the other in the rela-
tionship. The competitor experiences a sense of pride and joy in
accomplishment, but the accomplishment, and often the com-
petitor, "diminishes someone else. And that's depersonalizing, I

feel. Not that the intent is to do that. In some situations there isn't the knowledge. There is a lack of awareness." The diminishment is built into the context of competition: if one wins the prize, the other(s) must lose. If someone else wins, then you lose, so how can you be fully happy if someone else wins or is successful?

In the organizational context, Connie noticed, "There's a deliberate attempt to discredit the other person when two people are going for the same thing. . . . I think that is diminishing." She went on to describe how, when she presented reports of work she had done, people responded with diminishing and discrediting remarks. She felt people commented when they were not necessarily happy with themselves or their own work. "When there is a dialogue and there is engagement where people are truly diminished, then there is a winner or a loser context and I don't like to do that. I don't particularly like being in pain [said with laughter and wry humor]. That is not something that I want to spend my time being involved in."

Donna spoke of her sense of personal diminishment as a loser in the cheerleading competition when she was a teenager (described earlier). The loss was unexpected, so the hurt was deeper. "It's the type of thing [where] you go home, you agonize over it, you stay up all night, you don't sleep. . . ." She worried about what was wrong with her, whether she wasn't pretty enough; she agonized over what she might have done differently.

Sandy struggled to avoid competing against someone else because she did not like to outdo anyone in public. "I can be better than someone but not outdo them in public. I know that I'm better than some people at certain things. I don't want to show that to put anybody down, or be perceived to be putting anybody below me or anything like that."

All of these descriptions speak to the pernicious and insidious ways competition erodes persons by diminishing their sense of self and eroding their potential. Connie said diminishment was disempowering because losers, even when they are gracious about losing and bounce back with courage, experience a sense of being "less than" the winner. It's as if, to increase the stature of the winner, the losers shave off some of the substance of the self—a painful experience that is embedded in the context of competition.

Fouls and Loss of Trust

Part of diminishment is the resulting sense of helplessness. By virtue of the context or the rules of fair competition, neither party feels there is a choice. All competitors have had an equal chance. Often, however, the real rules are hidden and fairness does not apply.

In unfair competition, trust flees and, once lost, is not easy to recapture. Trust involves predictability, knowing how the other in a relationship will behave. It has to do with knowing that self and others follow known rules of conduct. At the root of even supposedly fair competition lurks the notion that winning takes precedence to fairness, and the end justifies the means. "Nice guys" (and gals) finish last. Competition singles out winners for glory. The rest are losers. When the stakes are so high, how much can we trust in fairness? And what does *that* mean for selves involved in the game?

Donna stated:

> *I'm a very trusting person. Those [fiercely competitive] people are not people you can trust because they'll do whatever they need to do to get where they want to be. So they're not sincere. Fiercely competitive people—depending on the person, because there's a lot of [different] people that are very competitive who are good people, but I don't know that they are people I would want to trust too much with anything of real importance to me, because they might be my friend today and not tomorrow.*

When people compete, outside of games where a referee guards against the players' violating known rules (at least as long as they are within the referee's sight), other people, things, the environment, become casualties, because competition means there will be a winner and a loser.

Bonnie stated that one of her coworkers was trustworthy, but then revealed:

> *My trust level isn't very high. I truly don't trust very many people. People that break their trust with other people by*

sharing their confidences with me will break mine to other people. People are users. In bureaucracy, what you use is ideas and knowledge. So, if I share my ideas and knowledge, they will be used against me.

Bonnie had figured out that, in order to excel, to do the best job she could, she needed to be in control of her own resources, her own domain, as it were. This required information and the power to draw boundaries around her domain. She protected her turf.

It's a way of protecting, and competition is part of control, as you well know. [When you're] good at what you do, . . . the competitiveness adds to the control [and] that gives you more control. If you are competitive and do [your job] well, then you are given more responsibility, and you have more control than you would have if you didn't do it well. The noncompetitive person in a bureaucracy gets stepped on.

When people compromise their moral principles in order to ascend, to do well, to *win,* we can trust only that people will not be trustworthy. Trustworthiness also has to do with constancy. Consistent ethical behavior that solidifies and protects the integrity of self and others builds trust. Related to personal trust, Donna stated:

People whom I have seen and have known who are very, very competitive, who want to get ahead, are chameleons. Depending on whom they're with and where they are, they change colors. I don't like people like that. . . . Fiercely competitive people have blinders. I see them as very driven, . . . very aggressive. . . . I'm just not comfortable with people like that.

When a goal takes precedence over people (when the end justifies the means), making competitors, or even innocent bystanders, expendable commodities, little basis exists for trusting that one will be safe. In competition where rules bend or are discarded, depending on who looks on or the desirability of the goal, no one is safe.

Knowingly Doing Harm and Causing Fear

Compromising values of fair play and knowingly doing harm can become byproducts of competition. When the societal context rewards winners and abhors losers, many are willing to compromise their principles regarding the value of the integrity of others and fair play as a natural price to pay for winning. Some compromise their integrity and do harm knowingly; others do it in a state of unawareness. Women judge doing harm knowingly, or consciously choosing to dispense with rules of fair play, more harshly than doing so out of unawareness. The sad lesson? "Sometimes life is just unfair and you can't always be in control of what happens." When the choice is between winning and another's well-being, winning often prevails.

Women also differentiated the palatability of competition according to the closeness of their relationship with the opponent. When the opponent remained an unknown, as in employment interviews, they found competition more acceptable because no hurt was done to a visible other. Women found it more unsavory to face an opponent they knew, especially when the stakes were high. For example, in a move for an internal promotion, competitors often know one another. One will "get the job," but the competitors (winner and loser) will need to work with one another on a continuing basis. The pain of the loser will be visible, or, even if well hidden, surmised by the winner because the winner knows how she would feel had SHE herself lost. The strains on a relationship, within the competitive context, are great, and may even jeopardize the relationship.

Donna described how she chose to stay out of competitive situations insofar as possible:

I'm interested in doing a good job and I'm not out to take somebody's job away. If I'm interested in a promotion, it's because it's something I want to do, not just because it's important to get ahead and keep moving up the ladder. There's a different type of intensity of competition depending on what you're working toward.... So often there's a harshness and a hardness [in competitive people], and sometimes you're aware of a lot of people

*around that person who have suffered or are suffering be-
cause of that competitiveness, because they're so driven.
And that's kind of sad to see that.*

She went on to describe her own application for a job:

*I just changed jobs, and I had to compete fiercely for the
job, not that I was aware of competing with this person or
that person [the competitors were unknown], but because I
knew that the job I was fortunate enough to get was
wanted by many, many people. There were many, many
applications. In that sense, there was fierce competition. It
was not an* active *fierce competition, but [it was fierce]
simply because of what the process is. . . . I didn't have to do
anything that was backstabbing and take . . . steps where I
knew that I might be hurting anybody. It was just a matter
of an application process. . . . I had no knowledge of any-
body else.*

She went on to acknowledge that this type of competition felt
fine:

*I did not have to knowingly do anything to anybody. To my
knowledge, I didn't knowingly kick anybody out of a posi-
tion. These were new positions that were created, and I was
competing fairly with other people. I happened to have an
edge and I got the job. . . . It wasn't one of these cutthroat
things that you hear about where somebody's pushed out
because of this or that, where people are hurt and, you
know, you feel bad about it.*

Competition involves fear for self and recognizes that others
fear you. There may even be fear about what you yourself might
do. The root of fear is knowing that, in a winner-take-all society,
losers are less than winners. Losers lose more than the competi-
tion. They lose a part of themselves because they are viewed as
losers rather than as persons suffering a loss. The latter leaves the
self intact. Sandy noticed an effect of her competence:

Most of the time, people feel threatened by me. In the higher levels. . . . [they] are threatened by what I know and my background. I have worked very hard to achieve and I'm very good at [her areas of competence].

She had once held a position that demanded public presence, aggressiveness, assertiveness, and political savvy. In that role she was a target for those who wished to discredit her or to diminish her in the job. Similarly, Marcia noted that in her high organizational position, she was a target for those who wanted her job or simply wanted to discredit her.

I think it's much more [pain] when you're not competing, when someone is competing against you—particularly if they're actively competing, because that kind of gets thrown out in your face and you're not really competing. I think if you are actively involved in the competition, there's less pain because you strategize differently. You set up defensive lines and offensive lines, and you're more active. If you're not competing, you're just being attacked. . . . I think it's more painful because of the vulnerability and you are not focused on the same goal. . . .

She described how difficult and painful the experience is for someone who is unaware of the competition. For example, in trying to achieve a goal for the organization, a person may covertly compete, and may try to move someone out of a job and create a place for herself by making the incumbent look bad. Thus, both the incumbent and the organizational goal could be losers. When energies focus on survival rather than achievement, everyone comes out a loser. It's painful to be on the receiving end of attempts to "bring you down," and where the attempts are successful, the people brought down experience personal pain and agony.

Sandy said, "I love people, but I'm afraid of some. I'm afraid of my colleagues. The most hurt I've ever had in my life has been from them." In one situation, she had inadvertently hurt someone else and had felt bad about slighting the person. "I felt this

terrible hurt in her." Sandy tried to make amends for the pain she felt she had caused. "I took quite a bit of time with this letter, to say the right words and to give her love, which is what she needed [to help heal the hurt]."

Fear may also surface when individuality is threatened. In competition, we often play the game according to someone else's rules. We are part of a team effort, yet the underlying value is individual ascendancy. Each of us deserves to have our contribution recognized. Pain occurs when diminished selves do not develop their own uniqueness. If they view winning as being as valuable as self-development, they end up in a real dilemma, especially in a context where winning a coveted prize or promotion depends on conformity. Competing for a place in a coveted situation, one participant realized, "That was the scary thing. That was probably the most serious part for me, to give up my individuality, or what I thought was my individuality, and I didn't like to do it."

Competition assaults the self and hacks away at its integrity. To remain in a high organizational position, to achieve tenure, to be promoted or hired, often demands conformity. Sandy recalled,

Script

> Two women had been friends for several years. They worked together in the same department. An announcement came out in the personnel bulletin: the Vice President for Nursing was resigning for reasons of ill health. The institution was searching for a person to fill the position. Both internal and external applicants were sought. The two friends knew that preference for selection was often given to internal candidates. Both were well qualified; in fact, their credentials were essentially the same, and both had career plans for moving into an executive role. Both were highly motivated to apply and actively seek the position.
>
> Will the organization provide a context for peaceful resolution of their situation, such that both could achieve the coveted prize? Are there models for a peaceful resolution that would enhance the development of both parties? Or is the usual competitive corporate bloodbath the only solution?
>
> What is wrong with this picture?

"That's what [was] so disturbing about these past years. I was being someone else's pawn. I knew I couldn't continue. I was not going to subordinate my own ideas to hers, for politics, you know? I wasn't going to do that." Losing the self in that way was too painful. "If I feel like I'm going to be confined, I get scared. Somebody's going to try to put a noose around me, or seal me off, or try to box me in to a specific idea, or role. I didn't like it." Fear evolves from the felt need to form the self into someone else's expectations in order to win. There can also be fear that somehow one will be unable to "measure up," that best efforts will not be enough. And that hurts. "I was afraid that I couldn't compete, that I couldn't be like the others."

HIDDEN ENGINES DRIVING THE BUS: CONTEXTUAL DIMENSIONS OF COMPETITION

Like the rest of society, women tend to think that competition and individual ascension in the hierarchy reflect what is good in our culture. Women in this study were inclined to believe that, as experiencing persons, competition is inevitably woven into the fabric of our being. In fact, several stated that competing was just "human nature." Paradoxically, these women believed competition was often hurtful, even harmful, yet in the same breath stated that competition was necessary for excellence and motivation. I believe that we accept the notion of the essential nature of competition because the assumptions undergirding it are so ingrained into the societal context that they go unquestioned. As we grow and learn in this society, we are given no other lens to see human nature differently. From infancy, through grammar school and higher education, and certainly in the learning fields of everyday work in America, ideas of individualism (Bellah, Madsen, Sullivan, Swidler, & Tipton, 1985, 1991) and competition (Kohn, 1986, 1993) rank along with motherhood and apple pie as societal sacred values.

Connie recognized the importance of context in creating competitive situations. In many instances, there are no other choices for developing those situations because the assumptions are unquestioned.

I experience it through something that is happening. I ex-
perience it contextually because the context is created
where, in a way, the people that are in it feel that they have
to develop it that way. . . . I can sense, it's a knowing that
the people I'm working with . . . must do it in a way that's a
deliberate, but not necessarily conscious, action to outshine
or outdo someone else. I don't know how to describe that,
but I know it.

She was describing group interaction at a workshop, where the
stakes were not high, yet many of the groups behaved as though
they were competing with the other groups when competition
was not written into the task. "There's a tension created, so it's
not flowing in the same direction, and I say to myself, 'Wait a
minute, [that's competition].'" In the situation is constant com-
parison, a need to be "better than" in order to outshine the other.
Connie went on:

We live in a capitalistic society that's built on the notion of
competition for the betterment of personkind. Capitalism
is a very productive and effective system for people to take
their creativity and develop in ways that they can offer it
to the world. I think, in that context, it is probably very
effective.

The assumption that progress, even excellence, depends on the
need to be or do better than others, to have a better product,
drives the engines of competition in this society. We inhale the
fumes from the day of our birth, and many of us never question
whether there might be another better way.

Donna described how competition becomes embedded in all
of us as a societal value:

Now there's so much more focus on competition. From the
time [we're] very, very young, competition is a part of our
lives. And it's necessary. It IS necessary. I believe that. But
sometimes it becomes vicious and all focused; it becomes
all-centered, and parents may feed on it by their pushing
children to be THE BEST.

Think about how many children, how many people there are in the world. Everyone can't be The Best. In a room full of first graders, not everyone can be The Best. Why does being The Best feel so good when, by being The Best (according to some rather arbitrary standards), everyone else is relegated to loser status? Donna observed the needs of parents to have their children be involved in many activities, even prior to preschool.

And why do parents want their kids to read and write by the age of two or three? Because they're competing with all the other children. And they want their kids to grow up to be the best. To compete for the best colleges and the best jobs.... So competing is very definitely a part of our lives. It's not going to go away and it SHOULDN'T go away.

Thus, rather than fully developing our unique talents, we learn to conform in order to compete for limited places that have known prestige value. We mold ourselves into someone else's idea of what is best in order to achieve our own self value, because value is often contextually defined. We learn to look outside ourselves for value and wisdom, rather than within. This sounds a bit dualistic, too much either/or. When we allow ourselves to see through new lenses, perhaps we can achieve some balance. But first we have to see the tyranny of unacknowledged assumptions, the tyranny of the context.

Snapshot

First-grade Bluebirds or Redbirds (we know who's best).
High school varsity or junior varsity (we know who's best).
Teacher or principal (we know who's best).
Third-floor office or first-floor office (we know who's best).
Mechanic or physician (we know who's best).
Special education or gifted program (we know who's best).
CEO or vice president (we know who's best).
What's your choice? Do you want to be The Best or a loser?
Then try harder, compete to push your way to the top of the top group.
It's the American way. Getting from Redbirds to President!

The idea that competition will not go away and the imperative that it should stay with us define our lens for viewing competition in this society as: Just human nature, a good value. Yet, there are those who question that mainstream American viewpoint. Kohn (1986, 1993) asks us to retool our lens for seeing the world, and consider competition as it appears in everyday situations. How does it affect performance, quality, individuals?

The viewpoints expressed by the women in this study were paradoxical. On the one hand, the women talked about the pain experienced through competitive experiences; on the other hand, they spoke of the necessity of competition and the good that comes from competing, whether one wins or loses. A winner gets a reward for being excellent; a loser "builds character" by growing from the experience. The purpose of the pain seems to be to educate, to inform the self. Pain, like competition, is also assumed to be good and inevitable. Underlying the pain, the women recognized the effects of competition on shaping the self, shaping what is believed to be true of human nature, as if it were a given. Women puzzled over their own responses; several indicated that they heard their own ambivalence as they spoke. Yet, they questioned themselves, rather than the contextual foundations of their paradoxical experience. Despite what they said about the deleterious effects of competition, they judged competition as good and essential. Diane spoke about the absurdity of continuing to chase contextually determined values regarding competition, on some level recognizing how she upholds the societal values. She spoke of competing for grades:

Diane: [A grade is] some standard that has been created in *my* head probably . . . or somebody else's head. You know, it's some arbitrary standard. Getting an "A" is a standard that's set up by the educational system. I mean, what the HELL does an "A" mean? It doesn't mean SHIT! It's a letter assigned to something, but we all chase it. When I take a step back, and *just look* at things, some of the arbitrary thing that I chase, I *crack* up. It's just stupid. And here I put all this time and energy into it.

Author: But you keep doing it.

Diane: Yeah, of course I'll do it. I keep doing it. It has no real
 meaning. I mean, does it make a difference if I gradu-
 ate with a 4.0 or with a 3.95? NO! Nobody's going to
 ever ask me unless I happen to go on for more school
 ing and then it won't make a difference anyway. There
 was a period in my life where I would have been *very*
 disappointed. Now I'm at the point of saying to myself,
 "Who gives a fuck?"

Yet she admitted that she feels good about herself when she gets
an "A"; it gives her a lift. She also recognized that it fed her desire
to be "perfect," which she experienced and observed to be hurt-
ful. About the hurtful nature of competing to be perfect, she
stated:

> *I have to spend so much energy* striving. *When I look at the*
> *grand scheme of things and how* tired *I get, it seems rather*
> *dumb for me to expend all this energy to get good grades.*

As she continued to speak, she came to realize that good grades
came as a result of striving for learning, and that she would strive
to learn anyway because she simply loved to learn. However, the
educational system dangles the carrot of grades, and students
continue to compete for grades rather than for depth of scholar-
ship. The context, in many ways, creates a monster of competi-
tive frenzy focused on the wrong things. Diane recognized this
and participated anyway, perhaps because the value of the self is
also contextually defined. We play the game, dance the dance to
the tune of the band chosen through the competitive process,
rather than create our own unique tune. We respond like good
girls, do as we are told, and thus, WE THINK WE WIN.
 On a deeper level, winning the game according to a contex-
tual blueprint may not be winning at all. By continuing to play
the same game, dance the same dance, while using the same
fogged lens we have been given for seeing, we avoid becoming
people we ourselves value. Society says we are doing great when
we win, when we are The Best, when we get a standing ovation.
But we know that, like the cartoon character, Ziggy, who talks to
himself in the mirror, the next morning we must see our own

clearly reflected self and ask, "How do I like what I see? How does what I do and who I am feel to me? Am I proud of me? Have I lived as I believe, or have I started to believe the way I am being molded to become? Do I craft my life, or live a script? Can I feel proud of who I am becoming as I live my life according to contextual prescription?"

Stacie spoke of the competitive context in relation to self-definition. She had played in a high school band where the band competed as a unit, but individuals played solo parts that reflected on the outcome for the whole unit (not unlike a corporation, or any other group where external reward depends on how individuals within units perform). She prayed there would be no solo part for her to play because she was afraid she might not do well and then the whole band would be judged more poorly. They would be losers, and she would be the biggest loser of all! What a heavy burden! Stacie's statement highlights the contextual nature of competition. While her wry humor shines through, one can feel her pain as she remembered her band days:

> *I do remember in high school, saying, "Please God, let there not be a flute solo" in one of these all-state competitions. And God came through. There wasn't a solo performance, because I would have had to play it, and the performance would have affected the whole band. That's a tremendous burden, although other people seemed to handle it without saying their prayers. They just used to* DO IT *[obedient to the contextual imperative]. I always prayed. I was scared to death what would happen, but I entered individual competitions, some solo stuff, but you didn't give a thought to it, because that's just what kids did then.*

Stacie also did well in school, responding to societal and home-generated expectations, noting that doing so "set up an external focus. Self-esteem, control, whatever. . . . Everything came from the outside. If you didn't achieve there, then you weren't proving your worth. . . ." She was also on a career trajectory that dictated that she "compete with my peers to make sure that I got in the literature, that I did the research projects, that I got some

grants. . . ." She followed the rules of the context she had chosen, without much question about their wisdom for her own life's path, until later events called forth different choices.

Victims of Competition

When people (women, in this case) feel they have been diminished or hurt by "unfair" competition, they tend to assume the stance of victim. When rules are unknown, or the attacker is unseen, when the competition has been "sleazy" and "sneaky," a minimal outward enemy is available for open challenge. There seems to be no way to fight back, no enemy to vanquish. Participants feel they have been "done in" by the competitive situation. Similarly, if everything is not fully known and public, the "winner" may feel guilty about winning, because she knows the loser is hurting. The apparent contextual protocol for competition demands fair fighting, obedience to rules, and competitors and weapons that are visible and understood by all. Then, competitors can "kill" each other fairly (or at least diminish the worth of the other). Women accept this perspective. But when the game is more subtle, the rules are unknown, and the fight is unfair, then the loser becomes a victim. A victim is a pawn, a fool, a patsy, and somehow an innocent prey. The winner becomes the villain. What women do not seem to think about is that these roles are inherent in competition; they are created by an unquestioned context.

Women and Competition in Context

Contemporary women, emulating men as role models, have become more fiercely competitive as they claw their way to the top. Bonnie noted that "women don't define themselves as competitive. It's not something that's really valued with women." But women now compete in the workplace as well as on the homefront. Women seek ascendancy in workplace hierarchies, often competing with men for positions. On the homefront, women seek to know whose child is "smartest" or "best," which recipe is tastiest, and so forth. Perhaps fierceness of competition creates a

more public image of women as competitive. If women are to ascend in what were formerly men's arenas, they must take on the values inherent in the context. They must compete fiercely and strive to win, or so they think, because the context does not automatically provide other options. The outcome of the competitive context determines the worth of the worker.

When Bonnie stated that noncompetitive people in bureaucracies were stepped on, she was speaking about the contextual imperatives inherent in hierarchical organizations. The way to win, to make more money, to develop power and prestige, is through competition, through doing it better than someone else, to being best at what you do so you receive the appropriate rewards from

Snapshot

A woman holds a high position in her organization. She has a staff of very bright professional women who are generally very capable. They were chosen by her because they reflect her stated values of caring for one another in a context that is supposed to support the growth of all persons. The organizational context reflects traditional rules of ascendancy: all cannot achieve coveted long-term organizational commitment. The woman, let's call her Nora (but she could be anyone operating within the contextual mandate for competition and individual ascendancy), needs to continue to achieve in order to ensure her own position. She needs to "look good." When other women in her division achieve external recognition, or a coveted speaking engagement, or an invitation to consult, she says the right things, with the right bright smile, but hidden within her is a small nagging germ of fear for self that grows more virulent each day. It grows into a disease called oppression, and it masks itself in smiles, and statements like, "I can't let that happen. It wouldn't be good for the organization. It wouldn't be right or fair for the others." She is geared to suppress the creativity of those who work for her, because the strengths of the others might make her look less strong. All of these responses are subtle and outside her awareness, but they are clear to those who work with her. They are all a part of the contextual imperative mandating hidden competition.

There is something wrong with this picture.

the system. (Systems, by the way, are all of us—a shocking notion, isn't it?) If you are not competitive, you will not be rewarded; in fact, you may be punished and put out of the organization. To be in the organization, as the societal imperatives for competition become stronger and stronger, means to engage in the race, to do possible harm, and not to question the context too deeply, or you will surely feel the pain.

TURNING POINTS: EVENTS THAT HERALD CLEAR VISION

Several of the women in this study talked about turning points in their lives, times when they realized that competition as contextually defined did not fit how they would like to live. The turning points varied; their common thread was that they led women to question deeply the meaning of their own existence, to assess the influence of competition on their lives, and to choose another path.

Stacie spoke about traveling the expected competitive trajectory toward a career in higher education, when "right in the middle of that, a good friend of mine had cancer, and it just totally reversed what I thought was important." She had done several of the right things, and was "winning" her way up the ranks.

And I said, "This is it, I'm on my way." Well, I came to a screeching halt. Life's too short. How much time do I want to spend worrying? I'm in my 40s and I'm still worried about grades? And you have to stop and look and see what's important. Had I continued on that path, I would have felt more a sense of competition. . . . But I don't anymore.

Competition and being rewarded for one's efforts was fine for others, but not for her.

. . . if it feels good, do it. . . . But I'm not sure I want to do it. I am not sure I want to get out there and compete and do that. I want to keep my job because I need a job. However, I don't want to compete. I DON'T WANT to have more articles

*than anybody. I DON'T WANT to produce. I JUST DON'T
WANT TO DO IT. It's not what gives me pleasure.*

Her priorities shifted from work and being goal-driven. Maintaining relationships and making a difference in people's lives "in a much different kind of way" became her central goals. Even her definition of "winning" changed.

*What was winning before that was getting the "A's," doing
well, not necessarily in competition with a person, but certainly achieving at the highest level I could. Which meant I
never got a "C." But now, what winning means is making
enough time to go fishing with somebody I care about. Winning to me means making a livelihood so I can take a nice
vacation and . . . share things with people, . . . treat people
and do special things for them. . . . It doesn't have to be huge
amounts anymore. It doesn't have to be everything.*

She also decided that *things* were less important to her. Having enough was important to her, but not to the extent of requiring things for status or overindulgence, like a boat or a new car. When she observed others scrambling, working excessive hours to get the coveted items, she observed:

*Well, that's nice, boats are nice; if you want a boat, have a
boat. But when are you going to spend time with your family? I think, "What a waste." Time is very precious now that
my friend is ill, and since my mother died young [she herself had passed the age of her mother's death], I figure that
time is a very valuable commodity, and I want to use it
how I want to use it.*

So she chooses to work enough, but not to excess. In essence, she has "dropped out" of the competitive race, much like Simon, the homeless, very wise bum in the movie, *With Honors.* He told his young friend, a competitor in the race for honors at Harvard:

*I'm not a loser, I'm a quitter. You try too hard. Winners
forget they are in a race. They just love to run.*

Simon dropped out of the race when he heard the competitive cry, "Arise, you too can rule the world. You just have to crush everyone else first."

After much reflection on competition, Connie also related that she had been competitive, pretty much engaged in the race, until her mother died.

A lot of my perspective on life changed about what was important, and I gave up a lot of the perspective I had held on to. . . . Though I wasn't always aware of that in myself . . . I deliberately started to pay attention to [competitive situations], and I didn't participate in them anymore. . . . as people informed me, I was receptive to hearing how I had engaged in behaviors that were not facilitating of other people. To know that, I, too, unknowingly, caused the diminishing of other people's integrity [was painful].

She went on to speak, somewhat tearfully at moments, about the sadness that came with growing knowledge of her own participation in competition that hurt others.

For me, it became "I'm not willing to do this anymore." Because nothing is worth it for me. It's not worth it. I guess as I started to try to see . . . in myself the things that I wanted to change, I started to experience [them] in other people. I can laugh at myself now. . . . I can let go . . . and [move on].

She now chooses to live her life by creating a noncompetitive context.

For others, watching the pain that emerges from competition resulted in their reflection on how they were living their lives. Among the events that can trigger reflection are: an illness, a death, a particularly traumatic competitive event that hurts the self or someone close to the self, or even doing a phenomenological study on competition. I am appalled at the interpersonal violence we do in the unspoken name of competition—unspoken, because the most devastating violence occurs when competition is disavowed. In many ways, through competition, we murder the spirit that is the self. Is this much different from physical murder?

Is the violence any different from what occurs in other abusive situations? Or is it worse, because it goes unquestioned and often unrecognized?

REFLECTIONS AND ENDING THOUGHTS

Reflecting on my own experiences with competition, I remember a lot of pain, a kind of gut-level hurt because, in some arenas, I was never quite good enough. As an adult, I realized I was good at many things, but I did not have to be the best and it was OK to be average or below-average in many areas of my life. This I learned on my own, by reading and reflecting, and from some wonderful mentors along the way. However, conventional wisdom still dictates that winners are more important. In some ways, we value life in the abstract, but not particular people. We treat one another in ways that disavow the fragility of the human spirit and we begin tearing away at this fragile spirit through demanding that our children, a vulnerable and impressionable population, compete to find their value in society.

I remember, in team sports, as the team captains selected sides, I was always the last chosen. I would have high hopes at the beginning of the choosing, and as each person was picked, I felt an ever-deepening, sinking sensation in the pit of my stomach. Always, I knew I was not desired, somehow not good enough. (Never mind that I learned in adulthood that I have no depth perception. Thus, the reason for my not hitting a ball or kicking a goal was that I could not gauge the position of the ball.) I just knew no one wanted me, and felt less than adequate. Teammates were picked because they could help the team win. My friends, much more athletic than I, were often the team captains, and they would say, "No hard feelings?!" And I learned to cover up the sick feeling with a bright smile and say, "No way! I'd do the same thing if I were captain!" And sadly, that was true. Even I knew better than to choose me for a winning team.

Those feelings stayed with me well into adulthood, when I watched my son become involved in soccer. As a mother, I was reluctant to have him start at age 6. He was so little. But his best friend was going to play, and his best friend's Dad was the coach.

Surely, with that coach, Rob would have all the support he needed. Little did I know that the coach harbored a well-hidden drive to win. He screamed at his own son when he did not do well. Rob played on the recreation league team for two years. Then, the father of my son's best friend picked what he thought was a stellar team to go on to competitive soccer, and left my son out. His coach, someone he loved and trusted, didn't even tell him himself. His best friend did his 8-year-old best to tell him with compassion. I watched the pain in Rob's eyes, the anger and sadness because he was being told he wasn't quite good enough, and I hurt with him. After it all shook out, of course, we put on a brave smile, covered the hurt, and said, "No problem!" because that's what we were supposed to feel, and say, and do.

Society seems to set up a ranking system to determine the value of persons. The ranking is hierarchical, meaning not everyone can be a star in the coveted arenas of life—sports, boardrooms, publishing, offices, and so on. The positions are scarce. Because so few can reach "stardom," many are externally defined as losers. When we allow our own self-valuing to become entrapped in the external definitions, we diminish ourselves by losing and we take on the identity of loser. But when we choose to take another path, drop out, or quit, we may be defining ourselves by nonmainstream criteria and holding ourselves and others in high esteem. That ground can be shaky when "COMPETE OR LOSE, LOSER!" messages still come from the contexts of our lives as if through the air we breathe, because we have chosen different symbols to declare a life well-lived. It's far easier to keep on slogging upward, without questioning, toward the rewards from society's coffers— the symbols of wealth and prestige that define our worth.

I recall a cheer from high school football days. Little did I know then that it was the clarion call for our society's most deeply held and sacred values, holding within itself the essential meaning of competition:

> HIT 'EM AGAIN!
> HIT 'EM AGAIN!
> HARDER! HARDER!

As we drive to the goal to WIN! Or do we win?

STRIVING FOR HEALTH AND WELL-BEING

The health of our nation's people, of all of us, depends on finding new ways of seeing, and making some very hard choices. Two editorials recently caught my eye. The first, by Molly Irvins (1995), was entitled "Congress finds it too hard to bite the hands that feed it." She wrote: "The first law of politics is: You Got to Dance With Them What Brung You" (p. 9A). She discussed the many special-interest groups that gave money to the incoming 104th Congress; contributions came from finance, insurance, and real estate. Insurance industries help our leaders to compete for coveted public office, and insurance industries fuel the managed care environment. Competition fuels the fires of the existing systems of rationed health care, making money—for whom now? Irvins' summary statement about hopes for reform of existing systems was: "Beloveds, until they reform the way campaigns are financed, 'reform' is a tale told by an idiot, full of sound and fury, signifying nothing" (p. 9A). Competition drives campaigns *and* the decisions of our law and policy makers.

The second editorial, by William Raspberry (1994), stated that we haven't seen much change since women entered the workplace in full force, aiming for the ceiling (the real one, not the glass one you hit before you get to the top), because ". . . women have started acting more like men—or, at any rate, think they should" (p. 7A). The rules of the competitive context will not move us forward with a more peaceful agenda.

> *On television—our present-day marketplace of ideas—political or ideological opponents are more concerned to defeat one another—to believe that the rules* require *them to try to defeat one another—than to seek points of agreement that could move the society forward. This little boys' way of playing seems to have become everybody's way of playing. Indeed, it seems the* reasonable *way to play the game—until it dawns on you that it doesn't work. The people who are open to cooperation and community building are the ones who create positive change. We keep scouring the terrain for enemies, when what we need is to remind ourselves . . . that the* problem *is the problem. (p. 7A)*

The *problem* facing all of us is how to provide health care for a growing population while maintaining the health of health care workers and not contributing to greater economic ill health for the nation. Competition has led us to where we now reside, in a very precarious place. Choices for women, for nurses and other health care workers, require new lenses for seeing, not just a modified competitive prescription. As we strive to find solutions to the *problem*, we need first to look to ourselves and where we fit within the scheme of things. How dependent are we on the existing system to provide our livelihood, our rewards? What do we really think about the systems we are creating? Do they create healthy places to work? What is the workload like? How good is the care? What are the real values that drive the organization? What am I willing to give up? What do I see when I look at myself in the mirror? Will competition in the health care arena meet the health care needs of the population? The place to start *reform* is within ourselves, so that we can find the courage to meet the challenges ahead. We need to *see clearly*, as best we can, so that we provide a way that is responsive

> *... not just to competing interests and the demand for rights, but, rather, focuses on the next evolutionary step in growth for each individual and group. It directs resources and structures institutions to help citizens meet their own needs while learning to embody the virtues common to all religions and systems of ethics—compassion, honesty, and the sharing of skills and resources. (McLaughlin & Davidson, 1994, p. 6)*

Competition doesn't fit this picture. We need to harness all of our energies to move forward in ways that value dollars only as tools to provide for the needs of people and our planetary home.

Method

Phenomenology has become a lens for viewing the world, the world of my everyday existence. I live in a state of unawareness until something tweaks my brain saying, "notice me," and a study

is conceived. It takes awhile for it to germinate into a full blown study. First comes noticing. Once the phenomenon is named, examples pop out at me from every corner of my existence. In the case of this study, a good friend told me I was competitive, and I wondered, "What does she mean by *that!*" I had already selected a different phenomenon for this book chapter, but this question grabbed my interest and would not let go. Sometimes that is the way studies happen. They take over your life until you get it figured out. For this study, I chose a hermeneutic phenomenological way of coming to know: "A good phenomenological description is collected by lived experience and recollects lived experience— is validated by lived experience and it validates lived experience" (van Manen, 1990, p. 27). Seven ordinary professional women engaged in an interview with me, talking about their experiences with competition. The dialogue was thoughtful with time passing swiftly as we became lost in the re-experiencing of competition in these women's lives. In doing this research, I followed the steps outlined by van Manen. I turned to the nature of the lived experience by continuing my investigation of a phenomenon that continues to intrigue me, searching for full, rich, and deep description. I investigated the experience as lived by seven women, incorporating, when appropriate, information from my earlier work. The women were asked to fully describe their experiences with competition in their everyday lives. The seven women in this study fulfill traditional women's occupational roles and consider themselves to be ordinary, well-educated women. After gathering data using in-depth, tape-recorded interviews, the data were transformed into script. I reflected on the whole and parts of the data, generating themes, along with snatches of insight. This chapter is the result of writing and rewriting and is the best description I am capable of at this point. The "snapshots" were a way to capture the phenomenon in a moment of time, and freeze it for your inspection. They contain the essences of the phenomenon. Taken together, they form the unity of meaning, a fusion of meaning capturing the essential nature of the phenomenon. As you read, ask yourself, does this ring true? Does it reflect competition as I know it? Does it help me to see competition more clearly?

REFERENCES

Bellah, R. N., Madsen, R., Sullivan, W. M., Swidler, A., & Tipton, S. M. (1985). *Habits of the heart: Individualism and commitment in American life.* New York: Harper & Row.

Bellah, R. N., Madsen, R., Sullivan, W. M., Swidler, A., & Tipton, S. M. (1991). *The good society.* New York: Knopf.

Feldman, E. S. (Producer), & Peerce, L. (Director). (1975). *The Other Side of the Mountain* (film). Available from Universal City Plaza, Universal City, California.

Irvins, M. (1995, January 5). Congress finds it too hard to bite the hands that feed it. *The Boca Raton News,* p. 9A.

Kohn, A. (1986). *No contest: The case against competition.* Boston: Houghton Mifflin.

Kohn, A. (1993). *Punished by rewards: The trouble with gold stars, incentive plans, A's, praise, and other bribes.* Boston: Houghton Mifflin.

McLaughlin, C., & Davidson, G. (1994). *Spiritual politics: Changing the world from the inside out.* New York: Ballantine Books.

Raspberry, W. (1994, November 22). Let's trade the win-lose game for what works: Cooperation. *The Boca Raton News,* p. 7A.

van Manen, M. (1990). *Researching lived experience.* New York: State University of New York.

Weinstein, P., Robinson, A. (Producers), & Keshishian, A. (Director). (1994). *With Honors* (film). Available from Warner Home Video, Burbank, California.

ABOUT THE AUTHOR

I am a faculty member, Director of the Nursing Administration Major at Barry University, a researcher, a wife, a mother, a friend, and . . . , a person who is trying to sort out how I want to be in relation to what I am learning about the meaning of competition in my everyday life. Some days it feels as if I step on a treadmill in order to stay in place. I think I am good at what I do, but the multiple tasks are overwhelming at times. I love just about everything I do in my work and life, except the mundane repetitive

"stuff." I love students and ideas, and being a part of creating an atmosphere where people can flourish. Like the rest of us, I am always trying to sort out what it means to be human, what it means to be fully human in the everyday work world, and where I want to be in the scheme of things. The phenomenological perspective guides my way of being in the world, helps me to see more clearly, so that I can choose knowingly, rather than be a victim of hidden assumptions that provide the basis for life's rules. I thank each of the participants who shared their life experiences of competition with me, and treasure their contributions to this chapter. They helped me to see more clearly.

4

On the Road to Self-Discovery: Women in Psychotherapy

Ellen Ehrlich

As a student in psychoanalytic training, I have been in analysis for several years and have found the experience to be both frustrating and rewarding. Living in the metropolitan New York area, I found an interesting dichotomy regarding psychotherapy. In New York, "being in therapy" is often considered a status symbol or, at the very least, a normal part of city life. In a recent *New York Times* article, Foderaro (1994) states: "In brownstones and gracious co-ops, the quest for self-understanding and personal growth goes on behind closed doors in the same way that stocks are traded around Wall Street and ads are concocted on Madison Avenue. . . . People say to themselves, 'I know people in therapy, and they're functioning.' That makes it less frightening and more accessible" (p. B1). Across the river in New Jersey or in the distant suburbs, psychotherapy may often be viewed initially as shameful or degrading. At first, living in

New Jersey, I was hesitant to admit to many of my acquaintances that I was in therapy and was a student of psychoanalysis. I wondered, "What would they think about me?" Would they say, "She knows what I am thinking"? Instead, they accepted me, the fact that I could appreciate what it takes to have a real understanding of oneself, and the reality that the function of psychotherapy or analysis is an individual's own pursuit of self-knowledge. It is the work of the therapist to facilitate this self-understanding.

Early in my training, it was difficult for me to express my emotions. I grew up in a home where it was not acceptable to express anger. As a student of psychoanalysis, I was surprised to find, in the classroom and in therapy, that emotions such as anger, fear, and pleasure were demonstrated verbally. It was not easy for me to become able to express my feelings publicly; yet, doing so liberated me.

I began to wonder what the experiences of other women in therapy were like. When an initial literature review revealed few studies of women's personal experiences in psychotherapy, except for some extremely dysfunctional individuals who are not a part of this study, (see, for example, Schiller & Bennett, 1994), I thought that research from the phenomenological perspective would assist other women and professionals in understanding this experience. Many women would benefit from therapy but are hesitant to engage in it. An understanding of the experiences of the women in this study may allow women who would not ordinarily engage in psychotherapy to reap its benefits. Furthermore, professionals can gain additional insight on how women view the experience of psychotherapy and thereby enhance the women's future experiences.

There is a large volume of literature in which noted analysts have written about women's experiences in therapy, beginning with the father of modern psychotherapy, Sigmund Freud (e.g., Freud, 1904; see also Baruch, 1988; Bernstein, 1993; Serrano, 1988; Benjamin, 1988; Horney, 1967; Kissen, 1992; Young-Bruehl, 1990). According to Appingnesi and Forrester (1992), one of Freud's first cases, Anna von Lieben, had kept a diary of her analysis. "Unfortunately, this was destroyed by one of the doctors who, from 1893 on, followed Freud in the treatment . . ." The paucity of descriptive material elicited directly from women in psychotherapy encouraged me to continue my exploration of

women's experience in psychotherapy. I began to meet with women who were in psychotherapy.

The women in this study came from different walks of life and from a variety of religious and ethnic backgrounds. They ranged in age from 30 to 58 years. Their education ranged from bachelor's degrees through doctorates. Some of them I knew through school and work. I met two of them while sharing a summer rental at the shore, and one at an international conference.

While engaged in casual conversation, I would mention my research interest and indicate that I was looking for women who were willing to talk about their experiences in psychotherapy. Six women showed great interest in my project and volunteered to be a part of this study. As I listened to their experiences in psychotherapy, numerous themes appeared. The five most frequently occurring themes will form the outline of this chapter:

1. Starting therapy
2. Therapists
3. Change and the journey
4. Outcomes
5. Process

STARTING THERAPY

Now isn't that incredible, to think that it's less crazy to have a lousy relationship than a good one? That intimacy is more terrifying than loneliness? God, the world is so crazy. It's like saying garbage is more delectable than food. (Wells, 1991)

Women come into therapy with many different issues and with feelings similar to those expressed by Wells. However, when women start therapy, they talk about their most immediate needs. They express ideas about what they would like to achieve in therapy. Though the initial needs are varied, the final consensus is that they acquire a better understanding of themselves.

For most women in this study, some crisis or precipitating factor seemed to have brought them into therapy initially. They had

known for a period of time that they needed assistance, but the crisis gave the impetus to initiate the therapeutic process. In Rossner's fictional work *August* (1983), Dawn (a patient in psychoanalysis), has an automobile accident, which brings her into therapy. I read *August* after analyzing my talks with the women in this study, and I found the thoughts and ideas expressed in the book related profoundly to them.

For Corrine, the precipitating factor was her sister's cancer. However, her story revealed that, since childhood, her close relationships involved associating with people who abused alcohol. She is a very giving, considerate, hardworking woman in her late 50s.

Corrine teaches at the local community college. She lives in a beautiful oceanfront home with her 24-year-old son. Her significant other lives in Virginia, and she often spends weekends and vacations with him.

Corrine: I was at a very low point in my life when my sister had surgery for cancer, and I was having a hard time teaching at the college, with personalities and so forth, and I was pretty depressed, not doing too well in a relationship, and so I started therapy with a colleague of mine.

Lois did not like the fact that she was constantly crying and feeling angry. Her inability to function well as a person and as a mother and wife brought her into therapy. While in therapy, Lois finished her PhD and has recently published her first magazine article. She has a 9-year-old son, and lives and works in Connecticut.

Lois: Well, I was not coping well. I was crying all the time, I was feeling angry. There was a therapist that we had taken my son to, when he was in first grade, because he was having trouble with coping with the teacher. I really liked that therapist so I went back to him.

Annie is a doctoral student in the health sciences in New York. Now 30, the search for a partner in life seems to be a priority.

Annie came into therapy because she was very upset with her own sense of self. She wasn't sure of who she was at that time, and she felt extreme pain. She was still functioning outwardly but crying inwardly. A distressing incident occurred and she was not sure who was the real Annie. There was a self-assured calm person who functioned in the outside world, but there was an anxious, scared, insecure individual who lived inside of Annie.

Annie: I went into therapy because of a bad experience that didn't fit with my sense of who I am, and this was very, very disturbing and distressing. I continued to become, I might say the word *decompensated* but not in the sense on the outside; I just got more and more anxious.

Though she was functioning well outwardly, Annie was so upset emotionally she termed it "psychic pain." Annie knew that she must get help to relieve her pain and anxiety, so she sought the assistance of a therapist.

Annie: This experience was so traumatic that I didn't understand who I was anymore. I felt so much psychic pain, it wasn't OK anymore. If I did not get help, I would have, like, really freaked, or gone into despair. So I was plodding along OK and then something happened that just didn't fit and I went into therapy.

Not being able to deal with her boss was the crisis that brought Daphne into therapy. She had wanted help for a long time but, like many other people, she felt that she needed a "specific" reason. The situation with her boss was the crisis that brought Daphne into therapy and allowed her to begin to understand herself and improve the interpersonal relationships that she cherished. Daphne (age 31) is a successful book editor and is fluent in several languages. She has a very close relationship with her two sisters, and lives in Greenwich Village.

Daphne: I started therapy when I was having a crisis at work. I was working for a boss that was really driving me crazy, very unpredictable and very high strung, and it

was really getting to me. But I think, you know, that
was my excuse for going, but there were a lot of other
things, reasons really, that were happening. I think
often people come to a crisis point and that's what
pushes them to actually go.

Sophie, a grandmother, is in her late 50s but looks as if she is in
her early 40s. A social worker, she lives and works in the suburbs.
Somewhat of a tomboy as a child, Sophie still enjoys all sorts of
athletics. Over ten years ago, when Sophie was still a homemaker
and a mother and her children were leaving the nest, she felt she
was left with an unhappy marriage.

Sophie: I was feeling unhappy in my marriage and family and
I was about 42; and then I had a friend who was in
therapy and she said, 'Why don't you try therapy?'
And so I did.

Katie (30-something) is married and has two school-age chil-
dren. She was working as a director of a community health
agency when she began therapy. Katie is a thin woman who is in
constant motion and gives the impression that she is in control of
the situations she encounters. Katie went into therapy initially
with her alcoholic husband.

Katie: We went together and nothing seemed to develop
from that because we never really talked about the
issue of alcohol. It was more of the other issues—
mostly how the children were being disciplined—
that was being talked about, so nothing really got
accomplished. And then when he went into rehab, it
started. I was going to go for emergency help, actu-
ally, a couple of days before rehab, because I needed
courage to get him in there. I think the therapist be-
came mine then, and not his.

These women all had different reasons for beginning therapy
but, for most of them, one major factor or crisis situation was
the catalyst for treatment. As they started therapy, they talked

about what they thought they wanted to gain in the therapeutic relationship.

Women who come into therapy want to address very specific needs. These needs are quite intense and become the focus of the initial therapy as the women begin the journey of self-enlightenment.

Sophie felt an intense need to become stronger. This idea was expressed through the metaphor of steel in much of her talk.

Sophie: So I started with a male therapist. What I wanted out of the therapy is to have some steel. I wanted some steel, because my husband's complaint about me was that I didn't have any steel. He didn't see me as a very strong person. I was too wimpy, just not effective enough. He was a businessperson and I was a house-wife. My children were growing up and I didn't know what to do with myself.

Control issues and dealing with the feelings that being in therapy was a stigma were the first topics that Katie talked about.

Katie: It was hard for me at the beginning because I didn't know what you do in therapy. I felt stigmatized about it at the beginning because I had gone to Alanon in the past and stopped. And you'd hear people saying things about how they go for therapy and I'd start thinking, 'My God, no one has it together! They're really crazy people.' And to me, it was extremely important—it still is—to have everything together. I'm an organized person. Not only do the things around me have to be organized, but I have to be too, at all times in my life. I think it got me a little less rigid in that area, which helped a tremendous amount. Not everything has to be in its proper place. I don't have to have control over everything, which is one of the big things that I had to deal with in therapy, . . . my control issues.

Annie wanted help finding a career that was meaningful to her.

Annie: In addition, I also was very unhappy with my options for
 a career. I remember, that first day, going and saying,
 "This is what I want. I want help to get another career."

Though these women started therapy with very distinct ideas and
subject matter, eventually they began to seek *self-understanding*.
Consciousness raising, self-understanding, and acceptance of self
and others are issues that women deal with as they progress in
therapy.

Therapy helped Lois to understand herself and to accept the
fact that she could not change people and had to accept them for
themselves. She was then able to comprehend her own reactions.

Lois: I've developed understanding of myself and of the expe-
 rience of being in therapy. I've developed understand-
 ing of insight into what I can expect from my father and
 what I can expect from people in ways that I couldn't
 before.

Encouragement or nurturing toward self-understanding was
not fostered when Annie grew up. Annie felt that she never had
been allowed to "find herself," that no one had really listened to
her in the past, and she did not take the time to listen to her own
thoughts and needs. She did not know what her strength was or
even what she liked to do. Like many other people today, Annie
was involved in the tasks of everyday life and did not take time
for herself. The "distressing incident" brought her into therapy,
where she has had the freedom to explore her own needs,
wants, and desires, and to determine who the inner person re-
ally is.

Annie: I've never had the space or the freedom in which to dis-
 cover what it is, who I am, what it is that I'd like to do,
 how I'd like to do it; . . . I've never had the space to
 think about it. So, that's what the therapist is allowing
 me to do.

Daphne notes that, by dwelling on herself, she can understand
herself, move beyond herself, and engage in the world around her
as a more productive person. Recently, I heard that a prestigious

publisher for whom she had been a consultant created a position so that she could be a member of their team.

Daphne: It's [being in therapy] like reading your horoscope. I mean there are also times when I think that therapy is one of the most sophisticated things you can do. You know, it's me, it's MY OWN, it concerns myself.

You know—God—it feels like I've already spent more than enough time thinking about ME, MY PROBLEMS, AND I, and now I'm going to spend more money every week and think about it *even more*. It seemed like how could I possibly justify that, but now I'm realizing that actually doing that is probably going to help me, first of all to get over ME, MY PROBLEMS, AND I, and second of all to contribute more to the world and be a more productive person—maybe even help other people more, so it's not completely egocentric.

Daphne talks about how she begins to experience self-understanding.

Daphne: At other times, it [therapy] can be very productive without being very emotional. I mean, where it suddenly seems like my mind is feeling very logical and sort of limbered up or something like that and so my mind can come to these huge understandings about myself; whether they're really understandings or whether I'm just able to articulate them, I don't know.

Women gain a greater understanding of themselves through the therapeutic process. Often, these women discussed how they chose the individual who helped them with these insights and why they continued to stay with that particular therapist.

THERAPISTS

Choice of a therapist is a very personal and often difficult decision. A woman must feel comfortable with her therapist. The gender of the therapist is often an important factor in the choice.

Lois has chosen to stay with her male therapist because she feels she is dependent on him and she senses the need for a healing and/or positive male relationship. This is often an important issue for women. Nonetheless, Lois believes that this male therapist cannot understand her in the way a woman could.

Lois: I have a male therapist and I've often wondered whether it would have been different to have a female therapist. There are things that I bring up in therapy that I don't think he understands. He doesn't understand how it feels to be a woman. How it's not comfortable to be a woman, in a woman's body. I also have an eating disorder, and I don't think he understands that—or abuse—in a way that a woman therapist would. But one of the reasons why I'm sticking with him is that I'm really dependent on him and I really like him. I'm afraid of men and I think that it's important to get through a relationship with a male that's healing.

Sophie has had both male and female therapists. Her first therapist was male, and for some time she saw both a male and a female therapist. Now she no longer sees the man. She has chosen to work with the woman therapist. During the period of transition from a male therapist to a female, Sophie dreams of getting "steel" from the woman. She felt men had power over her. Yet, she discounted the woman therapist and treated her as her mother. Initially, Sophie talked rather disparagingly about her mother and felt that she had had little knowledge about important matters. One wonders whether the feelings about her mother's knowledge relate to her willingness to allow a male therapist to care for her and her reluctance to allow caretaking by a woman therapist.

Sophie: The first dream I had . . . , my female therapist was going to give me a steel vagina. This symbol of steel came back again. I told this to my male therapist, as well as to my woman doctor, and he winced and made some kind of threat. It was almost a contest of wills and I had to choose between him and the female therapist. I chose her. I used to have the same feeling with my

supervisor [at work], that he has the same kind of power over me. I was feeling, like, really wimpy, and then I couldn't explain things. I didn't feel that way with my woman analyst. I felt kind of like my woman analyst didn't know anything. I really discounted her. It's kind of a funny thing. I think about this often. I say, "Is it because she's female, because this doctor is female?" Yet I treat her more like my mother. Like my mother, I always discounted her. I didn't think she knew anything.

I think so much about the sex of the therapist. It's always supposed to matter. . . . One of each, just like parents.

Paradoxically, at the end, she states:

I do feel better with a female therapist though.

Rossner's (1983) character Dawn reflects some of the thoughts of the women in this study. "Dr. Seaver thought I didn't get more upset because I was okay. You know, he understood me a thousand times better than anyone before him, but it wasn't like you. Men just don't understand the way women do." Many women feel more relaxed with a woman therapist.

Katie was pleased that her therapist was a woman. For her, it was important to be comfortable both emotionally and with the physical surroundings so that she could express her thoughts and feelings.

Katie: I was glad it was a woman. All the stuff I was dealing with in relation to N.—I think a lot of hate was going on and I didn't think a man would understand the stuff that I was going through. But she certainly did. She's been wonderful. We sat in a nice small office—it was nice and comfortable. She always had some sort of herbal stuff smelling in the room. It was nice. It was a very, very calm atmosphere.

Most of the women in this study felt more comfortable with a woman therapist. They continued to describe their psychothera-

pists and the feelings that occurred. Support and understanding from the therapist form an essential part of the relationship.

Feelings and Descriptions of Therapists

My personal thoughts about therapy begin with words such as: warm, kind, gentle, generous; then come action phrases: being there for me; allowing me to explore my own thoughts and experiences and come up with my own decisions; allowing me to be me; accepting me even when I make mistakes. When I walk into the therapy room, I feel a soothing, warm atmosphere. I feel cared about and able to say almost anything without fear of rejection. In other words, it is a very safe space in a dangerous and unpredictable world. At times, issues are brought up that generate distress and discomfort, but this occurs in an environment that feels supportive and nurturing. Other women have had similar experiences. A supportive, nurturing environment is important, to allow difficult thoughts, feelings, and issues to emerge in therapy.

Lois describes her therapist as a cuddly "teddy bear with teeth." Though there is warmth, there is also pain in the therapeutic situation.

Lois: He's like a teddy bear. He's like a teddy bear with teeth. That's what I told him one time, because he's sort of short and round, and has a beard and looks like he's cuddly; he's nice, he smiles a lot and he is very gentle, but the teeth are when he pushes me into the painful stuff and that hurts.

Corrine had two female therapists; the first was a psychotherapist and the second was a modern psychoanalyst. The analyst would not give Corrine advice. The psychotherapist would give Corrine advice and chastise her if she did not take it. Corrine's response was to dig in her heels and do nothing. She felt masochistic and guilty in this relationship. When people are pushed, they often rebel and either do nothing or react negatively.

Corrine: I just got the impression my therapist was critical of my not being able to do what she suggested I do. My

modern analyst, of course, is a lot different. She would never say anything like that. She would say, "Well, let's study it"; she would not give me advice that I don't want to take or that I couldn't take. And my first therapist wouldn't do that. . . . she would say things like: "How long are you going to keep doing this? Or keep beating yourself? Or keep putting up with this?" or whatever, "How long? Where is this getting you?" Or something like that. "How masochistic can you be?" or whatever. That made me feel guilty or more inept that I WAS NOT MAKING A MOVE THAT I SHOULD BE MAKING. I think it even makes me more dependent on her and less able to function the way I would like to function.

Annie thinks her therapist is excellent, but has difficulty accepting that thought because of her own issues dealing with perfection. When her therapist showed signs of imperfection, Annie began to doubt her clinical skills. As the treatment progressed, she learned that perfection is not necessary for someone to be excellent. Annie feels that learning this was particularly helpful. Recognizing that one does not have to be perfect has allowed Annie to explore other professional and interpersonal opportunities.

Annie: She has to be perfect and if she's not perfect, then she can't be good. So that my needing her to be perfect would never allow her to be acceptable. She's not perfect by any stretch of the imagination, so that's one thing and then nobody who's so connected to me could be OK, so she probably is an excellent therapist.

Warmth and humanness are two adjectives that Katie uses to describe her therapist. Access and encouragement to use other support systems are important to her therapeutic relationship.

Katie: I mean, someone that you could pick up the phone and call at any time. And she knew all the garbage I was going through and still she was very calming.

One other positive thing. When she knew I was going to Alanon, she didn't find it threatening. . . . she actually encouraged that I use all the support systems that are appropriate for me. And I think that was wonderful. And she would ask, "Did you go to Alanon? How many meetings did you go to? What issues came up for you?" So I thought that was really a positive thing that she encouraged support rather than saying, "I'm your support, your sole support."

Warmth was also important to Dawn in Rossner's novel (1983):

"You remind me of Tony [her surrogate mother] . . . except that you're bigger. And not so fluffy."

Dr. Shinefeld smiled, and they paused together in that restrained mutual good feeling that was so essential to satisfactory treatment while raising such difficult issues for those involved.

Difficult issues and problems occur frequently in therapy. In the talk of the women, they are discussed. When problems occur in people's lives, the natural instinct is to resolve the problems immediately. This quick fix often leads to more problems without remedying the situation. With their therapists, women discuss their *problems* and find new and productive ways to deal with distressing situations.

Depression was a problem for Katie and she describes her sadness in trying to "fix" her husband. Since she has been in therapy, the depression has lifted and she is happy.

Katie: I think I do give a little more because I'm happy. I was very depressed; I mean, nothing was diagnosed, but there were two years [when] I just didn't know what to do with myself. I spent so much time fixing things and kept thinking, how could I not fix more. I'm a nurse. How come I can't fix my husband? And I just couldn't do it. But I did get very depressed with it. I spent a lot of time crying.

Katie describes life with an alcoholic. Here is not an uncommon scenario.

Katie: It was just, you know, every time he went out he came home drunk or something, I'd get crazy. We had our little ups and downs. He'd tell me, "I won't do it any more." A week or two later it would happen again, and there I was crying. There was a lot of forcing myself to get up in the morning and just go through the routine and move along. Oh, good, then, another day's up. A lot of complaining of "I'm not having fun any more." It was awful. It was so sad. I spent times when it really got bad at the end I would be at the bus stop and as soon as the kids would get on the bus I'd sit on a park bench and start crying right there.

Women wonder whether therapists can tolerate them. In Rossner's *August* (1983), a few of Dawn's problems relate to sharing her analyst with others and wondering why her analyst would continue to see her when she does so much complaining:

> "... *Don't you know it's bad enough I have to share you with your other patients? That every time the door closes behind you and another patient, I think I'll never see you again?" She began to sob.*
>
> *"No," the doctor said, "I didn't know that."*
>
> *"Well, it's true. Especially if you're smiling, if it looks as though you're having a good time. I think, why would she ever come back to me when I'm such a miserable, whiny, little drag? And then I have to remind myself of the times you've smiled at me." (p. 183)*

Smiling is seen also as a form of support. The women talked about what support meant to them. Women value *support and understanding from the therapist.*

Different sources of support from the therapist are found to be valuable. Confidence, being understood, positive feedback, and recognition of emotions are important aspects of the therapeutic relationship.

Lois found that the confidence her therapist displayed in her abilities helped her to function and to accomplish tasks she initially feared.

Lois: He would tell me, "You can do it. You're OK. You know
 that your students love you and once you start teaching
 everything will be fine. You know your subject matter."
 He would give me affirmations and I found that very
 helpful.

Annie felt supported when someone (the therapist) really lis-
tened to her words and when she felt that she was understood.
Other women related that feeling understood was very important
to them as well.

Annie: So I think that's a very important experience—to
 really BE LISTENED TO and to be able to, whether or
 not the person understands, TO BELIEVE THAT THEY
 UNDERSTAND.

Understanding and positive feedback were two of the forms of
support that Katie valued when she was able to resolve her own
problems.

Katie: . . . I had someone on my side. Not that she was taking
 sides between N. and myself, but that she understood
 where I was coming from, and she would even spend
 time arguing points. She spent time listening. She
 helped me sort out my own problems. She also gave a lot
 of positive feedback about the things I was doing well
 so that I could move along with something else. That
 really helped, because there were times when you think
 "Jeez, nothing's working." But she always found some-
 thing to give me a little praise on. So then you didn't feel
 so discouraged that things aren't going as well as ex-
 pected.

An emotional reaction from the therapist to Daphne's words of
sadness or humor allowed her to recognize how people react and
further reinforced her own emotions. She felt that she was under-
stood. Support is conceived as a therapist who really listens and
communicates that he or she has understood.

Daphne: There have been times when I'm very glad to remember that she's human. There are times when I've said things and I've seen that she's actually crying. But I was very surprised that she wasn't SO removed from the situation that it wouldn't affect her that way. Then, I thought, I'm so glad that she did. I mean, that's the way you react to someone who is telling you something that is emotional and something that you find touches you, too. It would be almost inhuman NOT TO REACT. She laughs sometimes if I say something funny.

Rossner's (1983) character Dawn talks about her relationship with her (surrogate) "mother" Tony and her first therapist.

I figured I'd be able to talk to Tony about how I felt, but even she didn't really understand. Not the way Dr. Seaver did. Sometimes I didn't even have to explain things to him. He spoiled me for other people. (p. 15)

Dr. Seaver didn't care what I looked like. He barely looked at me when I talked to him. I remember that right from the start. Nothing I said ever surprised him because he didn't even see *the outside me. (p. 3)*

Continued therapy helps to validate the understanding of the inner person, beyond the physical image portrayed. This is an essential part of the therapeutic process.

Therapy assists women with issues and problems. At times, people bury their issues within and a resultant tension, anxiety, or other manifestation appears. As women begin to talk about their issues and express their emotions, they find great relief. The catharsis of liberating. Women also recognize problem situations sooner, before the problems escalate to a point where they cannot handle them by themselves and need outside assistance or resort to destructive behaviors.

The participants noted how therapy assisted them in dealing with life. When Daphne started therapy sessions, so much tension was forged within that she needed to cry and found catharsis

in crying. Well established in the therapeutic relationship now, Daphne talks regularly with her therapist and does not allow her problems to fester.

Daphne: I mean there have been times, especially in the be-ginning, where I was so, I guess RELIEVED to be in therapy that I'd be crying all through therapy and then crying all week afterwards.

 You know, just because it's very cathartic—IT REALLY IS—and once that valve is kinda' opened, then, you know, and I mean that hasn't happened to me for a while BECAUSE I've been in therapy I think things don't "bottle up" quite that way.

Daphne entered into a relationship in which she found she was doing things that she did not like. Therapy assisted her in recog-nizing the problems early and leaving the relationship.

Daphne: I was getting pushed just imperceptibly further and further beyond what I thought I should be and I think that kinda' started when I was with this guy. My con-science began shifting a little bit because this guy says, "Oh, it's OK to do this."

 There's something DREADFULLY WRONG and I think again that being in therapy was what helped me keep in perspective what my own parameters have to be.

The things that bothered Daphne were questions of con-science, not physical issues. She found these "things" morally un-acceptable and was able to resolve the situation.

The housewife who entered therapy in search of steel now drives and walks with conviction, and her family sees this. She has also developed professionally and now holds a Master's de-gree and a job that she loves. She credits therapy with assisting in these life accomplishments.

Sophie: My daughter said to me the other day, she said, "Mom, you drive a car good. You drive it with such conviction,

and in fact, even walk with conviction any more." So, they can see. Like the visual pieces, they can see. Plus I didn't have my Master's degree and had no profession to get a job. I don't think I would've gotten by without therapy. I was just too emotionally confused to get out of my own way.

In a recent discussion, Sophie's daughter told Sophie that she felt "unfinished." Sophie revealed that this is how she used to feel and that it is only recently that she feels complete. She added that though she feels complete she wants to do even more with her life.

Therapy allowed Katie to treat herself as well as she did others. Even going to therapy sessions was seen as a gift. These gifts to herself served to enhance her self-image, and as she grows emotionally she is able to give more to others as well as herself.

Katie: I never used to do things for myself. It was always for others. And to have baby sitters come in, and the expense of therapy. It was, like, wonderful that I was giving myself that. It was a gift. And I still give myself gifts. I don't give the gift of therapy anymore but I still have time for myself and I still buy myself things that pamper, and that's real good.

It is exciting to see the women mature and develop many new resources within themselves as therapy progresses. They talk more about change and the journey. Women recognize their progression and their personal growth.

CHANGE AND THE JOURNEY

Often, therapy is a tenuous process and the path is not immediately apparent. Metaphor again comes into play. Here, it is the journey that Lois takes as she learns how to "live again." She learns about herself and others and how to interact. The journey is slow and the road is long.

Lois: Psychotherapy has been like a journey. That's the way I think about it, as a metaphor. I feel like I'm only about a third of the way through it, even though I've been in therapy for so long.

It's a journey of learning how to live again. A journey of learning about myself and learning about other people and my relationships with other people. The reason I called it a journey is because it takes so long. I feel like I've come a long way.

Lois has noted changes in her sensitivity to other people's emotional needs, both personally and professionally. She is also able to express her own needs and is better able to take care of herself.

Lois: Oh, it's changed me tremendously. It's changed me in a lot of ways from the inside and it's made me a better person—more sensitive to other people. It's made me a better nurse 'cuz it's made me more sensitive to other people's pain. It's made me not as much of a doormat. I'm more assertive, more capable of saying no to things that I don't want to do.

Daphne feels great excitement and self-worth when she learns something new about herself. This self-understanding has allowed her to make significant changes in her life.

Daphne: I get older and wiser. It comes from me and it comes from the outside too, I think. There have been career things. I HAVE DEFINITELY noticed change; I mean, it took me a little while before I started saying, "Boy, I'm really getting my money's worth out of this."

Sometimes those are mainly the greatest sessions, when it feels explosive and great, that all this movement is apparently happening. All these things that I'm learning about myself—what could be more interesting?

Therapy allows women to communicate in a way that they never would have thought possible in the past. An openness

ensues that allows verbal expression of emotional needs. Changing patterns of intimacy and communication with her spouse was a major issue for Katie.

Katie: The major thing was intimacy with my husband. I'm not talking about sexual intimacy, I'm talking about communicating, because when he came out of rehab it was very different. Our patterns have changed tremendously. Our friends have changed. Everything's very, very different. So the therapy has helped me in communication.

Besides spousal relationships, friendships have also changed and grown. The outcomes of therapy are multifocal.

OUTCOMES

Outcomes result from the journey and, as they progress, women change. Friendships take on new dimensions; learning is enhanced, as are familial and interpersonal relationships. Women are able to deal with all of their feelings, including those of anger and rage. Friendship is of great importance to these women.

Friendship

Through the work of therapy, friendships are enhanced. The women redefined what friendship means to them.

Lois realizes that friendships involve both giving and taking. Now she is able to accept help, and her bonds of friendship have strengthened.

Lois: One of the things I've had to learn in therapy is to accept help from other people and so it's made me more willing and more able to call on my friends . . . before, I was the one that was always doing things for everybody else, and now it's more reciprocal. Therapy has helped me with that.

For Annie, life has acquired depth; her friends are more diverse and her relationships have deepened. For her and many other women, strong interpersonal relationships are essential.

Annie: My life is richer. I think I've made more interesting and intimate friends.
 I think that because relationships are so important to women it is also important to have very strong relationships and BELIEVE THAT YOU DO.

Daphne is proud of the fact that she can manage well on her own. She is normally a very productive person but tends to be a loner. Therapy has helped her recognize that relationships with others are also useful in helping her own growth and productivity.

Daphne: I'm a very detached—I mean a very isolated—person by design, and in some ways maybe I'm overly proud of that. It's hard for me to not see my sense of self-sufficiency as a great boon in who I am. I think therapy is helping me to realize that other people can be a very good and necessary catalyst to even my *self*—not only in terms of my relations to other people in the world but to my own ideas. I think it really does help to interact.

Friendships have enhanced these women's lives. They have learned much about this important part of their lives. The women have indicated that they have learned many other effects in therapy as well.

Learning

Women learn that they cannot change others. The recognition of this is often painful. Lois continues with her journey as she learns about her abusive relationship with her parents. She recognizes both the pain and the beneficial results.

Lois: It's helped me tremendously. It's helped me understand what has happened in my life. It has helped me

to get out of this abusive relationship. It's helped me
realize that there's only a limited amount of under-
standing I can expect from my father. My father was
one of the abusers. And it's helped me understand
that I'm not going to be able to expect him to under-
stand or apologize.

Lois talked about a poem called "Bitter Rue." She identifies
with the painful process of growing and developing. She notes
that there is also pain as a flower bud bursts open and becomes a
beautiful flower. Lois states that she would like to spare her child
the pain but recognizes that "It's part of the journey."

For Corrine, like Katie, the journey involved learning to com-
municate in a different manner. In the therapeutic relationship,
women learn to ask for what they need.

Corrine: I guess I felt that she was listening but I didn't get the
feedback that I wanted to get, and I had to learn how
to make contact so that she would respond to my ques-
tions and stuff. So, I'm still learning that, and I think,
well, actually most of the sessions, I do feel better
afterwards.

Learning to make her own decisions gave greater strength to
Katie. In the past, she tried to please others whenever a choice
needed to be made. Now she considers herself as well.

Katie: I think it's empowering, too, rather than other people
giving you solutions. People cannot give you their so-
lutions to your problems because everyone is an indi-
vidual. . . . I think that what therapy did was help me
to become more independent. It was the first time in
my life I made decisions. I never made decisions in
my life, ever. I didn't have to. I did things to please
people.

Learning involves many different aspects of women's lives.
Growth, learning, and positive interpersonal relationships develop
as women engage in therapy. As women acquire more effective

ways of communicating and living, they also become role models for their own families.

Family and Interpersonal Relationships

Though Daphne enjoys being alone, therapy has guided her to interaction with others and has allowed her to grow. Daphne shows how her relationship with her sisters has developed.

Daphne: I think therapy definitely has helped me to begin to deal with a lot of things in my life in terms of my family. I'm very close to my family. Interfamily relationships are much more profound.

 I think actually all three of us are in therapy, and for all of us sisters, it's been great. We really have come to an arrangement now where we can deal with each other very well. If there is a disagreement, we can discuss it. It doesn't end up being something that gets buried and, you know, sort of "festers" and becomes a big infection inside or something.

Therapy has assisted Daphne in dealing with problems as they occur, rather than waiting until they become grave issues. Prompt attention to problems has cultivated positive relationships with her sisters.

Sophie is future-oriented. She states that improvement of her personal, family relationships will hopefully impact on her grandchildren. She would like to be a positive role model for her family.

Sophie: What I'm working on is trying to make family relationships better, so that my grandchildren will have better lives. I don't know that they'll have less pain or not—that's a fact of life; but getting to tolerating it, that's what I'd like.

Sophie knows she cannot eliminate her family members' pain but she can be a role model for how to deal with difficult times

in life. Often, in the past, Sophie could not deal with difficult situations in a positive manner. Now, Sophie is able to put her feelings into words, and this allows others to know how she feels about things. Prior to therapy, her failure to express some of her feelings, such as anger and rage, interfered with her relationships.

Anger and Rage

Often, women cannot recognize anger and rage in themselves. Anger is then directed inward as women find fault with themselves. Sophie used to direct her rage and anger toward herself. Now she is more at ease with these feelings. She understands them and is able to express them openly. At times, however, she is still confused. Yet, when she was able to express her anger appropriately, she stated, "I'm much more open about how I feel and much more demanding about what I want. That's pretty good." Sophie now believes it is "important to get angry at the right place."

Sophie: I have to say that I feel better in analysis, but I'm not quite sure why. I think one of the things that I've gotten in touch with—and I know [it] intellectually through reading, but I've also experienced it—and that's the feeling of rage. I think that feeling was totally denied to me before and [I] just downright did not know what it was. And most of the time I would direct it at myself, I was really terrible. . . . I'm getting to experience all that rage. But I certainly wouldn't like to feel this way without the intellectual piece.

Prior to this time, Sophie was unable to tolerate her own feelings of hate toward other people. She dealt with them by becoming numb or depressed and withdrawn. Since she has been in analysis, she has learned to express her emotions appropriately and is able to deal with problems as they occur.

Corrine is able to express anger with her therapist when she does not feel that she is getting what she wants.

Corrine: I GET REALLY ANGRY at my analyst because I can see
that she fosters dependency Like, she won't give
me any encouragement that I'm doing any better.

Appropriate expression of anger and rage is liberating for
women. It also facilitates the therapeutic process. The *process* of
psychotherapy assists women in meeting their needs. Different
methods are used by therapists. Greenspan (1983, p. 337) talks
about compassion and the experience of connection to others as
an essential part of the process of psychotherapy. Some other ex-
amples of the methodology therapists may use are: Freudian, Jun-
gian, or Modern Analytic.

PROCESS

The process of psychotherapy is fascinating. It is one way women
can discover who they are and who they want to become. It is
about inner growth. How does it work? Some of the women in
this study described their experiences.

Daphne: When I first started going, it was difficult for me to
take seriously lying down, not facing the therapist,
and I felt a bit foolish. And NOW that feels VERY
VALUABLE to me. It feels, to me, more like my own
inner monologue thing. I don't feel like there's an ob-
vious relation with my therapist. I feel like she's
there, like, sort of catalyzing what goes on for me.
She's doing a fantastic thing there, but I feel very
much like it's MY process.

In psychotherapy, Sophie finds herself wondering what her
therapist understands about a situation and tries to please him by
saying the right thing. She stated that, when she started psy-
chotherapy, she was "desperate and really alone." Sophie thought
about her therapist constantly. In analysis, with the female doc-
tor, she just talks without questioning why.

Sophie: One of the things I didn't like about psychotherapy: I thought I was under a spell. Any time when I'd think to start either analysis or psychotherapy, it's almost like a druggish kind of feeling that comes over you when your psyche begins to get into a transference/counter-transference thing, and in a way you feel more because the therapist gives you the support to help you to feel better. But it seems to muddle my thinking. With my first therapist—every time, I think—I was thinking, "Does he think this, does he think that?" In analysis, I never would think of that. It's totally different and that's kind of like a dream thing. I never think of that. I just do it.

Part of psychotherapy is the relationship of childhood events to adult behavior. By interpreting childhood events and linking these to the present, Lois can feel emotions of childhood that she previously had not allowed herself to feel.

Lois: He made me feel stuff and he would interpret it and he would bring it back to my childhood and back to my marriage and connect up what was going on in the present with what had gone on in the past. And I would literally feel the way I had felt as a child.

Discussion of the therapy process with her male therapist and, now, her woman therapist occurs also with Rossner's (1983) patient, Dawn, and Dr. Shinefeld.

Dawn: I never felt as though he (her first therapist) was pushing me . . . or pulling things out of me. . . . I don't know which is worse, having something rammed down my throat or pulled out of it . . . but I never felt that way. When he told me something I didn't know, I felt as though he was *teaching* me. Not *pushing* me. . . .
 . . . I guess the truth is, I loved to explain things to him. He was teaching me but I was teaching *him,* . . . about what it was like to be me. With you (Dr.

Shinefeld, the second therapist) I don't have the advantage of being different. There's nothing about me you don't know or couldn't know because it's the same as yourself. Maybe he was a little smarter than you are, but you have, whatever, a different kind of power over me. I remember the day you told me that story about the little girl, you know, *I'm leaving a part of myself with you*. . . . It was magical. It changed the whole world. All the colors got brighter. *Literally*.

Daphne talks about how therapy is a long-term investment and a process. She recognizes that "psychic crash diets" generally don't last. Therapy is not friendship. She is able to tell her therapist things that she would never divulge even to her closest friends. Therapy has been very beneficial for Daphne.

Daphne: Here I am investing all this trust in this person and confiding in her in the most deep way. Basically I know she's not just a mercenary. But there's something there also saying that this isn't a friendship and yet I'm telling her things that are deeper than the things I tell my friends. Other times I feel sorry for her for having to deal with all this shit.

For me it [therapy] has been good. I have known people who have gotten involved with real quick "fix it" plans, cults like crash diets—psychic crash diets or something like that—and it just seems obvious to me if something has taken so long to get to this point, there's not going to be a quick remedy for it.

And therapy I know is a long-term thing and it sort of tries to help you from the deepest level. So it's—I think it is helpful. I think it could be helpful to everybody.

For the women in this study, psychotherapy and/or analysis has been beneficial. Their stories revealed the formidable circumstances that first brought them into therapy. At first, women had specific needs that they wanted to address in therapy. As they

progressed in therapy, it became evident that the journey brought to light other problems and distress. As the journey continued, the women began to understand themselves and learned much about their feelings, friendships, family, and interpersonal relationships. It was important for the women to discuss their choice of therapist, what the therapist was like, and how the relationship between them developed. The women talked about what helped and what annoyed them. Therapy is about getting to know the inner person, for both the woman and her therapist. Doris Vanderlipp Manley's (1991) poem, *words never spoken,* talks about getting to know the real being:

walking through the city I saw the young girls
with bodies all silk from underthings to eyebrows
legs shaven
heels pumiced
nails glossed
hair lacquered
thighs taut
eyes clear
gladbreasted tittering girls

and I wondered how even for an hour
you could love a woman who has no silk
only burlap
and that
wellworn
tattered
and frayed
with the effort of making a soul.

Therapy that is beneficial involves a connection between individuals that extends to great depths. Finding the "right therapist" and making the journey can produce "steel." There is an important strengthening that comes from psychotherapy. Therapy is very meaningful for many women, particularly for women who have not previously had the opportunity to be heard or to listen to their own needs. For the women in this study, and, I hope, for

many more women who will engage in psychotherapy, the process has changed their lives and allowed them to engage in more fulfilling lives.

ABOUT THE STUDY

Purpose

In today's world, women are confronted with many dilemmas, stressors, and emotional situations. Frequently, the burden is great and the support is limited or inappropriate.

Recently, I have had several major crises occur. Luckily, I had entered into psychoanalytic training and therapy. As I worked through my problems with a difficult marriage, teenage children, and a frail elderly mother, the analytic process sustained me and nurtured my personal growth and development. I have also observed fellow students and colleagues grow and develop despite adversity and begin to enjoy life after they engaged in psychotherapy. Yet, many women shy away from therapy.

This study was proposed to begin to understand the experiences of women in psychotherapy so that women and the professionals who come in contact with them might glean insight into the experience and dispel some of the myths and taboos that are related to the subject.

It is important to capture the complete experience of women in psychotherapy. This involves their personal life experiences as well as influences from the world around them. Even fictional works and poetry come into play here. Thus, a phenomenological approach was chosen utilizing van Manen's (1990) methodology. Phenomenology is a qualitative form of research that attempts to understand the meaning of the world of humans as we experience it. It is holistic. Rigor is found in the depth and breadth of the information. It is exhaustive; the full meaning of the experience is sought. Here, there is room for the subtle, intuitive, and sensual, as well as the objective lived experiences. The questions explored in this study are: What is the lived experience of women in psychotherapy? What is the meaning of the experience of psychotherapy for women?

Method

The six women in this study came from a convenience sample in New York and New Jersey. Criteria included at least two years of psychotherapy or, if therapy was complete, at least six months out of therapy. Women with severe pathological diagnoses were excluded.

Sessions with the women were tape-recorded, transcribed, and examined in detail for themes. The most frequent themes were included in the text, utilizing van Manen's methodology to illustrate the phenomena. The writing was shared with the participants for reliability and validity.

REFERENCES

Appingnesi, L., & Forrester, J. (1992). *Freud's women*. New York: Basic Books.

Baruch, E. H., & Serrano, L. J. (1988). *Women analyze women*. New York: New York University Press.

Benjamin, J. (1988). *The bonds of love*. New York: Pantheon.

Bernay, T., & Cantor, D. W. (Eds.) (1986). *The psychology of today's women*. Hillsdale, NJ: Analytic Press.

Bernstein, D. (1993). *Female identity conflict in clinical practice*. Northvale, NJ: Aronson.

Berry, P. (1982). *Echo's subtle body*. Dallas: Spring Publications.

Foderaro, L. W. (1994, July 28). A district for mining of Manhattan's minds. *New York Times*, B1.

Greenspan, M. (1983). *A new approach to women and therapy*. New York: McGraw-Hill.

Horney, K. (1967). *Feminine psychology*. New York: Norton.

Kissen, M. (Ed.) (1992). *Gender and psychoanalytic treatment*. New York: Brunner/Mazel.

Lerner, H. G. (1985). *The dance of anger*. New York: Harper & Row.

Lerner, H. G. (1988). *Women in therapy*. Northvale, NJ: Aronson.

Manley, D. V. (1991). words never spoken. In S. Martz (Ed.), *When I am an old woman I shall wear purple* (p. 89). Watsonville, CA: Papier-Maché Press.

Olivier, C. (1989). *Jocasta's children*. London: Routledge.

Rossner, J. (1983). *August*. Boston: Houghton Mifflin.

Schiller, L., & Bennett, A. (1994). *The quiet room*. New York: Warner Books.

Wells, J. (1991). Two willow chairs. In S. Martz (Ed.), *When I am an old woman I shall wear purple* (p. 118). Watsonville, CA: Papier-Maché Press.

Young-Bruehl, E. (1990). *Freud on women*. London: Hogarth Press.

ABOUT THE AUTHOR

In the past year, my mother passed away, I changed employment (and no longer commute to New York City), and I moved to a new home. My daughter Beth returned to New Jersey after eight years in North Carolina, and Janice, my youngest, began college. For the first time in my life, I am living alone (even the animals have left home). I find myself enjoying life even with all these changes.

I am now an Associate Professor at the UMDNJ School of Nursing, teaching in the RN to BSN program, and enjoying the change immensely. I also work per diem at an eating disorder unit at Saint Clare's-Riverside Medical Center near home. This helps satisfy my needs to interact with patients.

I continue as a student of psychoanalysis. This began as I finished my doctorate at Teachers College, Columbia University, when a colleague suggested I might miss school after all these years. I am glad I listened to her advice.

My interest in women's issues and research continues. As a qualitative researcher, I am about to engage in another study that has piqued my interest. Also, in April 1994, I was honored to present my doctoral research at the Stewart Conference at Teachers College, Columbia University.

The Children of the Shelter for Battered Women

Carol P. Germain

Your children are not your children.
They are the sons and daughters of Life's
* longing for itself . . .*
You may house their bodies but not their souls,
For their souls dwell in the house of tomorrow,
Which you cannot visit, not even in your dreams.
 Kahlil Gibran (1923, pp. 17-18)

INTRODUCTION

*K*em Jones's daughter was standing next to her mother, who was sobbing uncontrollably in the office of the shelter for battered women. The daughter, Suzie, was patting her mother on the upper back, repeating, "Poor Mommy, poor Mommy." The mother

had just been prevented by me, in the nick of time, from crashing her newly casted arm onto the head of another mother, after the two had had a brief argument about the toys their children had selected from the playroom. Kem's daughter, standing on the sofa and giving comfort and consolation to her mother in this strange new place, was only 22 months old.

Mrs. Jones was an overseas military bride. Her husband's family overtly reject her because of the interracial nature of the union. Kem, who had looked forward to the good life in America, thus became a source of shame to her husband. She was kept isolated in a small apartment with the two children (the second was a boy, then 9 months old), which effectively kept her from public view and denied her the opportunity to establish her own support networks. She was permitted out only with her husband. This day, however, Kem's husband had shoved her into a wall, fracturing her humerus. The emergency room staff had suggested that Kem seek admission to the shelter. When she arrived with the two children, she was in pain from a marked circulatory deficit caused by swelling in her hand, which protruded from the awkward angled cast that ran from her wrist to her shoulder. The continued swelling required a return visit to the emergency room. In addition to the untold effect of the abusive environment on the children, the imposed isolation in the home had prevented the mother from taking either child to a health care provider for basic immunizations. Thus, the major method of the abuser, isolation of the mother, resulted in neglect of attention to the health of the children.

It was evident from this and other observations that little children, even under the age of 2, are sensitive to their battered and/or abused mother's plight. But what of Suzie's future? How will her tension-filled home environment, her observations of physical and emotional abuse of her mother, the neglect of health and social development due to her mother's isolation, her abrupt move to this battered women's shelter without her clothes or toys, even her separation from her father, affect her? How will her role reversal as nurturer and comforter of her mother at this very tender age influence her life? Will these experiences change this tiny girl in very negative ways?

FINDINGS

The shelter I studied had a capacity of 25, and the population usually consisted of 7–8 women and 17–18 children ranging in age from newborn to high school teens, although most children were preschoolers. Despite this large number of children, the house always seemed relatively quiet to a transient like me, especially when I considered that 25 meals were prepared and served three times a day by the women residents in their turn. The staff offices were adjacent to the living room of the old farm house, and although this permitted easy supervision of the shelter's residents and activities, it was distracting to the staff. As one case aide said, "When you are living with other people, you know, and you work here, it's total involvement."

The children in the playroom, or around the kitchen tables, or in other group activities, with rare exception, did not look or act differently from groups of children elsewhere. They were of various ages, sizes, colors, hairstyles, and stages of development. But each child was already traumatized, at least emotionally, because every child accompanied a mother who had to have evidence of physical abuse, or battering, to be admitted to the shelter. Most of the instances of the abuse of children in this study are not of the types that merit headlines in daily newspapers. But one value of phenomenology is the uncovering or exposure of the taken-for-granted realities of everyday life. Hence, to move closer to an understanding of the trauma of the children of the shelter, this study addressed the question; What might it be like for children to live in circumstances of abuse or battering?

Besides Kem's daughter, described above, other children demonstrated how they were protective or supportive of their mothers. Angela, a resident, commented:

It's got so that this baby [a boy, 19 months old] steps in between anybody that comes close to me because he thinks they're going to hit me. Just the last few days at the shelter I notice his standing back and watching more. Even if somebody comes to kiss me he'll get in the way. He thinks I'm going to get hit.

I said, "The sensitivity of some of these little children amazes me." Angela replied, "Well, he's been watching it since he's been in an infant seat." Another resident said of her abuser, "He very rarely beat on the children. They would get hysterical. My son is always trying to help me."

Very young children also show sensitivity to the needs of other children who are being neglected. A mother was sitting on a sofa in the living room, smoking a cigarette, and watching TV. Her wailing toddler (11 months old) kept trying to raise herself onto the sofa to be held by her mother. The child wasn't strong enough to climb all the way up, and the mother pushed her off. The child kept trying. Finally, she made it up to her mother's shoulder and the mother pushed her hard onto the sofa. The little girl screamed harder and raised her arms up again to her mother, but was ignored again. She finally got off the sofa and toddled to a coffee table. She knocked the mother's cigarettes, matches, and ashtray off the table, still screaming. Her brother, about four years old, came by and climbed onto the sofa into the fold of the mother's left arm. The toddler was on the floor, still screaming. Mikey, a 3-year-old boy, attempted to comfort her. The mother got up and walked away. The toddler followed, screaming. Her older sister (5 years old) attempted to comfort her. The mother then gave an empty cigarette box to the baby, who rejected it. Another resident asked if the baby's behavior was unusual and the mother just said, "She's tired." The staff described this mother as difficult to relate to, and defiant.

Some women made the decision to leave the abusive home after a particular beating because "I'm afraid he'll hurt the baby," or "I'm concerned about the welfare of the baby." Others, mostly mothers with children, came when they could not take the abuse any longer.

Women were told by the staff on admission that the purpose of the shelter was to meet the needs of battered women, but the women were responsible for their children because there was insufficient staff and other resources to address children's needs beyond the basic ones of safe shelter, food, clothing, indoor and outdoor play areas and toys, and referral for health and social services that could not be provided in the shelter. The state's

Division of Child Protective Services (a pseudonym) was notified if any child had experienced physical or sexual abuse prior to coming to the shelter. Children who exhibited serious behavior problems were referred for counseling, but there was no counseling program for children in the shelter. Angela's 7-year-old daughter, for example, was taken for regular therapy because she had signs of depression, including saying that it would be better if she wouldn't live any longer. Staff were concerned about the children, and regretted that there was insufficient money to provide needed mental health or counseling services for them. They did not want to disempower mothers by taking responsibility away from them, and tried to make it clear to the mothers on admission that the shelter did not include a day care center. Staff noted that many mothers were attentive to their children; some were not.

For part of the period of participant-observation in the shelter, external grant funding permitted the hiring of new, though temporary, staff as child care workers. They viewed their role as enrichment, providing for planned play/learning experiences and mini-field trips that would help the children learn and grow. Some mothers took it for granted that the child care workers were supposed to be babysitters for their children. They became annoyed when the workers did not take the children outside to play or take them off their hands so they could have some time to themselves.

On the other hand, a child care worker stated her belief that some of the women are as defensive about their offensive behavior toward their children and as controlling of their children as their male abusers are of them. Some child care workers were dismayed at what they perceived as mothers' disinterest in the children and their eagerness to "dump" the children on them. They claimed that they did not see a lot of loving behavior from mothers to their children and did observe a lot of overt rejection. One worker said:

It's so sad . . . so sad. Their [mothers] main tone of voice is yelling. They don't treat children like people. They pick up their kids, put them in the cribs, then close the door and yell at them if they attempt to come out. They leave these

kids in dirty diapers for hours. . . . There are very, very few mothers who have spent any time playing with their children, and that's all they have to do here. I have seen one per cent maybe, pick up a ball and throw it to their kids. They would rather sit in the other room and watch soap operas than have any contact with their children.

Such withdrawn behavior is not unexpected in the beginning days of the shelter transition, when the women can experience a number of overwhelming emotions (Germain, 1994). Both staff and residents help a newcomer. But continuing neglectful mothering behavior bothered the child care workers. The differing of role perceptions and related expectations created tensions between child care workers and residents. At resident group meetings, clients complained or asked for clarification about the child care workers' functions. A job description was made available to the women, and the staff leader reiterated that mothers were responsible for their children although staff did want to make the care of the children easier for them by providing help when necessary, and maintaining a nurturing and safe environment.

Another source of tension between staff and residents was the shelter rule that mothers could not discipline their children by physical means. This position was consistent with the shelter's philosophy and staff beliefs that "It's not OK to resolve issues through physical force," and that the physical disciplining of children contributes to the perpetuation of domestic violence from one generation to the next. Infractions could be issued by staff when mothers used physical means of disciplining children. Several infractions, or even one very serious one, could result in dismissal from the shelter. One teenager/mother dyad had to leave the shelter because the boy would not stop deliberately terrorizing the little children. One suggested alternative to using physical means to discipline a misbehaving child was to send the child to bed before the 9:00 P.M. shelter-established children's bedtime. This rule allowed some evening respite or meeting time for the mothers downstairs; all the bedrooms were on the second floor. Vera's children, ages 11, 9, and 8, did not like the 9:00 P.M. bedtime. Vera commented about her method of discipline:

All I do really is tell them to put their hands out. Spanking them and abusing them are two different things. I do see the chance for abuse with some of these women. Now that I think about it, I think it is a good rule. I think Kris would have beat her son. She got worse and worse here and didn't care for him. She got a job as a go-go dancer and cocktail waitress. She came first, not her son.

The physical disciplining of children was normalized by many mothers. One resident, whose boyfriend was the father of the two children, was asked by another, "Does your boyfriend hit the children, too?" She replied, "He beat the children only when they deserved it. . . . It was just part of a normal beating." Another resident stated, "If I don't give my kids a beating once a week, they get out of hand." In the kitchen one night, a mother, glowering with anger, muttered to her teenage son, also demonstrably angry, "I can't wait to get out of here and chastise you in my own way."

One women was seen smacking her children on the hands but, instead of issuing an infraction, the observing staff member referred the resident to another staff member for advice on how to handle the children. The resident said, "I have books of my own to tell that."

Another mother, expressing her dislike of the shelter in a resident's journal, wrote, ". . . You can't beat or smack your child if they are bad, most of them act bad because they know they can't get hit."

Some mothers avoided getting an infraction by slapping fingers or hitting the children upstairs when everyone else was downstairs, or taking them outside into the woods, out of sight and out of hearing range. Although many mothers stated their belief that there's a difference between abuse and physical correction by a concerned parent, staff were aware that women come to the shelter with raw emotions that can easily erupt with the stressors of a new environment, communal living, and future unknowns. Staff understood that the most likely to receive a mother's abuse if she loses control is the child. Angela was one of the mothers who saw her children's discipline regressing because of the no-hitting

rule. Her son was 19 months old and Angela was not happy with the fact that:

> ... *He has the full rein of the house and he needs his fingers slapped. He's starting to have temper tantrums when I correct him. ... This place is really messing up his behavior. He knows I won't hit him on the fingers here and he just deliberately laughs at me when I correct him.*

Sometime later, Angela came to see the wisdom of the no-hitting rule after she nearly lost control because of her many frustrations from an unsuccessful day of apartment hunting. While trying to hold her restless, overtired toddler in a hot car with the midday sun beating down, and coming very close to striking him because he wouldn't sit still, she caught herself and said:

> *It's so hard to deal with him when I'm feeling this way myself. Now I understand why they don't let you hit your children in the shelter ... it would be so easy to take out your feelings on them.*

Several mothers who disagreed with the no-physical-discipline rule made a distinction between a spanking and a beating. Janeen said:

> *I figure a spanking is different from a beating. I don't say a spanking every once in a while will keep the child in line but if you see a child doing something, they will keep on doing it because they won't get spanked. ... like my little girl [3 years old] out there in the hallway. She's been put to bed two times already. Now if I spank her butt and put her into bed, she'll stay in bed. She wouldn't be out there right now. But, it's a rule.*

Other mothers ignored the rule. Said Stella, who had four children with her:

> *I don't pay the rules no mind. I watch who I hit, and I watch who's watching me. Occasionally I smack them on*

the behind when there's no one around. You have to do that. Threats don't work. I give them a pinch or squeeze of the arm.

Children tell other children when they first come in that they can't get hit. Beverly said:

So they [children] try out everything they can and then when you go to discipline them they give you an infraction if they find out you spanked them. I hit mine the other night [a 7- and a 5-year-old]. I smacked them on the backside. I understand the rule because they think you might take some of your anger out on the children. It's a good rule for some women, but for myself, when I feel that way, I won't go near them; and if I'm spanking them and I feel myself going that way, I'll walk away. It really all depends on the person.

Pat, a staff member who worked closely with the children before and after the temporary child care workers program, told me:

I have never seen mothers hit the children in my presence, but I know they do it. Women here are under so much stress they don't hit on the behind. Some of them get carried away and whack and whack and whack at them.

George, a male staff member, noted:

I am positive about the no-hitting rule. Wife abuse is a problem of generations. Sons see their father use force and figure, if it's good enough for Pop, it's good enough for me. Somewhere, somehow, you have to try to break that cycle.

Some staff agreed that the shelter policies "offer a rule not to spank but they don't offer enough alternatives for discipline. No one teaches alternatives. The ones who can get away with it still hit their kids. There are some parenting books here but no one

reads them." One staff member ultimately prepared a brochure for the residents: *Who Are You to Say I Can't Spank my Child?*

But there were successes. A staff member explained, with regard to disciplining the children:

Most mothers will go through a period where their kids are super-defiant because they know they are not going to be spanked. Vivian had five, some teenagers, some preteens, and they were testing her limits most of the time and she was very upset when she first came here about not being able to discipline her kids the way she had been used to. She was here for quite a long time and it was amazing to watch all the time she was here how she gained control over those kids without having to resort to physical means and how much closer the kids got to her, how much nicer the kids became. The main problem the children have is figuring out, I guess, they have to redefine their relationship with their mothers, because they are being treated differently; they're not being spanked.

Dora's baby was just 1 year old. She said:

I have trouble with the no-hitting rule because he's at the age now where he's grabbing everything and to teach him not to do it, you should smack him on his hands, or something, to let him know not to touch it. And I did, after he was after a hot pan of grease, and I smacked him on his hand and I was telling him, "NO!" and I got an infraction for it. Which really made me disgusted because I figures, how was I supposed to teach him? If he poured a hot pan of grease on him, it would have been worse than smacking him on the back of his hand. I think some women could go too far and really hurt the child because you have other things on your mind, you get frustrated and maybe the kid keeps whining and crying or something, and you just haul off and smack him. Some women really hurt the child. I can understand it one way, but in another, you know. . . . They say it's violent but I think it's the way that you do it.

Dora was asked if she had thought of just gently pulling the child's hands away or lifting him away from dangerous things because 1-year-olds don't understand orders and hitting him might cause him to become afraid of her. She just shrugged and said, "Oh." Tonya, another resident added, "I believe the kids want discipline and if the only limits you set are physical . . . I hear the women all the time, heavy on the threats, lots of threats. I can understand their frustrations but I personally wouldn't do that."

Some mothers recognized their potential for physically abusing their children and sought help; for example, Laura went into the office crying hysterically, saying she was afraid she was going to hurt her 6-year-old daughter, the oldest of three. The staff member got her an immediate telephone conference with a sponsor from Parents Anonymous, and later transported Laura to meetings.

Although the hitting or neglect of some children did occur, staff acted quickly to relieve the immediate situation and try to help the mother, through counseling, to alter her problematic behavior. Some of the women told staff, for example, that Cindy did not feed her baby son and sometimes did not change his soiled diaper for over 12 hours. Mary, who had been in the shelter for two months with her three children, observed that "Rudy's mother told him she didn't love him and totally neglects him. She'll feed her 6-year-old daughter but neglect her 7-year-old son."

On occasion, outside help was sought by staff when a mother's excessive need to control was judged to be possibly harmful to her child and the mother refused to take staff advice. Connie had started a new job while she was still in the shelter. She left her child under the care of another resident. The child sounded very congested, and was very listless when he was taken to the pool with the other children. He just lay down on the concrete and made no attempt to move. He was supposed to be receiving an oral suspension of penicillin for a strep throat. The bottle of medicine was in the refrigerator, but the sitter was told by the mother not to give the child any of the antibiotic because it had been given to him for two days and his symptoms were relieved. The sitter asked staff if she should give the medicine, and the staff explained why it was necessary (as marked on

the bottle) to complete the full course of the medicine. So she gave the medicine. When the mother called and was told, she was very angry and told the resident not to give the antibiotic again because the child was better. Since the regular nurse from the Visiting Nurse Association (a pseudonym) was due the next day, the staff and resident babysitter decided to wait for the nurse to resolve the problem with the boy's mother.

Neglect of children was also noted when women occasionally left the shelter without asking another woman to watch their children, and without telling the staff they were leaving. Thus, the children were left unattended and at least temporarily abandoned in a strange, new place.

Many children of the same mother had siblings from different biological fathers. The term *father* was used quite often to refer to the current male partner, even though the man may have had no legal, emotional, or biological tie to the child. In several situations, a biological father, from whom the mother had fled with the child or children, had repeatedly taunted the mother with the charge that a child was not his. This kind of abuse, along with all the other kinds, has undetermined psychological effects on the child, depending on the age when the message is heard and understood by the child. Angela, whose 7-year-old daughter was being treated for depression, had been subjected to this form of abuse, and the child was present to hear it. Angela was certain her abuser was the father of the child, saying, "There was no other man in my life, and she looks just like him." Another young woman who had been repeatedly abused, said:

> *The baby's a girl but me and him are dark and she has bluish-gray eyes. So there's a problem there. He says sometimes, it's not his child. It all depends on his moods. Sometimes, he'll just go into that depressed state. "I don't know whether the baby's mine or not," he'll say. Which he knows the baby's his, because at the time when I got pregnant, I wasn't going anywhere. I was staying in the house. He tore up the house three days after the baby came home. He just picked up the fish tank and threw it across the room because he was talking about the baby wasn't his.*

A frequent form of emotional abuse of the child is that the father batters the mother in front of the children. Ginger told a staff member:

The first time my husband ever abused me was in front of my son. He started smacking me around, on the legs, the face, and everything. My son woke up and seen that and started having trouble breathing, just like gasping for breath, and we rushed him to the hospital and he was having an asthma attack and they asked us if anything might have scared him, you know, because when they are that young, they could be scared into something like that. I told them my husband and I were arguing and that he woke up. He was in the hospital for a week in an oxygen tent. My son still does that when we argue. He says, "Don't hit Mommy!"

Another young woman, Brenda, related, "He even beats me with the baby screaming and watching."

Some abusive fathers deliberately exclude the children from the battering scene in ways that are abusive in themselves. "Joanne's husband is different," said Angela. "He puts the kids [ages 3, almost 2, and 3 months] out of the house and turns up the stereo and then he starts it."

"Starts what," I asked?

"Oh, she's had everything done to her. She's been with him since she was 16."

Some of the children were growing up in very violent environments in which a mother retaliated with violence against an abuser. Brenda, a mother of four, including two boys aged 17 and 15 from a previous relationship, came to the shelter with two girls, ages 8 and 9, whose father was Brenda's boyfriend of 14 years. Over these years, Brenda had been beaten with a plunger handle, fired at with a gun, punched in the face, suffered a broken hand, and lost a couple of patches from her head—among other injuries. She finally went to a shelter in the city where she lived after she realized that moving from place to place to avoid her abuser wasn't working. When the boyfriend found out where she

was staying, she was transferred to this shelter. The boyfriend, "in and out of jail all the time," would always pry his way into Brenda's latest residence with a crowbar or a lug wrench. Brenda revealed:

I've been on welfare a long time and if I moved into a place, he'd move himself in. He acts like he has a right to beat on me, you know. Like my 17-year-old, it got to the point where he wanted to jump on my boyfriend. I didn't want none of my children getting hurt on account of something like this. And my other kids were kind of nervous. That's no way to live, never knowing when he's going to beat me or nothing. Violence . . . it's just no good for kids. I want a better life for my daughters than I had. I'm teaching them things.

Brenda's mother had been killed through domestic violence, and when Brenda's boyfriend was 13, he beat his father up for beating his mother. Brenda said, "It seems like he would think about that and not do the same thing." Brenda was not passive through these attacks. She added, "I've cut him a few times [with a knife]. Because he'd back me into a corner and that was the only thing I could do." Then he started to hide the knives so Brenda couldn't grab one. This time, Brenda said, she was going to press charges. She continued:

My daughters, sometimes they can't understand why I left from home . . . I don't think they would want him beating on me because that did upset them, 'cause he'd do it in front of them, he didn't care if the kids saw it. I got to the point where I thought the only way I was going to get rid of him was to kill him. I still have that on my mind.

"Could you ever be driven that far?" I asked. "Yeah," said Brenda, "because the time I tried to cut him, that's what I was trying to do, trying to kill him."

As with Brenda's teenage sons, other boys, especially teens, in the defense of their mother, come to emulate the father's abusive

or violent behavior. Geri said that her 5-year-old son told his father that when he grows up, he is going to kill him. Another mother stated, "It got so that my kids would carry a knife in their sock at home to protect me."

Unfortunately, some adolescents adopt the behavior of the abuser and act against the mother. One resident said she had been abused and battered for 11 years. Her growing children now harass her and use the same threats toward her as their father.

Adults make little children the targets of abuse in so many ways that some commonly promulgated broad, abstract categories of abuse—physical, emotional, sexual, and neglect (*About preventing child abuse,* 1989)—although a convenient typology, overlap and fail to convey the unending variety of real-life abusive situations that children live through, and that flowed through the staff's and mothers' narratives without prompting or questioning. For example, verbal abuse through belittling, constant yelling and threats, or denial of paternity affects a child's self-worth (Helfer, 1987). Any episode of abuse can hardly involve a single category. Emotional abuse of a child is part of every abusive act, and sexual abuse must involve all four of the published typology categories. How could it be otherwise?

Neglect of supervision even occurred in the shelter with the mother present; for example, a 3-year-old was observed in a partially filled bathtub, washing the back of her 9-month-old brother. The mother had left them unattended. When the staff told her she had to remain with the children when they were in the tub, they noted that she seemed oblivious to any danger.

Neglect of nutrition was described by one mother, who said:

The children eat vegetables but their diet is limited because most of the food stamps go for my husband's meat. He eats no vegetables or starch, takes a liquid protein and ginseng, and lifts weights.

Physical and verbal abuse were described by Tina, whose partner, the father, with whom she cohabited, ignored his 1-year-old son's overt need for help. Tina was living with her abuser in a resident hotel. After taking the frozen food out of the oven when it

was cooked, she put in on the bed and told him, "You watch Davey, 'cause he might stick his hands in the hot stuff." Sure enough, Davey did, and screamed and screamed, apparently immobilized by the pain. The father said, "I don't care if he burns his whole self up. What do I care?" and he didn't help Davey. Tina grabbed the baby and rushed outside. She found a police officer who took her and Davey to the hospital where the child was treated for burns of the hand.

The varieties of physical abuse of children by male adults seemingly could make an endless taxonomy. How do they abuse? Let me recount some ways:

He beats my son and slaps my daughter around.

He curses at my son. He has violently hit the child.

He injured my youngest daughter's leg. He has thrown things at her when she was walking the baby.

One time he slapped my little 2-year-old and left his whole handprint on her face.

I found Randy [age 7] bleeding from a belt buckle beating. His nerves got so bad he started with asthma. That was 6 years ago and he's still on medication all the time.

He smacks my son in the head every time he turns a corner in the house.

The daily shelter log included such entries as "The husband hit Pam with a bat and the daughter with his fist"; "Her father beat the child with an extension cord and there are bruises on her back and arms and all over." One resident told another that her husband had beaten her 7-year-old daughter two months before with a belt, and she still has marks all over her back. The child was caught stealing candy from the supermarket. The mother said, "I told him, 'You didn't beat her because she was stealing but because she embarrassed you.'" Another resident told this mother that she was as much at fault for not reporting the father for child abuse. The mother said, "Well, I have the two of them [children] and I knew I would be leaving the situation soon." Em's boyfriend started abusing her daughter when she was 9 years old. He slapped the child around, pulled her hair, pushed

her down, and kicked her "until she started to stand up for her rights." A woman said that her abuser hits the children also. He picked one child up and threw him to the next room.

Mae, another resident, described this scene:

Well, that night, he held a gun to my head. I was laying in bed and he came home drunk. He got the gun out of the closet and he seen me in bed. And I had my son in my arms just then. He picked my son up and just threw him on the bed and he bounced off onto the floor and hit his head. He got a bump but we didn't take him to the hospital; there wasn't any bleeding or anything. And he pulled the trigger to the gun but luckily, it wasn't loaded, but I didn't know and I was scared.

Even preborn children are attacked as targets of abuse. Sally said her abuser "kicked and beat me over the abdomen because I was pregnant." Visibly upset, Charlene recounted:

He beat me while I was pregnant with this baby [a 3-month-old boy]. He threatened to kick the baby out of my stomach. I had been pregnant by him before and he beat me and I had a miscarriage. After I had this baby, the beatings were still the same thing with me. He didn't harm the baby but he didn't really pay any attention to him.

Episodes of sexual abuse were identified by several mothers. Vera, weepy-eyed, related to Wendy, a case aide, "He forced my 1-year-old daughter to have oral sex." The mother said she carried considerable guilt over this, although she did contact the state's Child Protective Services about the crime and the abuser is now in jail. Another mother said, "I found sore marks near the baby's vaginal opening." Still another resident said, "My daughter was beat in the face and sexually abused by my husband." Prior to her last beating, Bertha's abuser threatened her by saying, "I'm going to kill you if you sign a complaint." This abuser was on parole and probation after serving time for raping an 11-year-old girl and trying to rape Bertha's 2-year-old daughter two years before their flight to the shelter.

Physical violence against children is frequently fueled by parents' lack of knowledge of, or lack of acknowledgment of (through drug and alcohol abuse, for example) the developmental capabilities of the children. For example, Barbara, a mother with three children, ages 7, 3, and 1, finally left home for the shelter. Marvin, her boyfriend and father of the children, had hit her, but Barbara left because he hit the children. She said, "He tried to make the baby walk. He would make him stand; if he would sit down, he'd hit him. The other children tensed up when he went to kiss them. He beat my 7-year-old daughter and left marks on her."

A night staff member, Betsy, heard a baby crying for a prolonged period of time in the upstairs dormitory. She then thought she heard a slap and went upstairs to investigate. She saw that a 3-month-old baby had a reddened welt on her face. She thought the baby was breathing irregularly, so she picked it up. The rescue squad was called to take the baby to the hospital. Betsy had to talk the mother into going with the baby. The next night, the staff asked me to speak to the young woman, Terri, an unmarried high school graduate. Staff members had not been able to communicate with Terri about the incident because she no longer viewed the staff as her advocates. This young woman came to the shelter because she had been physically attacked by her own mother in a dispute about the care of the infant. Terri said that she really thought that her baby could stop crying when she was told to stop crying, and that it would "spoil" her infant daughter if she picked her up and held her. Thus, Terri slapped the baby when it did not respond to her demands.

Such unrealistic developmental expectations created a point of dissent among the residents and staff regarding the appropriateness of mothers' starting the toilet training of their children while in the shelter. Some youngsters showed interest as a result of observing other children's potty or toilet training behaviors. Some staff thought it was an opportune time for mothers to start the training because they were not also burdened with the tasks of maintaining a household and could give much of their attention to the toddlers. Other staff thought it was not a wise idea to initiate training in a transient living situation and feared that a mother might revert to abuse if the child regressed after leaving the shelter. Mothers made the decision but were cautioned about the risks by staff.

CONCLUSION

What will the future of these children be? Will Kem Jones's 22-month-old daughter, Suzie, be resilient enough to remain as sensitive to others in her future, including possibly her own children, after the attacks on the innocence of her early childhood? Will she keep alive in her soul a spark of that innocence and love that enabled her to comfort and soothe her mother in her crises of emotional and physical pain? Or will Suzie's role reversal become patterned and interfere with accomplishment of her future developmental needs? And what about the older children and teens who have lived in violent, verbally abusive, and neglectful situations for most of their young lives? What help is there for them and their children?

It is not enough to answer, "I am not an abuser of children, so these questions are not my concern." These are all our children, "the sons and daughters of Life longing for itself," the future of our society. We can shelter and help mend their bodies, but what of their minds and souls? Beyond the current legal mandates, how can we prevent the awful abuse and neglect of children, or remedy it when it occurs? At the very least, as a society, we must develop policy based on the understanding that a child of an abused or battered mother is an abused and sometimes battered child. Although both mother and father need help to cease their faulty interaction patterns, the child needs a special kind of counseling and care to recover from multiple forms of damage and prevent its passage to another generation.

ABOUT THE STUDY

The persistent images of the children in a battered women's shelter propelled this focused revisit to stored research material that dealt with child abuse and neglect. The original ethnographic study focused on the day-to-day health needs and related issues in a shelter for battered women (Germain, 1984). Based on the assumption that people in every culture or subculture have what phenomenologists call "lived experiences," a second analysis focused on the shelter transition of the battered women from the women's perspectives (Germain, 1994). A phenomenological

approach (van Manen, 1990) was used also for this study of the children of the shelter. However, no children were interviewed, nor were mothers routinely asked about the abuse of their children. The unsolicited material about child abuse is as naturally embedded in the interviews and other dialogues with mothers and staff, in the shelter's daily shift-to-shift logs, and in my participant-observation records as it may be in the society at large.

Phenomenological research brings to awareness what it is like to live through selected experiences in situated contexts. Entering into the vicarious experiences of the abuse and neglect of little children can increase our understanding so that we may approach such societal problems with grounded knowledge that forms the basis for approaches to prevention.

REFERENCES

About preventing child abuse. (1989). South Deerfield, MA: Channing L. Bete Co.

Germain, C. (1984). Sheltering abused women: A nursing perspective. *Journal of Psychosocial Nursing and Mental Health Issues, 22*(9), 22–31.

Germain, C. (1994). See my abuse—The shelter transition of battered women. In P. Munhall (Ed.), *In women's experience* (pp. 203–231). New York: National League for Nursing Press.

Gibran, K. (1923). On children. In *The prophet.* New York: Knopf.

Helfer, R. (1987). The developmental basis of child abuse and neglect: An epidemiological approach. In R. Helfer and R. Kempe (Eds.), *The battered child* (4th ed.), (pp. 60–80). Chicago: University of Chicago Press.

van Manen, M. (1990). *Researching lived experience: Human science for an action-sensitive pedagogy.* Albany, NY: SUNY Press.

ABOUT THE AUTHOR

My very first clinical nursing experience was to care for a woman who had been attacked by her male partner with an ax. The attack left lacerations from her brain to her ankle on one side. She

ran into the emergency room bleeding profusely and, after surgery, was admitted to a private room. The brain damage left her mute and also must have propelled her to walk constantly around the periphery of her mattress. She seemed larger than life as I stood looking up at her, trying to reach her, aware of my own fright, and appalled that one human being could do this to another. That lasting impression influenced me, years later, to become a volunteer in a new shelter for battered women. I found little in the nursing literature to guide me on the subject of domestic violence, and that void led to a study of the health care needs and related issues in the shelter. The unexpected material I gathered about the children of domestic violence necessitated this further focused study.

Presently, I am Associate Professor and Chairperson of the Science and Role Development Division, School of Nursing, University of Pennsylvania. Here, I have taught undergraduate, master's and doctoral students, and have been a chairperson and member of doctoral dissertation committees. I have held faculty positions at two other universities, and clinical nursing positions as a hospital staff nurse, occupational health nurse, and nurse clinician in an urban health center. I am an ethnographer with a focus on sociocultural studies of health care settings where nursing is (or ought to be) practiced. My interest in phenomenology is as long standing as my nursing career and in recent years has been strengthened by more formal study. People in every culture have what phenomenologists call "lived experiences." As a very young student, I started repeatedly asking myself, "What is it like for people to live in these circumstances or through these experiences, and what can nursing do about them?" The place to start is by coming to know and understand our clients and patients in their own voices within their own contexts, so that further research and health policy decisions are based in grounded knowledge. My goal is that this study of the children of the shelter will increase awareness of their problems and needs, so that more effective prevention and remediation of their plight will ensue.

6

The Experience of Being a Woman with HIV/AIDS

Suzanne R. Langner

*N*ina died September 29, 1994. She was 33. I stared at the obituary and felt an ache in the pit of my stomach. My last memory of her is in the little room next to the church kitchen; she with the patch over her right eye and I, awkward, with my tape recorder.

Her voice is low and curiously matter-of-fact as she tells me about the past five years of being a woman with HIV. I fight my feelings of being an intruder and a voyeur, of something akin to shame and guilt because I, who am not infected, come here wanting to know what this is like for her. Yet, she willingly tells me—for herself, she says, and for other women as well. Her voice and her story become part of a chorus of women's voices I will hear over the next ten months as they share this piece of their lives with me; as they talk of their past life before HIV, and of how life is forever changed once they know the virus is in their bodies.

They talk about time, children, families, lovers and husbands; about safety and the bonds of friendship found in the company of women who are like them; about what it means to be a mother with HIV; about being young and facing death; and about what the disease has taught them about themselves.

FINDING OUT

The day a woman learns that she is infected with HIV is a blacked-out day, but it is also a day filled with rage, confusion, shock, and disbelief. "I was full of tears, anger. I wanted to run," said LeeAnn. Silver echoed her, "At the time, it was a year that I was clean. When they told me, I'm thinking, 'You mean to tell me I got clean . . . for this? Now I'm finally clean and I'm gonna die?'"

These women remember this day the way others remember the day of a first labor, the day a first child was born, the day of their wedding, the day John Kennedy was assassinated, or the night John Lennon was murdered. It is a day these women never forget, no matter how hard they try, a day when they are emotionally devastated.

On a hot summer day, over the hum of the air conditioner in her living room, LeeAnn looks away from me and says:

That is a day I choose to forget, but you can't. It'll never go away.

Joann echoes her:

My heart just dropped! And my mind just shut everything out. I say, I couldn't hear anything, honest to God. Nothing. My heart was down here somewhere, and all I could do was stand there . . . no, sit there, you know, in a daze . . . like, I don't believe this!

The rage, the incomprehensibility of the news tears at a woman's insides as she tries to make sense of the words coming

from the doctor's mouth, words that trample on years of trust and memories that will be now forever tarnished. Her husband has just died after being hospitalized for five days. She is told that he died from AIDS; she is queried about his risk factors. She doesn't comprehend what the doctors and nurses are asking her. They advise her to take the HIV test. She does. The day she returns to the health center is etched into her brain. She is told that she is infected with HIV. She recalls:

> *It was like everything blacked out on me. I just wanted to tear everything up that my ol' man had. But that didn't make it any different, because, no matter what, I still had this thing. But I couldn't understand . . . why didn't he ever tell me? Why did he leave me hanging like that? You know, later on, when I went to his grave, the anger came over me again. I almost couldn't see. I wanted to dig him up and kill him all over again! I did, I did . . . I wanted that.*

On this day of finding out, the woman feels terrified of dying, and at the same time she wants to kill herself—anything to ablate the pain of knowing and of dealing with the reality of what she sees as her death sentence. "It was the worst day of my life. I thought I was going to be dead in a year. And I really wanted to die—to not ever face this."

Silver, who has used intravenous drugs for 35 of her 52 years, talks about the paradoxical feelings of fear of her imminent death from the virus and the simultaneous desire to end her life. She says, "I went off! I couldn't stop cryin'. I was scared to death. I knew I would be dead soon, and at the same time, I wanted to commit suicide." Roberta, a 34-year-old mother of three young children, speaks of the moment she learned that she was HIV positive: "I was stunned. I felt doomed. Here, my husband was dying, and they tell me I'm positive. After taking care of him, I knew I would be dead within a year. I wanted to die." Something pulls her back from the desire to end her own life, as it does other women—her children. She continues, "I wanted to die, but I knew I couldn't . . . because of my kids."

BEING AN HIV-POSITIVE MOTHER

The role of children in the lives of HIV-positive women is a powerful one that sustains their energies to fight the virus. They speak of their fears as they contemplate the reality of their children being left without parents; the sorrow of not being able to see their children grow up; the struggle to find ways to protect the children from premature knowledge of their mothers' disease, and to provide for the children's safety and future; the desire to be strong and capable mothers and to live a meaningful life with their children in the time they have left. Roberta talks about this as she recalls her feelings on the day of finding out that she is HIV positive:

> *I just sat there and cried. I just . . . couldn't think about anything except my kids. I mean, I don't mind havin' it . . . I know we're all here and we're all gonna die, but it's just like . . . my baby's just 8 years old. And I just can't . . . [crying softly] . . . I just don't want to leave them here by themselves.*

Although Julene and Roberta do not know each other, the ties of motherhood bind them together. The normal expectations of motherhood include caring for children and watching them grow up, become adults, and begin to live their own lives. Both women keep their HIV positivity a secret from their children. Keeping HIV a secret allows the woman and her children to live a more normal life: the children won't worry about their mother's dying, and she does not feel burdened with dealing with their sadness and fears about her death. Being a mother with HIV, however, means that a woman is unable to feel normal, because being normal means you *will* live to see and experience your children as they grow up and learn to take care of themselves. Being a mother with HIV means that you may die before your children grow up. Holding the secret drains a woman emotionally, mentally, and physically. Roberta sobs as she tries to explain her sadness:

> *Just like . . . my whole life is just . . . like . . . I was lookin' forward to my kids graduatin' from high school, goin' to college, grandkids—and it's just . . . it's all over. It's all over. It*

scares me that I'm going to die, maybe not this year, but in just a couple of years when my baby will only be 10 years old.

Julene looks at me with dry, sad eyes and says:

I couldn't believe the fact that I wouldn't be here to see my kids grow up. That was my job—to be able to see them as adults and being able to take care of themselves . . . what really saved me was my kids. But now, the truth is. . . .

Her voice trails off.

Being a mother with HIV pushes a woman to think about who should know she has the virus. She thinks about her children and how that knowledge will affect them. If she decides to keep her HIV diagnosis a secret from her children, it means she must be careful about whom, among her friends and family, she can tell. People talk, and if the children find out, she worries that this knowledge will rob them of their childhood. Julene talks about the burden of keeping this knowledge a secret from her children. She is emphatic, however: she will not tell them until she becomes visibly ill and can no longer act as a mother.

I don't want to take their childhood away from them. I want them to enjoy it—climb trees, do anything they want to do to be a kid. Because if it screws me up mentally, how will I take them to a shrink too? I can't take that pressure too. I can take all that "Mom!, Mom!"—you know, everyday stuff, but I can't take them all upset, and every five minutes looking to see if I'm breathing. I want to give them their childhood!

Roberta tells her oldest daughter, who is 17 years old, but she is clear that the younger children cannot know yet.

I'm not ready to tell them. I don't want to do that. My 17-year-old . . . I'm tellin' you, she's great; she's handlin' this pretty good. But my 8-year-old and my 11-year-old, . . . I don't want them goin' to school every day thinkin' that

Mommy's goin' to die today—or that she's gonna die soon like Daddy. I don't want that. I want them to have a life. I want them to go to school and concentrate on what they have to do. And worryin' about me every day . . . every time they would hear me cough or something like that, they'd be right under me. I want them to have a life. And not have their life worryin' about me all the time. I'm the mother—I'll worry about them. They don't have to worry about me right now—they're just little kids.

Being a mother with HIV means thinking about the children's future, a future that does not include the woman. She thinks about who will care for the children after she has died. She makes decisions and preparations that surprise her, because she never thought she would ever have to think of these things—at least, not for many years. Her consciousness is pierced by the reality that her life will end before its time, and that others will watch and, she hopes, guard her children as they go through life's rites of passage and past its milestones. She prepares a will, a durable power of attorney. She talks to her mother, a sister, a devoted friend about what to do with and for the children after her death.
 Julene says:

I deal with what is. I got the will and stuff together for my kids. I got it together about who is going to take care of them—it will be either my mom or my sister. I have that power of attorney and living will. I did that! I just about got it all together.

Marla, who is 24 years old, lives with her mother and her 8-year-old son. Her 5-year-old daughter is HIV positive and lives with a foster family. Marla has been off drugs for over two years and talks about her children and her plans for them after her death. This 24-year-old woman, with the fresh-scrubbed face of a teenager, says calmly and with a certain dignity:

I'm healthy now. I'm clean. I did it myself and I'm proud of that, but it kind of makes me sad, because I probably won't be here when my son graduates from high school.

But I've talked with my Mom and she'll take care of him if anything happens to me. And my little girl—well, she's living with a good Christian couple who really love her. I could be selfish and take her back, but they're the only parents she's really known ... and I have to think about her, about what's good for her. I'm going to talk to them about what can happen—both to her and to me—because she's HIV too, you know.

KNOWING AND DENYING

For the thing which I did fear
* is come upon me,*
And that which I was afraid of
* hath overtaken me,*
I was not at ease, neither was I
* quiet, neither had I rest;*
But trouble came.

<div align="right">The Book of Job, 3:25-26 (1975)</div>

For some women, HIV comes as a total surprise; for others, the knowledge lurks in the back of their minds before the diagnosis is confirmed. An accident of fate or a turning point in a woman's life brings the knowledge that she is infected. The women respond in unique, yet strikingly similar ways. Although the terms HIV and AIDS were becoming part of the common lexicon by 1985, many women lacked knowledge about the virus and how it was transmitted. A woman's first knowledge that she is infected is too painful to bear; it begs not to be heard. The urge to flee—to block out the diagnosis, reality, and what it means—is strong. Nina, who was infected by her lover, echoes the words of other women who were similarly infected:

Oh God. I was ... in the beginning ... when they told me he was, I knew I was. We lived together 11 years and never used protection. They told me that I had to be checked. I didn't know what that was at that time ... HIV. I didn't think it was the kind of disease that would kill you. I

thought there was a cure for it. You didn't hear about this in 1988. I said, OK; but it took me about two months to get checked. I was pissed at him. I left him. I wanted to kill him, but he's doin' that for himself now. So, I had to find out for myself.

Roberta, whose husband was diagnosed with AIDS in late spring of 1992, waits until a few days before her husband's death in February 1993 before she allows herself to be tested. She talks about her need to deny that she might also be infected.

And then, for the longest, I denied it. I think I was just blocking it out of my mind—I didn't want to go to be tested. No! I didn't want to face it. Like . . . I can't have this! I got three kids to raise. I mean, I been married to this man for 17 years. I never cheated on him, and I wind up with . . . HIV?

When she is finally tested, it is only because her husband is dying and he keeps asking her, "When are you goin' to get your test done? When are you goin'?" She learns that she is HIV positive two days before his death. When he asks her about her results, she lies to him.

I told him the test was negative. I didn't tell him it was positive, because at that point he was so sick, I think he would have died right there . . . if he had known he had done that to me.

The woman who uses drugs and prostitutes herself to get high suspects she is HIV positive. When her suspicions are confirmed, she embarks on a frenzied period of denial that includes continued drug use and prostitution. LeeAnn, Sherri, Gina, and Marla talk about this time in their lives. Sherri says:

I didn't give a shit about anything. The only thing I wanted to do was to have the money to get high to erase all this. I didn't care who I gave it to, because somebody gave it to me! I was waitin' for that high to kill me. And I couldn't make it happen.

LeeAnn was 24 when she was diagnosed with HIV. Now, at 30, she recalls how she suspected that she might be infected well before she learned that she is HIV positive. A longtime drug user and prostitute, she is hospitalized for dehydration and agrees to be tested for HIV. The test returns negative. Six months later, during a second hospital stay for a kidney infection, her HIV test is positive.

> *My using got real bad after that. That's basically the way I shut it off. I was a heroin addict, so when I got high, I was just . . . gone. And . . . and really wanted to die—to not ever face this. The only thing that kept me from overdosing was my kids. I didn't want them to see their Mommy die with a needle in her arm. By using, I just blocked it out: "I don't have this thing—it's not there."*

Marla remembers learning she was HIV positive when she was 19, after the birth of her daughter. A cocaine addict, she left her premature baby in the hospital and, only later, found out from her boyfriend's mother that the baby is HIV positive. Although she says that she didn't understand what HIV was, she agreed to go to a local health center to be tested. She talks about this time and about her need to numb herself from reality:

> *Well, they told me I had it. It was horrible. I didn't really know anything about AIDS. I don't even remember hearing anything about it. I thought it was like a yeast infection and they could just give me a cream and it would go away. I really didn't understand at first that I was going to die from it. Then, I thought I was going to die immediately! And then I came to understand more—that it could be five to ten years before you could have symptoms. I know that now, but I didn't know it then. I thought, "Well, if I'm going to die, I might as well stay high." And I stayed high, smoking crack, prostituting myself. I wanted to die, but I didn't want to die. I really wanted to just block this out. I wanted to go to bed high and wake up high. I stayed high and doing this stuff until last June, in 1992. I decided I had enough—I just got tired.*

ASKING "WHY ME?"

Wounded and wasted,
it ain't what the moon did.
I got what I paid for now.

> Tom Traubert's Blues, *Tom Waits (1976)*

A woman tries to make sense out of her life, to understand the things that have happened to her. Being young and facing death does not fit in with the natural scheme of life. She had hopes for her future. Now, the present is filled with pain and the future is lost. She thinks about her past and how this virus got to her. The woman searches her life to find the meaning behind the crushing realization of a life truncated—*her* life, which will end before its time. She questions why she was the one to be infected. As she thinks about the past and where she is now, her speech resonates with questions about degrees of culpability.

The woman with HIV feels punished unjustly. She was always hardworking, honest, churchgoing, and faithful to her husband, and she never used drugs. In the beginning, Julene and Roberta ask over and over again, "Why me?"

> *I even blamed God. Why did you do this to me? Why did*
> *you let this happen to me? I always worked. I worked every*
> *day. I worked with retarded adults and older people. I*
> *never had no fun. Why me?*

> *I mean, I been married to this man for 17 years—never*
> *cheated on him, and I wind up with . . . HIV.*

For LeeAnn, HIV is an unjust punishment because, although she has been an IV drug user for a long time, she knows she never shared needles with anyone but her husband. Sherri wonders why she got HIV because, although she used IV drugs and prostituted herself, she never stole from anyone.

> *I was married—my husband supported me. I never thought*
> *I'd prostitute. 'Cause I wasn't much for stealin'. From my*

mother, yeah. From my husband, yeah. But from somebody else, no! So, I met my needs by turnin' to prostitution.

Maybe HIV is a punishment for doing bad things.

Well, this is what I get for bein' an addict. I just got what I deserve. What goes around comes around.

Yet, she wonders about HIV and how some people get infected when they haven't "done anything" to get it. Roberta says:

You wonder if it's a punishment by God. But then, I think, "That's stupid." We got babies being born with this and straight people getting this. I mean, having this, you know . . . it's not . . . [she becomes silent].

With time, she concludes that how one becomes infected is irrelevant. If it is a punishment for past sins or simply a random act of nature, none of it matters. What she must deal with is the reality of being HIV positive, of living each day with the knowledge that her life is different now because of the infection.

I know . . . there's nothing I can do about it. I try to . . . just keep going day in and day out, 'cause I can't change nothin'. It's here. I got it. It's life, you know—that's my life.

LeeAnn, a recovering drug addict and mother of two children, has been HIV positive for six years. She thinks a great deal about why she became infected. She says:

I get angry—at the disease. I have to learn how to channel that anger. It's real hard. Like, where do you put it? Who do you be angry at? Before, I turned that anger on myself—it was self-destruction. But, it serves no purpose. It just makes everything worse. I could really do a job on myself, you know. But, bottom line is that I didn't ask for this. I didn't know I was getting it when I got it. And even if I knew anything about it, it's not something that anybody wants! So, it

doesn't make a difference—this is what I've got to deal with—here and now.

THE SOUNDS OF SILENCE: STIGMA, SECRECY, STRUGGLING TO BE HEARD

On the breast of her gown, in fine red cloth, surrounded with an elaborate embroidery and fantastic flourishes of gold-thread, appeared the letter A.
The Scarlet Letter, *Nathaniel Hawthorne (1986, p. 50)*

Silence like a cancer grows.
"Hear my words that I might teach you.
Take my arms that I might reach you."
But my words like silent rain-drops fell.
And echoed in the wells of silence.
The Sounds of Silence, *Paul Simon (1982)*

Stigma

A woman with HIV understands stigma and shame. She feels that HIV is something she must keep secret from most of the world, because knowledge of her infection can drive people away. Rudd and Taylor's *Positive Women* (1992) resounds with the deep wounds of stigma inflicted on a woman who has HIV/AIDS.

Each woman in the support group has experienced the pain of feeling like an outcast. She knows that there are risks to disclosure. She risks being labeled unclean. She risks rejection and abandonment. She risks losing what little voice she has. She knows that simply being a woman places her on the margins of her society. "Well, you know, for women, it's kinda shaky in this society anyway," says Silver, as she talks about trying to clean up her life after long years of addiction, of tentatively letting herself be touched by others and reaching out in return, of dealing with a terminal illness and struggling to be heard by the doctors and nurses and all the other people who "are in the AIDS business."

There is stigma attached to this, where you're set apart and won't be accepted or will be abandoned. I try to make it so I won't get depressed. Sometimes I can't help it.

A woman who uses drugs and has been abused and is HIV positive knows what it means to be abandoned:

I have tried just about everything. I have seen just about everything. I have seen death. I was brutally raped two years ago, with my throat held off. And I saw myself layin' on the ground—dead.

Another woman says:

I've been an addict for 35 years, but I'm clean now for a year. [She looks away and then speaks softly.] You see, my family didn't really want to have anything to do with me. The only one that kind of tolerated me was my mother's mother—and that was only sometime.

An HIV-positive woman is afraid that people "outside" can tell she has HIV. As she lives with the knowledge that she is infected, she adapts her everyday life in order to protect herself from letting her secret be known. Nina explains:

I don't like to go anywhere during rush hour, or, like, early in the morning when people are going to work. I don't like to be on trolley cars or somethin' like that. I don't like to be around too many people. I get paranoid. I think somebody . . . "Oh, oh. She's got AIDS." Although I know you can't really tell, but . . . it's like . . . you're still afraid.

Secrecy

The secrecy surrounding HIV/AIDS stigma is different from the HIV secret the woman holds from her children. Keeping the children ignorant of her infection allows the woman to feel that she

is not interrupting their childhood; that she is continuing to act as a responsible parent by not burdening her children with the knowledge and fear that their mother will die. Keeping HIV secret from the children buys her time to get her affairs in order and to plan for their future. By contrast, disclosing her diagnosis of HIV to friends and acquaintances carries the risk of rejection and abandonment. While keeping silent creates pressure for the woman, she is afraid that breaking the silence will make her life worse.

I've got to pretend with them, because if they knew I had it, I couldn't be around them—because they wouldn't be around me. So, I'm pretending. And, as I say, it puts such a strain on you mentally, where other people and society as a whole they pressure you and can make things worse. . . . They don't understand. It's the fact that I have to be so secretive . . . it's like holding the biggest secret you ever had. And you can't tell no one. It's rough. It's more than rough.

Joann talks about telling her boyfriend that she is infected.

I did have a boyfriend then, but he was negative. I told him—I had to, you know, because he had to know what he was dealing with. And I knew it was going to come to this, but because he was . . . like . . . talking to some of his friends and stuff, or be playing basketball and what not—somebody told him that you could get the disease through your sweat. For a little while he stayed with me, but not long. After a while, he just stopped coming around. Stopped calling me. I would call him and he would say he's coming over—and never did.

Marla says:

You can't share with the people out there in the world. They'll mark you. Out there in the world, they don't understand. "Oh, my God! She's got that disease. If I touch her, I'll die."

Struggling to Be Heard

The women's voices cry out against the silence imposed on them by the nature of their gender, by society's rejection of them because of the ways in which they were infected with HIV, and, finally, by the contagious, incurable virus itself. Regardless of her station in life, or how she contracted the virus, a woman feels like a social pariah. She depends on doctors and nurses to help her with HIV, and at the same time learns that they are human and do not know everything about the virus. Emma, who is a middle manager for a large communications company, says:

This experience taught me something. I used to accept a doctor's orders without question. After all, he knew best, didn't he? I realize now that doctors and nurses are human, and that I should not be afraid to question or complain about something as important as medical treatment.

In the process of learning about HIV and caring for herself, it is common for a woman to feel discounted. For many women, this is not a new experience. LeeAnn talks about the way she was told that she was infected with the virus.

They don't know what to do with you. They don't know how to tell you what you've got. I got a call from my gynecologist. He said, "You better sit down." I say, "Why?" He said, "Sit down." "Am I going to die?" He said, "I don't know."

Joann, a woman who was infected by her partner, says:

I had gone back to my doctor to get the results, and what happened was he came out into the waiting area and gave his nurse an order. He told her to call me because he wanted to see me. I was sitting right there and he didn't know who I was or that I was even there. What he said to me was, "You have AIDS." I blanked out. You know, to say something like that? And then he said, "I can't treat you anymore." That was it.

The women struggle to have their voices heard. Silver says:

> *And sometimes I really get frustrated for myself and other women. And we do complain, I know. But we are afraid. And most of us, when we complain, we've really let it go for a good while—almost until its worst stage, because of the way they treat you. "Oh, you don't know what you're talking about." Well, they don't know what* they're *talking about! They really don't. They could learn something from us, if they would just sit down and be patient and listen to you. But most of them say, "Well, what do you expect? You have the virus, you know." They tell me it's because of the virus. Well, stop blaming everything on the virus—which they really don't know much about, especially what it does to women!*

Silver's voice is echoed.

> *I don't want to be a person that complains, but when I go to the doctors, I want someone to listen to me!*

A woman with HIV begins to think about why she is taking medications; about being experimented on and about whether drug companies are telling the truth. Is she being used as part of an experiment because she is a woman? Because she is a drug addict and an alcoholic? Silver talks about this fear openly:

> *They knew I was a terrible addict. I felt that, at my age, they said, "Well, we'll give her the virus and use her as an experiment to help women that are not out there mutilating and abusing their bodies and using drugs and acting crazy."*

Gina and Julene add their voices to the suspicion that women, especially women with HIV, are being used by the medical establishment:

> *I see them [physicians] once in a while. They don't do nothin' 'cept stick me with a whole bunch of needles and*

want you to take a lot of pills . . . which don't seem to do no good, anyway.

I don't take any medication right now. They keep telling me I should. But, you don't know if you're pumping more poison into your body. You know that experiment they did on black men? Well, . . . [her voice fades off].

BEING CONNECTED

A woman who learns she has HIV feels alone and disconnected. The woman who belongs to a support group finds safety and comfort in being with other HIV-positive women. The support group is a safe place. It becomes a sacred place when she learns that she can trust the others here, that she can be accepted; she can love and be loved in return. Julene explains:

I tell you, if you're between God—and God is as powerful as anyone—I'd put this place right next to Him. Because, this is what saved us. It's what saved me. It's like pullin' yourself up from a deep dark hole and cleanin' it. It's like my whole inner thing is clean. And when I leave the group—well, then I pretend again. I've got this sad place inside me, and I just deal with it, until I grow out of it—or call my therapist or I call one of the girls, and we talk.

Marla, who is 24 and whose short life has known brutality, drug abuse, prostitution, and early motherhood, describes what it means to be connected at this time in her life:

I can come here . . . and everybody *in this room is just like me. And that makes me feel good. I'm not saying that it's good that we have this disease, but good in that I can share with these people. You can't share with the people out there in the world.*

Sherri, who lives in another city, talks about her feelings of being part of a family for the first time in her life.

It's this here group. I feel I'm wanted. I'm not looked down upon. They're my family now. I don't think of my other family—I'm cut off from them anyways. They don't want anything to do with me. Don't even want to see me—had their telephone numbers changed and everything. The family is right here in this room. These women are my family.

A woman feels that when she is in the group, she can be herself and feel like she did before she was diagnosed.

I can let everything out. Everybody knows what's goin' on. I don't have to hide anything from nobody. You don't have to watch what you say. You can just be yourself like you were before the virus.

The women teach each other about HIV, about its symptoms and how to differentiate HIV from everyday aches and pains. Silver elaborates:

I've learned a lot from this group. If I had a headache or somethin'—it's on this side or it was usually on that side . . . and I was havin' a fit. But I wasn't sayin' it to the doctors. I was sayin' it to the people in here. So, when I came here and I learned, and I met all the other women and actually seen a lot of them being so close to death . . . they help sort things out. Listenin' to their stories and how they came about it, and the sicknesses they have actually been through. And they can still laugh and smile.

Julene, who is in the same group with Silver, agrees:

That first year, I'd think, my God, is this from the virus? Being here helped me to learn little by little. Like when I first came to the group, I was still thinkin' that I was gonna die, so I was speedin' it up—eatin' all this food to get fatter and fatter, because I thought the weight was going to do it. You know, you live longer if you have the weight on you. But as I started talking to the other ladies in the group, I found out we all felt the same way. We learned from each

other. It's because of this group. It's not because of the doctors . . . and I know that they are doing a wonderful job . . . but this is what holds it together for me.

Through the connection with other women with HIV, a woman finds that she has special knowledge that she can use to help others. Being able to be there for someone else who has no one brings a woman comfort and satisfaction. The women call and visit each other often, help one another with shopping and childcare, and listen. Through this experience, a woman finds that she comes to love that other person, even though she knows that they may lose each other. Nina reflects on her role as caregiver and educator to others.

You want to help them, you know? Make them understand the symptoms and help them through the fears. [She chuckles.] Listen, I also educated my family. I gave them literature of how you can get this, what's this and what's that. So you don't have to clean the tub out with bleach when I leave.

When they talk about the connections they have made with others during this time in their lives, it becomes clear that the experience has a profound impact.

Like Luigi, you know. He had nobody—I mean, not family-wise. I took care of him—little things, you know. I was right there. When he died, he died in my arms. Me and John D. And now John D. passed.

Sherri, too, talks about the bittersweetness of being HIV positive and the feelings that come with caring about others.

Today I can say . . . seven months clean and working, volunteering, taking care of my friends, I'm happy with where I am today. But I'm thinking about Sarah—can't get her out of my mind. I'll call her. I'm gonna be real sad, I'm gonna cry when she goes. It's all real—that's the thing. It's just going to keep on going on. That what's really sad—to

say goodbye to another. Then there's going to be another and another and another and another and another and maybe . . . someday me.

Having HIV and watching others die from it brings it home to a woman that it can be dangerous to allow herself to get close to anyone, because they too will die and she will be abandoned again. Yet, after a while, the woman becomes accustomed to the fact that people she loves will die. Nina's voice is hollow and quiet:

Living in that group home, you see a lot of people die. It was, "Well, I don't want to get close to nobody else." People just dyin'. Then you get so mad and pissed off at people dyin'. But then you get used to it—because there is nothin' they or you can do. You try to not let anyone else into your life.

LIVING IN THE NOW: TIME, BODY, AND RELATIONSHIPS

A woman experiences time, her body, and relationships with others differently when she has HIV. Before HIV, she took much for granted. HIV has changed all of that. She experiences rage and sadness, and grieves for the loss of an envisioned future. At the same time, she talks about "gifts" she has received and "lessons" she has learned as a result of having HIV.

Time and HIV

*Hold Infinity in the palm of your hand
And Eternity in an hour.*
 Auguries of Innocence, *William Blake (1955, p. 608)*

In her book, *Muses from Chaos and Ash*, Vaucher (1993) speaks of artists' sense of immediacy and time in connection with HIV. The cross-cultural collection of women's stories by

Rudd and Taylor (1992) is also filled with the women's sense of how they live in the life left to them.

The women in the support groups talk about how time has changed for them since they confronted the reality of HIV. Julene's voice echoes and blends in with all of the women's voices as they talk about their perception of time since HIV. Time is truncated, quickened with a new dimension of urgency for a woman with HIV.

> *If you really stop and listen—because before this ... you know, tomorrow is really not promised to you. We really just take it for granted. Trust me. I did too. Where a lot of bull is not worth it. Just deal with what's happening right now. And other things ... like I used to get so worked up when I couldn't pay a bill or whatever. I say now, "Look, that bill is going to be here when I'm dead and gone." I'll juggle.*

The knowledge that her time to be alive is uncertain and fleeting is a painful realization for the woman. She knows that she will not live into her 70s or 80s; that she may not see her children grow to adulthood; that her hopes for her own future are diminished. She feels that HIV cuts her life off before its time. Roberta talks about the way she views time now, with HIV:

> *I don't put things off. I don't take things for granted. If there's anything I want to do, I do it, instead of saying I'll wait until next year or two years from now. I just don't take nothin' for granted no more. I see life in a different way. I think life is precious. It's something—you should take it! Enjoy it—don't put it off. You learn you shouldn't take it for granted. You shouldn't say, "Well, it's just another day."*

She goes on to recount an episode that magnified her perception of time. What might be a relatively easy rite of passage for others, is pregnant for her with how important time has come to be. After her husband's death, Roberta learns how to drive and goes to take her driver's test. Everyday events cannot be dismissed

lightly, because time is precious, and she has a lot to do. She laughs as she recalls that day:

> *I went down for my license. And the first time I went down and I failed. I felt like tellin' the guy, "Look, it's not like I got all year for this! I don't have that much of my life now. I got HIV—just give me the damned license and be done with it!" I was, like, "You know, I can't be comin' back here, comin' back here." But, you know . . . it's crazy [still chuckling].*

Marla also talks about having taken life, and especially time, for granted before she contracted HIV and stopped using drugs. Her past, present, and future are represented in her statement of how she views herself and living in the *now:*

> *I don't take anything for granted now. I don't put anything off. Like, before, I thought about going to nursing school, but I kept putting it off. I don't do that now. If I want to do something that I know is going to be good for me or my son, I do it now. Because I may not have another time to do it. Because I don't know how I'm going to be when the last stages of AIDS are on me. I think about that, especially when I see some of my friends dying from this. But then, I think that I can't afford to think about that. I need to get as much good out of life as I can—and I have to do it now.*

The mundane activities of everyday life take on new meaning for the woman with HIV. She is more aware of her physical surroundings, of the way the world looks. Simply walking her dog becomes a vehicle for experiencing the world with more clarity and wonder. She is aware of how easily and quickly life can be taken from her. She finds that she does not take anything for granted anymore.

> *Like, before, it's like everyday livin'. You wake up and go to work, come home—do what you do. But now, when I open my eyes in the morning, the first thing I do is look at the sky. And I can see that sky—with my puppy dog at the side*

*of my bed. I just look right up—take him for a walk. And
while he's walkin' I'm lookin' up at that sky... because
there's so many people... they were so young. Why, Luigi,
he was 28 years old. There were others—they were 24,
26—they didn't even begin life, really, you know. When I
wake up every morning and do for myself, I thank God for
it. 'Cause you just can't take it for granted anymore—you
don't know what may happen or when.*

A Woman's Body and HIV

A woman experiences her body differently after being diagnosed
with HIV. As with time and relationships, before HIV she took her
body for granted. She paid little heed to changes in her body; she
abused it, ignored it, and often pushed it beyond its limits. Now,
she listens to her body. She understands that her body gives her
signals about how she must take care of herself. Her body senses
are sharpened by the experience of HIV.

*It's hard. It's harder on some days than it is on others. Feel-
ing like crap and not having the energy to be outside and
play with the kids—or cook their dinner. I've learned, for
me, that I have to take time out and rest—to listen to what
my body is telling me. There's just not enough energy left to
do everything. And I have to learn how to... and I am
learning from myself and other people. I call my girlfriend,
who's also positive. I just have to fall on my pride and tell
her what's going on. "I feel like shit today. Tell me that it's
going to be better tomorrow."*

The theme of listening to body signals is repeated over and over
again by the women. With time, the woman with HIV becomes
comfortable in the conversation with her body; she learns to pay
attention and begins to differentiate HIV-related symptoms from
other illnesses.

*I'm more sensitive to how my body feels now. Before, you
know—every ache and pain... now I can tell if it's be-
cause of the virus. You have to listen to your body. It's*

telling you stuff and you have to listen. You listen differently than you did before.

Julene elaborates on how she has experienced and responded to her body over the six years that she has been HIV positive.

In the beginnin', I was still livin' with workin' all the time. I was a workaholic, you know. So, I never stopped to listen to my body, to know I was tired. I thought, "I can push a little further—I can push myself." But now, I have that time where I can listen to it. When my body is tired and somethin' is wrong, or if I feel a little different, I know to call the doctor and ask, "What's what?" Whereas, before, I didn't ever listen. It goes in phases, you know. Like somedays, I'm OK with my body. I'm rollin' pretty good. I get up and I'm happy. Then the next hour or so, I'm shut down. It's like the virus, all of a sudden, got me, and I'm really weak.

As she becomes more familiar with her body and the physical ups and downs associated with the virus, she becomes more philosophical about the tricks her body can play on her. Her body can fool her into thinking she is going to die from HIV, when, in fact, she has something more common, less exotic, something that can be fixed.

Silver, who is 52 years old, recounts her frustrating experience of having mood swings and night sweats and difficulty with concentration. The physicians insisted that her symptoms were related to HIV. She persisted, however, and was tenacious in insisting that the symptoms could be due to something else. After a year, there was agreement that she was going through menopause. Her symptoms were almost immediately relieved when she was given hormone replacement. In *La Visite inopportune* by Raul Damonte Copi (1992), a Parisian actor, Cyrille, who has AIDS, is visited by his physician.

"Nothing grave in the last few days?" he asks.
"Only two heart attacks and a coma," replies Cyrille.
"Very good indeed, indeed much too good," the professor observes. "You should have been dead six months ago."

"Realistically," Cyrille asks, "when am I going to die?"
"You'll live," replies the professor, "as long as your AIDS
does." (p. 105)

In a similar vein, Roberta recounts, with a certain amusement, her brief hospitalization to have her gall bladder removed.

Who knows, if I were to die, it might not be from HIV—
could be from kidneys or gall bladder or something else.
Having this and survivin' it was like a test. I said to one of
the girls in the group, "I went into the hospital and it had
nothin' to do with my disease!" I'm almost thinkin' that the
only thing that can go wrong with me now is HIV. You can
have other problems with your body. I really felt, after
that—if anything happens to me, it'll be HIV now.

Relationships, Self, and HIV

You know I've heard about people like me,
But I never made the connection;
They walk one road to set them free,
And find they've gone the wrong direction.
<div align="right">Crossroads, Don McLean (1971)</div>

For some women, HIV confers a new sense of self; for others, it validates and strengthens their view of themselves. The woman who was a drug user or a prostitute and who is trying to stay clean experiences a sense of rebirth. Marla, at 24, talks about the "gift of life" that HIV brought to her. She feels a sense of accomplishment; she has triumphed over pain and despair even as she knows that her time is running out. She describes her feelings about herself and her relations with others:

I overcame my downfall. I'm not like I used to be. I'm a
new person—inside and out. And now I see things clearly—
like they're supposed to be. Before, I used to be so fogged up
in my head, you know, I couldn't think straight. My mind
couldn't stay on one thing—it would be this-this-this. But
now, I'm content with myself and I'm content with my life.

I wasn't before. I was scared. There were times I just wanted to lay down and die. And then, I'd be all right after I'd die—I was so hurting. And now . . . [she weeps], I thank God for that—it's as though my soul died—and that's not the way it is anymore. It's alive again. It's like a rebirth. I never knew I could be like this. Before, I was just out for me, to get what I wanted. I never meant to hurt nobody in the process, but if you got hurt, then you just got hurt. It's what I wanted that counted. But, I'm not like that anymore. I'm not out to hurt nobody. I'm different. In fact, I'm out to help people now as well as helping myself.

LeeAnn thinks about herself before and after HIV. She understands that, before HIV, her sense of self was badly wounded; using drugs, prostituting herself, and allowing herself to be abused by her husband fragmented an already fragile self. Nonetheless, after being diagnosed with HIV and suffering through two relapses into her drug addiction, she is now in her seventh month of recovery and she recognizes that she has untapped strengths.

My self-esteem was crappy before. I know now that I'm a strong person. What scares me, though, is that I can't always fix things. You know—like the little things . . . a major trauma, OK, but spill a glass of milk and I lose it. Like, put a rock in front of me and I can move it, but put a pebble in front of me and I'll trip over it. But the more I talk about it, the more I find out that there are a lot of addicts like that—very crisis-oriented. I can look at that now and realize that I have to take a look at what I'm doing. I have a lot of self-esteem now. I think it was there all along, but somewhere I lost it—in the HIV and the addiction. I think now that I deserve good things. I deserve to live a full life, and that it's the quality and not the quantity.

Along with time, the woman feels that relations with others are more important now than ever before. The relationships must be "real," however. The woman feels that she cannot afford either

the time or the energy to be frivolous in her interactions with others. Before HIV, she was not always aware of her self as being important. She often held back her feelings or committed herself to doing things for others, for fear that they would stop caring about her. Now she thinks that people either like her or they don't; her feelings are valid and she can tell someone what she thinks without being afraid.

> *Well, before this, I'd let people take cold advantage of me—take my kindness for a weakness. And I realized that I put everyone else first. And then when I found out that I had HIV... now, you know, I try to put myself first. I don't make any commitments that are unnecessary. I know I need to think about myself now—because of the fact that, without me, my kids won't make it. It's too bad that I had to wait to get the virus to know this, but I know what I can handle with other people and what I can't handle. Sometimes people who've known me for a long time, but don't know about the virus, say, "My God, your mouth is sharp—this isn't like you."*

Roberta characterizes her view of self before and after HIV as being relatively unchanged, with the exception that she can no longer be taken advantage of more than once. She sees herself as always having been a strong woman, one who did not shrink from work, responsibilities, or the realities of life. HIV is a shock, however, as she faces the loss of her husband, experiences feelings of betrayal by him, and deals with the fact that she is infected. She draws closer to her daughter and other family members; she receives solace from the support group and learns to open herself to others with whom she feels safe.

In a similar vein, Nina, Silver, Sherri, and other women think about themselves as always having had a certain strength, but feel that HIV has made them stronger. HIV confers a unique experience on the woman, as she faces the loss of loved ones as well as her own life. Time, knowledge of self, and relations with others become more precious. Irony frames the relationships between the woman and others in her life.

I think I'm a better woman for going through this. I don't like to think of myself like that, but it's true. Because I experienced a lot of deaths with havin' this virus. And I know that if I didn't have this virus, I wouldn't have experienced that. I lost friends and people I really loved, and it made me have an outlook on life—that I thank God that they was in my life when they was.

Roberta is a widow of HIV and was infected by her husband. She works full-time as a nursing assistant and takes care of her three children. She has always viewed herself as strong and capable, with the goal of being as independent as possible; she acts as the giver rather than the receiver. She finds herself silent and somewhat detached from the other women for a long time after she joins the support group. As time passes, however, she becomes more comfortable in the group and recalls a trip she made to Atlantic City with two other women. The trip was fun for her, "And there we were in Atlantic City, just havin' a ball." Like Nina, she recognizes the irony connected to the relationships she has with the women in her group.

It's amazing to think about it. If we didn't have HIV, we wouldn't have met each other. It's a sin to say that, but it's the truth. Even with everyday stuff, I can come in here and share.

Can you remember who I was,
Can you still feel it?
Can you find my pain?
Can you heal it?
Then lay your hands upon me now,
And cast this darkness from my soul.
For you alone can light my way.
You alone can make me whole once again.
 Crossroads, *Don McLean (1971)*

At some point, the woman with HIV faces her feelings about romantic relationships. The need to be loved romantically, to love another person in a sexually intimate way, remains, regardless of

the virus's presence. This is potent and painful ground for her, especially because she knows that her body contains a lethal weapon. The woman's feelings about her sexuality and how that plays out in a love relationship are fraught with ambivalence and longing. The woman doubts that she will experience another romantic relationship before her life ends, and she states her case poignantly:

> I loved my husband, but I felt betrayed by him. That's why, now, when people ask, "You going to get married again? You going to get a boyfriend?", I think—I wouldn't put nobody through this—even if they used protection. I wouldn't put nobody through this. I really wouldn't. So, I'll stay by myself until the day I die. I won't sleep with anybody else until the day I die.

She goes on:

> To sleep with somebody, and to think they could catch this from me . . . I would be so hurt. It's like killing somebody. I got this . . . this bomb just waiting to explode—and I could give it to you!

Joann, who was deserted by her boyfriend after he learned that she is HIV positive, is devastated by his rejection. Although she isolates herself in her house as a form of self-protection, she longs to be in an intimate relationship with a man.

> I've really counted myself out. I want to meet somebody, but suppose I meet somebody and then I have to tell them I have the virus. How would they react? Would they take the news back to wherever they came from? You know. I can't take it, so I just stay by myself unless something real good comes along, and right now it doesn't look like it's gonna happen.

Other women, like Sherri and Silver, are content in not having a romantic relationship. Life before HIV involved drugs and men,

and they find a relief in not being consumed by those desires any longer.

> *It's OK to not have a man in my life. I don't care if I never have sex again, really. Through prostitution and all of that . . . sometimes it was good when I was high, but it was a means to an end. If I could find a man who doesn't want sex—fine. [She laughs as if this is an absurd idea.] Truly, I don't want it.*

Emma, LeeAnn, and Nina are in relationships with men. The three women entered these relationships after finding out they were HIV positive and with the full knowledge of their partners. The relationships are a testimony to life as well as validation that they are wanted and supported in a significant and meaningful way. There is a bittersweet undertone to their conversations as they talk, with wonder, about how much the relationships mean to them. They know there is a price for this happiness. Emma, a widow who was infected by her first husband, marries for a second time. Her husband is HIV negative. She says:

> *I cannot put into words how blessed and lucky I am to be with Jim. I truly believe that my asymptomatic status is a direct result of his love and caring. Having a wonderful relationship with someone was something I believed would never be available to me again.*

She adds:

> *The effect of my medical status on Jim is, as expected, staggering. It has impacted our sexual relationship because we have to be so careful. I can't have children and that makes me sad since Jim has no children of his own. We would love to have had a baby. But I know the biggest worry he has is the possibility that he will lose me. I remember too clearly watching someone you love die slowly. It is very difficult for me to think of Jim having to go through such a sad, painful process.*

LeeAnn is divorced from her husband and now lives with Jack, whom she met through Narcotics Anonymous. Like other women, she has known rejection and suffering in her life. She describes her past relationships with men:

Every man I've ever been with has abused me, beaten me, mentally abused me ... whatever. And they always would throw it at my head. "You're not good enough. I'm the only person who would ever love you." Like that. And so, when I got HIV, it made it even worse. Now I was really dirty. No one would ever want me. It was just best to stay where I was. So, it was the drugs—that's where I stayed.

Now she has been clean for almost a year. She has worked hard to change her life. She and Jack live in a neat and nicely furnished rented home. She expects that her 12-year-old son will come to live with them. As she speaks about her relationship with Jack, she smiles and the fatigue fades from her eyes.

He was a gift to me. He was something I gained from all of this. He helps make me feel like ... like, just maybe I'm worth something. We're honest with each other and we respect each other. The way I look at it ... I don't really know how much longer I have. And I want to enjoy what I have. Jack is part of that. We have each other to worry about— that's a little scary.

Nina, who was infected by her lover, and six years later continues to feel tremendous anger toward him, married an HIV-positive man. The relationship and the marriage take her by surprise. She did not expect to fall in love with someone or to be married, with this diagnosis. She laughs as she shows me her wedding pictures:

It's ridiculous, is what it is! Being married with me full-blown. We can't have any children, but before we have sex, I want to use my condom and you're gonna use your condom. It's like ... it makes me feel like I'm wanted, you know. I mean, when I walked down that aisle, I couldn't

believe it. I was in shock! Because I thought I was at the end of my life. When he asked me to marry him, I thought, "Huh? What kind of life are we gonna have?"

She pauses and then says:

What will we do when one of us gets sick? You know, you think of things like that. It's a burden, and that's one thing I don't want to be. I ain't been sick yet with him. But I see him losin' a couple of pounds or somethin', I get worried. I didn't figure I would be able to do that—worry about another man again. But you know, you can't help that when you love someone. You can't help that—it comes with the territory.

Regardless of the context in which the HIV-positive woman views relationships and herself, she needs others. The others may be a child, a sexual and lifetime companion, or other women and men with HIV, but her needs for affiliation are important as she lives through this experience. Relationships with others are woven into the fabric of being HIV positive. Although painful and unrelenting in its reminders of her mortality, HIV brings an unforgettable context to the woman as she struggles to move through her days and to make them count.

LIVING WITH HIV

She takes just like a woman.
She makes love like a woman.
And she aches just like a woman.
She breaks up like a little girl.
 Just Like a Woman, *Bob Dylan (1970)*

Living with HIV is ironic; it is a dynamic state that is filled with paradox. A woman experiences that HIV cheats her out of life and, at the same time, brings rebirth. Life is different now, compared to before HIV. Living with HIV and facing death makes life clearer and more precious. Emma says it simply:

Among all the terrible effects of contracting this disease, AIDS has offered me one small gift. It has made me deeply appreciate life and all it offers.

The new appreciation of life is not without its pain. While the woman sees life more clearly now than before HIV, it also brings her sadness. Gina talks about the years of feeling that she was a "loner," of having lost contact with her only child, of her regrets at waiting too long to get clean of drugs, and now of living with HIV.

It's like blinders come off. But, you see too much. It's like you have been given more power—to see through a lot of things, whereas before, you didn't give a damn. And it causes you to look into too many things . . . [her voice trails off and she looks away from me].

Sherri, with gut-wrenching honesty, hammers out the truths she knows about herself and how they relate to her current everyday life.

Well, I found out about honesty with sobriety. Once you're honest with yourself, you can be honest with others. And if I'm gonna start lying and not being honest with myself, well, then I'm gonna start saying that I'm not an addict. It's easy to get into that dishonesty, you know, and not be honest with yourself. Well, I have to be honest with myself. I have to be real honest and know that I am an addict and an alcoholic and HIV. All these things, I have to accept. It's daily work, and hard work!

A woman can never forget that death will come; yet living with HIV has made her search her soul, discover her strengths, review her life and past hurts and injustices as the means of uncovering her resilience and finding peace in herself.

I live with this today. I don't die with it. Before, every day, I was dying with this . . . until I got honest about it. I'm really scared to die [her voice quavers]. It's hard to admit

that I'm scared of this disease. I've always been . . . like, real tough. And now I feel real weak and vulnerable. And I don't like it. But I'm working through it. And I'm finding out that it's OK to be weak and vulnerable because this is a scary disease. I'm scared of the pain I might go through. Facing my fear was probably the best thing that ever happened to me—to get real with the fact that I'm scared and it's OK to be scared. Because, I don't think there's anybody out there with this who isn't scared.

Although the image of death is never far away, the woman with HIV comes to understand that life must be placed into a perspective. She assigns priorities; she learns that everyday hassles need to be sorted out, because unnecessary and trivial irritations can make her feel worse, more vulnerable to the virus.

I have figured it out, that I'm not going to let anything aggravate me. Because when I get aggravated, my legs hurt, my back hurts—maybe it's psychological, but this is a disease of the mind as well as the body. The other thing is—I can't dwell on everything bad because of HIV. There's more to my life than that.

For the woman who used drugs and is in recovery, the diagnosis of HIV pushes her to consider her life in a deeply visceral way that she has never experienced before, even though she has gone through drug rehabilitations in the past. Sherri has diagonal scars almost an inch long on the inner aspect of each of her arms. The scars are from a failed suicide attempt a year earlier, when she took an unknown amount of pills and slashed her arms in a frantic effort at ending her life. She survived and remembers waking up in the intensive care unit and crying out soundlessly to God:

God, you won't let me die, so tell me how to live, please! I can't keep going on.

She feels that this last effort at death was a turning point for her, even though she was HIV positive for several years by this time. She feels that now, at this time in her life, she has found a place

for herself, a place where she experiences satisfaction and a sense of fulfillment as she shares her experience and knowledge of drug abuse and HIV with others. As she says:

I've been around the world and back. I am what I am and I can't undo any of the past. I think I had to go through all this to get to this place. I don't think anything would have made a damned bit of difference. I have to take the cards that has been dealt to me—one day at a time.

The woman with HIV goes on about her daily business. If she is strong enough, she goes to work. She takes care of children and grandchildren and she looks after her friends who are sick or worried. She buys groceries, pays her bills, and works hard to get her life in order in the time she has left.

I have to take things a little at a time. This is what I have to do for myself to live longer. I would like to be here as long as possible. Another thing, there was a time where I said that one of these days, I'll go on a trip—I'll think about the future—one of these days—stuff like that. But now, the truth is, this is what I deal with: the stuff's that gotta be done. I got the will and stuff together for my kids and for whoever is going to take care of them—my mom or my sister. I have that power of attorney and living will. You may think it's morbid, but I did it. I have to do it. I just about got it all together.

The notion of the future is ever present for a woman with HIV—perhaps more so than for a woman who is healthy. A woman with HIV thinks about what can never be, even as she must occupy herself with the everyday tasks of life. Emma's words resonate with those of the other women as she talks about living each day and thinking about the future:

What do I think about my future? Well, I don't allow myself to think about the long term, like ten years from now. Planning for more than three to four years away just doesn't seem to apply to me.... So, I am learning, very slowly, to

deal with the idea that I am going to die very soon. I want to be able to deal with death, its practical aspects (memorial services, wills, cremation versus burial) and its emotional aspects, with those I love. I want there to be closure to my life. I want to have said goodbye to those I love and to have resolved any open issues in my life.

LeeAnn tells about how a conversation she had with her lover one evening upset him. She tried to soothe him as she explained that it was essential for her to plan ahead if she is going to live in a meaningful way. She says:

One night we were talking about my funeral, and I tried explaining to Jack that I wanted to bare all this stuff so that I could go on with my life. And he became so upset. The next morning, he told me, "I can't bear to hear you talk about you going to die." And that's hard for me, because I need to talk about it now. In order for me to accept it and for it to be reality . . . I don't want to die. I have this disease and, maybe, with any luck, I'll live to be a hundred years old. I don't think so. So right now, reality is that this is a progressive, fatal disease. I have somebody who's making my quilt. There's certain things I want done at my funeral. I want everybody to cry, and I want them to cry hard! And . . . that's so they'll grieve and get it over with. And then, I want them to party! Because I'm going to be in a much better space, when I'm gone—at the end.

There are many daily reminders of HIV in a woman's life. Medications loom as one of the most persistent reminders. If the woman is sexually active, condoms are another reminder of HIV. LeeAnn expresses her irritation at the constancy of the virus in her daily life:

When you think about it—it gets to be a real drag, like depression, you know? Every time I put one of those AZTs in my mouth, it's there. And I take those three times a day— morning, noon, and night. Every time I have sex, out come the condoms.

Joann also chafes at the daily reminders of HIV:

> *Sometimes I think I'm still in denial. Like, I forget to take*
> *my pills and then I try to double up on them. I don't want*
> *to have to think about it all of the time.*

Changing her schedule, cutting back on work hours, or no longer being able to work are other markers for the woman with HIV. Although she makes new contacts and builds other relationships, she misses the normalcy that work represents.

The woman who lives with HIV sees herself differently from the men she knows. HIV-positive women who were the caretakers for their dying partners articulate this clearly. The HIV-positive woman observes how men with HIV cope. She sees a difference that she attributes to the caretaking nature of women.

> *When my husband was sick, he couldn't do what I'm doing.*
> *Even if he wasn't sick, let's face it. He's a man. He can't do*
> *the things I do—taking care of a house and kids and every-*
> *thing . . . I feel like a mad person sometimes, you know. I*
> *need 36 hours in a day instead of 24. But, I say to myself,*
> *"What the hell—I'd be busy those 36 hours just as well"*
> *[chuckling softly to herself]. It'd be just more time for me to*
> *do things.*

LeeAnn, too, sees herself as the caretaker; even with HIV, her world includes caring for others. She laughs as she thinks about how she is:

> *And it's like . . . it's never enough. I'm a real caretaker. I*
> *have to make sure that Jack has dinner on the table. Clean*
> *clothes. And when the kids are here—I need to make time*
> *to play with them, read to them. Just . . . sometimes there's*
> *not enough energy left to do it all.*

What is striking about the woman with HIV is her determination, her tenacity, and, in a sense, her pugnacious way of confronting her illness and her world. For the most part, she is a young woman who has children as well as other responsibilities.

All of her life's experiences are utilized in dealing with the infection of HIV and its consequences.

> *There's no need for turning back,*
> *'Cause all roads lead to where I stand;*
> *And I believe I'll walk them all,*
> *No matter what I may have planned.*
> Crossroads, *Don McLean (1971)*

As times passes, the woman experiences that she is not the *virus;* she is a *person* who has the virus. She is a fighter who refuses to go down with the first punch.

> *Yes! I'm a fighter, yes! And I'm not the disease! I'm a person with the virus. Look, it's* not *going to defeat me. I've got too much to give. Lord, I thought I could spread out further, because I thought I had more time—I have to give it* now!

She learns that she has some time left. In the beginning, she was certain that she was going to die immediately. She eats everything she can get her hands on, so that she won't waste away. She buys gifts for her children, takes them on trips that she would normally have put off for a few years. One day, she discovers she's fat and broke, and realizes that she is still living, that perhaps she has more time than she thought. Roberta assumes the voices of other women as she tells about this time. As she remembers, she is amused by her frenetic activity.

> *I remember when I was first diagnosed. It seemed like I couldn't get enough to eat. I thought, "If I'm gonna eat—I don't care if I get as big as this room, I'm gonna eat!" Then I got on the scale at work and I weighed 186 pounds. The girls said to me, "My God, what are you doing to yourself— eating yourself to death?" Now, I'm leveling off a little.*

She continues:

> *When I first found out, I went broke! In the first couple months, I did things with the kids—we went to Baltimore*

to visit my sister for three weeks. We went to North Car-
olina. Like I gotta do all this because I might not be here
next year. And the next thing, I turn around and realize,
"Hey, I could be here the next three years! And I ain't
gonna have no money!" So, we better stop for a while.

A woman is grateful for whatever time she has, and sees it as an
opportunity to experience life more fully. Julene explains:

I thought it was awful cruel of God to punish me, to take
life away from me. But, like I said, it's getting better, much
better. Also, I've looked at it to be different than I used to
think—that He gave me this time after I was so angry. He
gave me this time to get it all together.

The woman with HIV comes to understand that, unless she takes
her own life, she will have to learn to live with the disease. She re-
alizes that she needs moral support, friends, work to do, a way to
continue to live her life and to be independent. She learns that
dying takes time and that eventually death washes away the pain.
Nina found out all of these things during the time she lived in a
group HIV home and became what she called the "brood
mother."

Look, it took me a long time to realize this. Maybe it's a
death sentence, but hell, you gotta live until the end. You
learn by taking care of others, watching them go, so young,
and passing away like that. I said, "Well, God, when it's my
time, just take me, because I don't want to be in no pain
like others I seen." It was like—it was like a cloud lifted
over me every time someone passed, because I was close to
almost everybody. You just feel relief.

The woman with HIV is careful to point out that nothing
changes the presence of HIV. It is there in her body. All the anger,
all the tears, regrets, thinking about the past and wishing for the
future that is gone, will not change the fact that the virus is in
her. She comes to a point of equanimity where she and the virus

coexist. Yet, she is always aware of the specter of death and she is haunted by the stigma of the disease she carries. She holds the knowledge that as a woman who gives birth to life, she is unique and different from other women with a terminal illness. Not only does she face the reality of her own premature mortality because of the virus, but she contains the additional burden and the stain of knowing that she carries a lethal infection that can destroy others if she is not careful. She bears herself with a dignity and maturity that one sees only in those who have lived a long time, who have known adversity and have come through to the other side. Each day for a woman with HIV is a small lifetime. She faces her past and all that she once took for granted; she lives each day in the full knowledge that she may not have much more time. Yet, each day that she awakens is a victory for her and a defeat for the virus.

ABOUT THE STUDY

I do not know what it is to be HIV positive, to have AIDS. I know something of what it is to care for someone who has HIV/AIDS in my role of nurse practitioner, health professional. What strikes me are the first four letters of "health"—heal. How do I do that when I know so little? Late at night, after the day is done, feelings and thoughts flood in, as I reflect on what I have learned, how I am taught by my patients.

My clinical practice is based in an urban internal medicine teaching clinic. Over the past six years, the clinic's HIV population has grown to over 900 individuals. As the professional caregiver, I am often engrossed with the trappings of the medical diagnosis that are integral to "treating" this disease that is incurable and, at best, very difficult to control: CD4 counts, p24 antigen, toxo titers, hepatitis profiles, opportunistic infections, psychosocial issues such as housing, finances, arranging transportation, helping patients to get access to medications and clinical trial investigations (antiretrovirals, immunomodulators, vaccines, and the like). But it is the everyday life of the patient—how he or she lives with this disease—that marks the undercurrents of my concentration and ruminations. The nurse in me is

drawn to these pieces of humanness that leak out around the mechanics of managing this unmanageable disease.

By a quirk of geography, most of the people with HIV for whom I care are men. These men have given me an extraordinary opportunity to care for a group of people who are infected with a virus that is not politically, socially, or culturally correct. They have shared their lives with me and given me insights into my own fears about death and dying. They have taught me that the young can be very wise; that they are resilient in the face of death and that living, in the form of grace, poignancy, and humor, continues despite a fatal illness.

I am also a woman, a wife, and a mother. Caring for these young men has made me think about women with HIV. What about them? Most of the infected women go to other clinics or private practices in the city for their care. I began to wonder how they lived with HIV, how they lived with being mothers, being lovers, being daughters, and having this disease. I thought about myself. What would it be like for me to be infected with HIV, to be a mother and to think that I may not live to see my children grow up; to feel responsible for infecting my child? How would I be with the knowledge that I would have to tell my parents that their daughter's death would come before their own? How would this virus affect my friendship with my husband?

I sought out women who belonged to HIV/AIDS support groups. Because I have come to know how much psychic pain is attached to this disease, I felt it was important, for me and for the women, to have a built-in emotional support system. The support groups provided that. Ten women from two cities and four support groups agreed to talk to me, in the hope that their voices would be heard and would help other women and people "in the world" understand what it is like to be a woman living with HIV/AIDS.

A brief description of the study was left with support group leaders, who then presented it to women in the groups. Women who were comfortable with sharing their experience then called me, and we arranged to meet at a time and place that was best for them.

The group was racially mixed: six African American women, three Caucasian women, and one Asian woman. Two of the

women were widows, two were married, and six were single. Their ages ranged from 24 to 52 years, with an average age of 33.4 years. Five women were infected through heterosexual transmission only, four through drug use and multiple heterosexual contacts, and one through drug use alone. Eight of the ten women had children, for a total of 14 children in the interview group.

My effort to stay as close to the women's voices as possible was guided by van Manen's (1990) perspective of four existential themes that pervade the lives of all of us: lived or felt space, lived time (temporality), lived body (corporeality), and lived other (relationality). At the beginning of each conversation, I would ask the woman to try to stay in the telling of her story as much as possible, and if, at any time, it became too painful, we would stop. In this vein, some of the questions I asked included:

1. What is it like to be a woman living with HIV?
2. How did you come to know that you are HIV positive?
3. What was that day like for you?
4. What is it like to be a wife/lover/daughter/mother living with HIV?
5. Is there something about this experience that is different from the rest of your life?
6. What does your body feel like since your diagnosis?
7. How do you experience time?
8. What are your feelings about yourself now and about other people in your life?

The women were given descriptions of the study with my name, address, and telephone number if they needed to reach me. They all had the option to give me their information for contact as well, if they so chose. Approximately half of the women gave me their first names only. We would often meet again, when I reappeared at the support group meeting places to talk with another woman. On occasion, I would be invited to their homes. They guarded their privacy and the security found within the group. At the same time, they told in simple, eloquent terms how it is for them to live with HIV/AIDS.

Other information came from books, poetry, the bible, music, journal entries, and my own clinical practice.

REFERENCES

Blake, W. (1955). Auguries of innocence. In Louis Untermyer (Ed.), *A treasury of great poems.* New York: Simon & Schuster.

Book of Job, The. (1975). *The holy scriptures according to the Masoretic text.* Philadelphia: Jewish Publication Society of America.

Copi, R. D. (1992). La visite inopportune, quoted by David Wetsel, The best of times, the worst of times: The emerging literature of AIDS in France. In Emmanuel S. Nelson (Ed.), *AIDS: The literary response.* New York: Twayne Publishers.

Dylan, B. (1970). Just like a woman. In *Roberta Flack: Chapter two.* New York: Atlantic Recording Corp. Dwarf Music Company.

Hawthorne, N. (1986). The scarlet letter. New York: Bantam Books. (Original work published 1850.)

McLean, D. (1971). *Crossroads.* New York: Mayday Music, Inc. & Yahweh Tunes, Inc. Music Corporation of America.

Rudd, A., & Taylor, D. (1992). Positive women. Toronto: Second Story Press.

Simon, P. (1982). The sounds of silence. Warner Bros. Records. Paul Simon Music.

van Manen, M. (1990). *Researching lived experience.* Ontario/Albany: University of Western Ontario/SUNY Press.

Vaucher, A. (1993). Muses from chaos and ash. New York: Grove Press.

Waits, T. (1976). Tom Traubert's blues. In *Small Change.* New York: Elektra/Asylum Records. Warner Special Products.

ABOUT THE AUTHOR

I am Suzanne Langner, PhD, CRNP, the Director of Nursing Research at The Graduate Hospital and an adult nurse practitioner in The Ambulatory Care Services Clinic of the Graduate Hospital, Philadelphia. In my 30 years as a nurse, it seems I have done it all—hospital nursing, intensive care nursing, public health nursing, teaching, primary care, research. At heart, I remain a

clinician, because it grounds me in the fundamentals of what nursing and what life are about.

It becomes clearer and clearer to me that, aside from the high or low technology practiced by nurses in various roles today, the story of what it means to be human offers us the best chance of understanding illness and health—*life*, that is. As I care for people who come to me to find some kind of relief from pain and suffering, I find that I am increasingly awed by their courage, defiance, and learning, which, with time, become wisdom. AIDS is the ultimate metaphor for this experience, because I see men and woman who refuse to be defined by their disease.

I am privileged to do this work. Each day, I am given the opportunity to understand more about life. The women's voices heard in this piece are a further testimony to human resilience and our capacity to learn from each other as we go about our daily business. During a time when human pain and misery are part of our daily fare, when life and decency sometimes seem expendable, it becomes even more important for me to remember what I have been taught by the men and women with HIV: life itself is ambiguous and uncertain for all of us; we need each other; each of us is part of the stew called humankind, with its ingredients of life and death; and living well depends on caring about another.

The Pretending "I":
Women's Secrets and Silences

Patricia Munhall

Re-vision—the act of looking back, of seeing with fresh eyes, of entering an old text from a new direction—is for women more than a chapter in cultural history: it is an act of survival.

(Adrienne Rich, 1979)

Our nation has had a long and unfortunate history of sex discrimination . . . rationalized by an attitude of "romantic paternalism" which, in practical effect, put woman not on a pedestal, but in a cage.

(William Brennan, Jr., 1973)

*I*f I wasn't writing this chapter I would read it, knowing how often I pretend. I would want to know about women's secrets and silences and if perhaps some women shared my own. If so, I

wouldn't feel so isolated or lonely with my own secrets. I would know that there are common experiences that are not accepted by society and that we as women must keep to ourselves, for fear of repercussion, shame, humiliation, and ostracism. Or perhaps worse, these secrets would not be accepted by those close to us. And if we were to tell these secrets to those close to us, would we hurt them? The risk is too scary, so we tend to keep secrets. And the power of a secret held embodied within us can make us sick—or worse, pretending to be well.

Not all secrets are overtly so grim. Some secrets can make us look younger, thinner, fashionable, and help us manage our lives better. And since those values seem to be the way most of women's magazines and, of course, almost any publication perceive the value of women, let's get straight to the political-economic secrets for women: BEAUTY SECRETS. And there is more along those avenues. Secrets about how to get a MAN, secrets about how to KEEP a man, secrets so you won't (God forbid) BORE him. Secrets, within this vein, include secrets on how to be GOOD in bed, secrets on how to make your man COMMIT to you, and secrets about what men WANT in a woman. For our multiple roles, there are secret ways to go from seven in the morning to midnight in the same outfit and change "the look" with a succession of scarves and earrings, cook a five-course dinner in seven minutes, and still have time to exercise at a computer terminal while completing a report that must go out over the Internet with the same deadline as dinner. There are secrets to being this successful and efficient. While these secrets may not appear harmful, the messages and expectations they set often appear to establish standards that cannot be met. While appearing banal, they, too, can do their damage.

Darker secrets humiliate women to such a level of destruction that they eat the secrets, drink the secrets, drug the secrets to the brink of overdose, and even try to kill the secrets by killing themselves. Some are even "successful" at self-eradication. The secrets that objectify women contribute to the denial of women's authentic self; their very being is not good enough. The strategic marketing secret behind the most lucrative products for women is that the purchasers feel inadequate without them. This is a cynical approach based on one of women's most common secrets: women feel inadequate anyway. They are in a stranglehold; they

cannot breathe. A close friend of mine who died of asthma had bought all the stuff about beauty secrets. The last time I saw her, at a conference, we were the only ones in the gym. She was doing the stairmaster, panting, sweating, out of breath, disavowing the asthma, determined not to be inadequate even if it killed her.

I strayed to beauty secrets while I was doing research for this chapter. I focused my attention on everything around me that was related to women and secrets. Some of the reasons women keep secrets or feel inadequate are tragic. Even some attitudes or behaviors or self-images that may not seem so tragic are, at least, sad or pitiable when we look behind what is concealed.

INVISIBILITY

Being attentive to my surroundings, I began to pay more attention to the media and to women's conversations. One of the most repeated messages was that, even though aging is inevitable, a woman does not have to look old. In translation, the message is: If you do look old, you're inadequate, unworthy, and probably deserve to be described as "ugly." Germaine Greer (1991), who does not appear to have these concerns, states simply that when a woman turns 50 she becomes invisible. The ultimate secret is: At that age and beyond, she is no longer one of the players, she is in the indistinct crowd of spectators.

For those who choose to struggle against the threat of invisibility, some of the secrets are: Retin-A, collagen injections, chemical peels, alpha-hydroxy acids, and, if affordable, "cosmetic" surgery. One of the rituals around these remedies is that most women who use them invoke confidentiality. Those who do admit to their use are frequently embarrassed that they could be so superficial. They struggle against their feelings of inadequacy. Others though, in all fairness, love the stuff for its results even if its use is kept secret.

Before I close on beauty secrets, let me share some tips gathered from my research. Always try to sleep on your back, and remember that, after a certain age, this is also the best position to have sex. Powders with optical diffusers are recommended: they reflect light, always a good thing. Avoid frosted eyeshadow, and always wear lipstick. To make your teeth look whiter, wear

lipstick that has a bluish tone. As I sit here typing, my hair in a ponytail, I recall reading that the tension from a ponytail can cause the hair to break and be pulled from the scalp. I find this amusing. My ponytail was not a styling choice to contribute to my attractiveness, yet it still sounds dangerous.

THE BEST KIND OF SECRET: KEPT OR TOLD?

If only the labeling of what is safe and what is dangerous were that easy. Feminists can speak eloquently on oppression, the need for power/empowerment, and the identification of victims. Feminism continues to use the rhetoric of politics, economics, and social context, sometimes failing to understand the possibility that women's secrets can cause as many tragedies and messed-up lives as do the acknowledged problems of society. From a postmodern perspective, I do not see a necessity to make this an either-or issue; rather, we should acknowledge that women's secrets are extremely potent forces in the lives of women and organizations. Secrets revealed drove the tide of feminist progress and now enable the telling of more secrets. Public telling of secrets has become a multibillion-dollar item for TV networks, and the secrets range from sham, through heart-rending tragedy and hate-filled diatribes, to deadly violence.

The glare of these public revelations should not overshadow women's kept secrets and their effects. This chapter probes the meaning of secrets as determined from those that are confided. What are some of those secrets and how detrimental can the keeping of them be to an individual woman and her constellation? Because of conscious or unconscious secrets, many women feel as though they are pretending, they are fraudulent. Often, they do not know how to account for these symptomatic feelings.

In last year's volume (Munhall, 1994), I wrote that while anger had to be expressed to be healthy, it need not be expressed toward the person who caused the anger, and that diversion of anger could be a self-protective measure. The same can be said for secrets. A Pandora's box may open when secrets are revealed, thereby endangering the safety and support that are essential for the "Pretending 'I.'"

Psychosomatic Disorders

The secret kept, like anger, can be transformed into pathology. Secrets can become symptoms or health-threatening conditions. The kept secret can contribute to anger and rage. Depression, as anger turned inward, is evidence of the kept secret. This pain depletes women's hope and vitality, and burdens them with humiliation, fear, shame, and feelings of unworthiness. They not only worry that the secret might become known but they must expend energy, stay tensely alert to what they say, and create subsequent secrets to maintain the original one.

The pain of a secret may eventually be driven into the unconscious, where it is suppressed and repressed. It gets stuffed down but when there is a threat of recognition, a panic attack results. To keep the pain down, women layer on palatable food, or drugs, or wash it down with alcohol, or divert their concentration on it with different kinds of obsessions or compulsions. Anything is better than letting the secret emerge. When all else fails, suicide guarantees a secret stays kept. Many women take their secrets to the grave.

Prince of Tides

This is a book and now a film. I watched the film for the third time recently. I use it as an example of the many psychodynamics individuals use in their escape from pain. Each time I assign it to a class, I review it again before the class is held. Each time I see it, I understand more about things—about love, pain, hate, revenge, our vulnerabilities, and, of course, the power of repression.

I have never tried overtly to commit suicide, so I know about it only from my occasional contemplation of it as an anger response, as articulated by my friends or patients or in the arts. The "prince's" twin sister almost "succeeds" the third time she tries to kill herself. The psychiatrist (with her own secrets, kept hidden from herself, for who among us is exempt?) pleads with him to try to be his sister's memory. She cannot remember anything before the age of 12, the year the sister was raped. Three days after her rape, she tried for the first time to commit suicide. The prince could not remember his own rape, which occurred at the same

time. His repression had been working better than hers; he did not go to the extremes that his sister did. With therapy his defenses are gradually broken down, and the repressed shame, humiliation, self-degradation, self-blame, and, most critical, the excruciating pain of the secret are present again, raw and bloody. He sobs at the horror. This is not instant healing but it is a beginning for him and, through him, for his sister. A folk proverb tells us, "You are only as sick as your secrets." Becoming better is the removal not of the event but of the secret about the event.

Healing begins when the psychic energy spent, most often, in destructive ways is used to grieve and to acknowledge slowly how one was not at fault. As depicted in this film, a child knows only the horror, and that is too painful to keep conscious.

Not the Content

Not all secrets carry the same valence; they resist categorization. One can never say, "That is not such a big deal" because it is not always the content of a secret that is damaging, but the feelings about the content. Another qualification here is that it would not be very smart to judge another's secret. A woman's secret of an affair, which some might think trivial, may be borne in pain and loneliness or because of the abuse of another. There is so much to understand. I believe we need always to ponder what might be concealed behind the appearance of an action. Telling secrets told to you is another act of violence toward a woman. It violates all that has been concealed, and reduces the existential nature of a secret to nothingness.

Judging another's secret in a way that attaches more sympathy than perhaps is attached to other secrets creates a ranking order. In severity, we all agree this is psychological vacuity. What is really behind a woman's undergoing plastic surgery? Is it self-love or self-hate? These are the things that are concealed unless honestly revealed firsthand. This interjection may be unnecessary, but I feel compelled to make a humanistic plea *not* to judge, or compare, or rank-order, or be indifferent because of content. A woman's perception of a secret is what influences how that secret affects her. One of the major factors gleaned from my research is that women often associate the pain of a secret with

self-blame, and the woman assumes responsibility for what content needs to be kept secret. The secret is not just there, or kept hidden; it is hurting somewhere inside the woman.

KILLER MYTHS THAT CREATE SECRETS

Rather than reveal the long list of secrets that women have believed were necessary to keep, in order to maintain homeostasis in their lives, I would like to share what women have told me about how they believe their lives should be constructed. This distinction is critical, in that the secrets have originated from what is perceived by women as the "right" way to be or the "wrong" way to be. These perceptions can originate from much of the propaganda and prevailing social discourse that surrounds women's lives. What is really scary is that secrets often become a form of silence; they become unspeakable.

Yet they are often still visible. The lack of language contributes to repression of the experience, but its expression is apparent to those who care to look.

Shame, guilt, humiliation, fear, and feelings of inadequacy often come from definitions of the "wrong" way of being. Women's ways of being are defined by their education, religion, and societal and cultural mores, and by the power structure. Women who discussed their secrets with me believed they did something "bad" and then subsequently blamed themselves. I have heard this in various stories. It leads to self-hatred, then to pain, and then to symptoms.

But I'm getting ahead of myself here. We need to look at the standards women set for themselves and the myths that nurture them. The deeper the myths are believed, the more energy seems to be expended in rationalization and repression. Some of these myths as described are the "shoulds" that haunt women's lives.

Beverly's Dilemma

The standards she has set for herself are impossible. When she doesn't fulfill them, she then believes she deserves punishment. She experiences shame at not achieving her goals and then accepts or expects punishment for not fulfilling certain myths.

Beverly: There is no room for imperfection. I strive to be as perfect as possible in all that I do. I cannot leave my husband, no matter what he does, because in a way we have a perfect family. He cannot restrain himself at times, physically, but that is usually because I . . . or the children have provoked him.

Myths

- A woman could be perfect.
- A woman is responsible for how her husband behaves.
- There exists such a thing as a perfect family.
- A perfect family includes a husband.

Beverly's Secret

Beverly is a *battered wife.* However, this is an unspeakable secret for her. She cannot bring herself to even say those words. She was abused as a child, physically and emotionally, by her parents. She learned that silence was her best weapon against worsening her situation. Thus, a code of self-deception and "unspeaking" became her life's defense.

"Unspeaking" gave no voice to her experiences and perhaps enabled them to slip into the recesses of her unconscious. Tolerance to the experience developed, and she repeated the scenario in her marriage. Worse, she repeated the defense of silence, of rationalizing, and she repositioned herself into the subjugated role of the least powerful. This was the experience of Beverly as a young child and it is now her experience as a woman.

However, this secret has been very well kept from the outside world.

Her secondary secret has to do with wanting to kill herself. This is also not put into language; it is also unspeakable. I only came to know these secrets through her therapy. Years of silence about what is too painful to speak aloud is now spent on how she could be a better person: a year on one child's problem, another on her "boss." I use quotations there because at that time I felt

symbolically, at least, we had entered a conflict that involved power. Who is "boss"—or rather, her perception of who is "boss"—seems to be a significant element in a woman's life. Women speaking in their own language often subjugate themselves, as it has been deemed they should do. As an example, let's look at Anita Hill.

Anita Hill's Dilemma

Anita Hill wanted to succeed, to "get ahead in the world." She was unsure of what was normal office behavior and what was not. As troubling and anger-provoking as her "boss's" behavior was, she believed she had no alternative but to endure it for the sake of her career. So she pretended all was well.

Anita Hill

Anita worked for a successful man. She was herself a successful, educated attorney who believed she could work and be attractive at the same time without being harassed. After all, ten years ago, a woman who was an attorney and who had overcome the stereotypes of being an African American woman as well must have deserved some respect.

Myths

- Educated women will be respected.
- Educated women are at less risk of being harassed.
- Men respect the boundaries of women in the workplace.

Anita Hill's Secret

Anita Hill gave no public verbalization to her repeated experiences of sexual harassment in the workplace while they were happening. After ten years, she gives voice to them, and she is damned by many. She is called self-serving, a destructive and vindictive woman. If one wonders why Anita did not speak aloud ten

years before, perhaps the reaction she received, when the culture was supposedly a decade more enlightened, provides a ready enough answer. Her secret, both when kept and when revealed, contributed to her shame and humiliation.

A Pause

We know that power has always entered into the oppression of women. Collusion among men has also reinforced the power of power. Words spoken in truth by women to the holders of power are conveniently suppressed. What is the use of going before the United States Senate, particularly before a panel of white male Senators? In the magnitude of her actions, I think Anita Hill made a courageous heroine. This was a good example of what to do with secrets and with anger, humiliation, and shame, although Anita Hill paid a price. However, a formerly secret aspect of the workplace, detrimental to women's mental and physical well-being, is changed forever—not eliminated, but changed. Women still get raped. It is against the law; still, women often choose to keep it secret. Sometimes, they think, keeping it secret is in their best interest.

Lynn's Dilemma

Lynn: I was raped a few years ago. Then this man that I'm involved with wants to get married. So I don't want to continue hiding this from him. I never told him. I kept putting it off. There was just something there, my shame, my humiliation, the feeling I thought I was dirty in some way. So I get the nerve one night, the courage, and presto! everything is changed. He tells me how sorry he is but I can tell he is having difficulty. OK, I thought, I guess this is hard to hear. He said he needs some time. HE needs some time.

The long and the short of this was that he could not deal with it. My friends, of course, think he is a real asshole and I am completely better off without him. Yeah, yeah, but what about this huge gaping pain and hurt—

now, from two things. The rape was bad enough. Now, abandonment, no sympathy. This is an all-time low for me as a woman.

Myths

- Secrets can be shared with intimates with an expectation of understanding.
- A man, especially one who loves you, will be outraged by your rape.
- Men believe women's rape to be as awful as women do.
- Love is unconditional.

Lynn's Predicament

Lynn gave voice—with a loved one, or so it seemed—to an act of violence against her very being. He left, and it is easy for her friends to say she is better off. But hasn't her shame now become worsened? She has been rejected for something that killed part of her spirit, dignity, and sense of security in the world. Will Lynn ever feel safe? Say some nice fellow comes along next time. Will she feel safe enough to reveal this secret? What is the toll if she doesn't? Will it make her sick? What if she tells him and he comforts her, and, down the road, they argue and say things they wish they could take back? What if he uses that as a way to hurt her? What if, what if? Sometimes there just are not good answers. What a burden she now bears. Can we as women help her? Can we do better with telling *our* secrets and stories? Can we teach the men in our lives?

SECRETS FROM A SHAME-BOUND CULTURE

A word about our culture. Our culture varies. Secrets, or the content of life that is to be kept secret, are often bound by culture, including religion. Ah, religion. Some secret thoughts are considered sinful, especially if they are impure. We may have media mayhem about cultural or religious taboos and myths, yet what lives outside a newsstand filled with pornography and exploitative behavior is

quite different. In our own everydayness, we are surrounded by sexism, racism, homophobia, double standards, and continued proliferation of a myth of social conformity. The family suffers in many ways from this myth of social conformity. I bring this up because we all know who is most often responsible for the family's well-being.

At a time when "a return to family values" is at center stage, one needs to know what secrets must be kept and what conditions might be endured to maintain "appearances." Politically, we need to ask, what is being swept along with this concept? Are women to return to their "proper place"? Should they become subservient to the greater good of the family? Should they feel guilty if they secretly or not so secretly rebel against this vacuous slogan?

Myths about Family Values

In my clinical practice, I have seen enough fallout from traditional families that the thought of returning to the state that existed, say, mainly in the 1950s, is frightening. The worst aspect of such a return is its hypocrisy. By that, I mean the secrets that were the most intricate part of maintaining the appearances of "the family." Of all the myriad of secrets to keep hidden, the most important to appearances was that of incest or child sexual abuse. This kind of abuse, because of the threat of power differentials and/or lies, has to be kept secret. Once kept secret within a no-way-out scenario, the repetition of abuse is allowed to continue.

Keeping peace in the family, or keeping the family "together," has various ways of constructing itself. A few women's secrets illustrate the variety.

Lisa's Dilemma

As a child, Lisa was sexually abused by her father. This is a secret that just came to her awareness and is being kept at all cost. By this I mean that it has been so well kept, it had not been conscious. She really doesn't want to discuss it. It is too confusing and painful. She also believes *she* must have brought on the

abuse. It must have been something she did. When it has been so long repressed, Lisa wonders why talk about it now? She tells me she was the oldest of four children and, in a way, she took her mother's place. She looked after the younger children, did cooking and cleaning, and, as is very characteristic of this intact family, took care of her parents as well. Role reversal is all too common. Remember, Lisa was a child, and a child knows only that her survival depends on this family. What else could she know?

Myths

- Fathers are perfect and protective.
- Mothers will protect you.
- You lead your father on by being flirtatious.
- The oldest child needs to assume more responsibility.
- A child has an obligation to be loyal to her parents.

Lisa's Secret

Lisa, blaming her sexual abuse on herself, feels shame and guilt. Her father should have adored her and, if nothing else, should have known better. Now, Lisa has become heavily overweight, to be sure this does not recur. While it may be true that Lisa secretly desired her father in some way, a good parent always says no to sexual advances by a child. In other words, the parent is always the adult and is responsible. Yet I have listed that statement as a myth. It *is* a myth. Parents do not always behave in a responsible way. That is *their* secret. A child coming on to Dad or to Mom is as old as the Oedipal legend, as are a child's coyness and desire for approval. The tragedy of Lisa's secret is that it has affected all her relationships with men, in that they all have been repetitively abusive. Like Lynn, Lisa fears telling this secret to the men who come into her life. What should be her father's shame is deeply embedded into Lisa's superego as her shame. Until the day comes when Lisa can believe affectively, not only intellectually (because that is easy), that her father was entirely at fault, for whatever his reason, and can express her rage at his transgression, the

effects of this secret will continue to haunt her. I once asked a woman who had experienced sexual abuse as a child to tell me what would be appropriate in the following scenario.

Wanting to Have Sex with Daddy (or Joe Buttafucco)

A young girl decides she would like to please her Daddy (or Joe). Let us say that neither Daddy nor Joe has approached this young girl and that she is about 13 or so. (You can do your own variation of these particulars.) The girl has been watching MTV for years and knows what is sexy. She decides to assume an MTV persona. She could even be 7 years old for this role, but let's keep her 13 to make a point. She knows she could look for a boyfriend at this age, but she is scared and feels safer with an older man. One day, no one is at home except the girl and her father. Her father, who has not had sex in a year because of marital problems, is in his bedroom reading a newspaper. The girl, with her ripening, developing, innocent sexuality, enters the father's room. Her bathrobe is open, revealing her nudity. She seductively goes to her father (or to Joe) and places her hand on his thigh. She lets the bathrobe fall open more and says, "Daddy (Joe), I want to do something to you."

What should the father (Joe) do at that moment?

When Our Secrets Are in Court

For many years, rape victims had to endure hearing how they were "asking for it," or being treated as though they had a sordid past. Even today, the secret of rape is often left "unspoken." Can you imagine the above situation in court? Can you hear Joe saying, "I didn't know what she was going to do"? Can you imagine that a male judge might get off on the whole scenario and have it become a fantasy in his own sex-starved life? Can you imagine that if something occurred (as with Joe), the judge might understand the father's (Joe's) "predicament" and absolve him of any wrongdoing? There are a million Joe Buttafuccos, but we know of him because of the assault Amy Fisher was perhaps driven to commit. Perhaps, for many young girls who are sexually abused,

the world becomes distorted, and they do not know anymore what is normal or what is permissible. They are constantly told about "our little secret," or how "special" they are, or that "If you tell anyone, you will be very sorry."

Sexual Abuse: A Mother–Daughter Secret

Always, there is the question: "Where was your mother?" More shame for women, more responsibility? Was the mother neglectful? Or did she too fear for her survival? Fear of physical harm and abandonment overrides, for many women and especially for young girls, a concept we could call "obviousness." Public performance is a way of life for women, and the appearance of an intact family is the prize. A strong family value is "loyalty," and at what a cost! An entire life may be robbed of possibility because of the burden of pain, humiliation, and guilt. This burden, we noted earlier, takes form in repetitious behavior that continues to punish the person for being, as she or he sees it, "bad" in some way. The victims then hurt themselves. Can we bring this stuff into the open more? Can we give it voice? Can we shout, "If my sister is allowed to be abused, I will not say that it's her problem and not mine"? Or, "If she has the burden of a secret, she is not whole and neither can I be. Society should not let her burden be so heavy." I believe that a secret robs a woman of her authentic self, her self as a whole. She is dented; a part of her has been amputated.

Another Pause: This One about Men

Men are not coming off good in this chapter thus far. Perhaps as my study continues, I will come across secrets that have nothing to do with men. After all, I do know already that women harm women. However, that harm does not seem to be what women bring up (and I can't help that, I hope) when asked about secrets. Again, I think the root problem is power. As liberated as women may think they are, there does not appear to be any doubt about who holds the power, whether directly or indirectly. This is the prevalent perception. I know as well as you do what the following passage is saying:

> *When women do try to fight back, as in the case of Anita*
> *Hill . . . the backlash can be enormous. . . . Professor Hill was*
> *excoriated on the one hand for her years of silence, for not*
> *leaving the scene of the crime, . . . and on the other, for*
> *speaking out, for viciously smearing a respected man, for de-*
> *stroying his life. . . . The meta-message was displayed in the*
> *context itself, the all-white male Senate Judiciary Committee*
> *vividly reinforcing our understandings about who controls*
> *the said, who makes the rules for social discourse, thus*
> *demonstrating the precarious future for any woman who*
> *does not know when to hold her tongue. (Miller, p. 252)*

It doesn't look good for men, but I will proceed.

SEX, LIES, AND SECRETS

Victoria's Secret*

Victoria: I was married to this man, who, as it turned out, was what I think they call a philanderer. First I found condoms in his shaving kit when we were first married, and I knew they weren't for me. Then he used to come home with his hair wet—that is, supposedly from work—and I rationalized and believed everything he said. I struggled with this one but I wanted the marriage to work out; I almost bought it. He was on a business trip and when I called his room, a woman answered. Said she didn't know where he was. He told me it was the maid. All of this was played out in ways at home that affected me profoundly. He was inattentive, he was not available for sex, I did not feel loved, he was hypercritical of me, and, at times, physically, "something"; I used to think not exactly abusive but a little rough. I was extremely depressed.

* All names are pseudonyms; I could not resist this one.

This is not to make excuses for what I am about to tell you, but I was so far gone I had no idea what it was like to be cared about.

On a business trip I met a man and, of course, I was as vulnerable as they come. But I had lost my identity. I even had to ask my roommate, should I go with him? She was as conservative as they come but she knew what was going on. She said go. I needed the care. Notice not sex, but care. He lived far away but we continued a long-distance relationship for almost four years. This was not the solution.

Myths

- Fidelity comes with marriage.
- If you ignore things for a while, they will go away.
- Getting love at any cost is worth it.

Victoria's Dilemma

The affair as a secret was eventually discovered, as it was probably supposed to be. In the meantime, Victoria, like many women who enter into affairs with married men (or otherwise, but particularly with married men), did not understand the enormous power differential. Victoria had become dependent on this relationship, thus reducing more of her power. However, a married man has far greater resources than an unhappy married woman who has lost her identity, or a single woman. The obvious differential: the married man has an alternative partner, whereas, in Victoria's case, she really never had the security of having her own partner. It is interesting in a study of secrets to see these kinds of relationships having, at their core, the construction of a mutual world of secrets, so the secrets bind the secret relationship.

In this instance, as is very common, the relationship, except for rare instances, caused much more pain than happiness. Victoria actually became a hostage to the crumbs that the affair could give her. As with other secrets in this study, the interests of the most

powerful were protected. For Victoria, there was enormous sadness, loneliness, and disillusionment.

Can women learn from other women's secrets? Throughout history, the extramarital affair, sex, and secrets have been mainstays of drama, opera, literature, comedy, and now films, lyrics, and videos. However, a woman is most often left alone with these secrets. When a secret relationship ends, as it most often does, there is almost no support in deconstructing the little that it offered, which was allowed to become all-consuming. The secret isolates her and then, paradoxically, when she ends the secret, so to speak, once again the woman can give no voice to it. Perhaps that is an exaggeration. This is one secret that women do tend to tell a friend. One of the worst outcomes of this kind of secret occurs when obsessions develop. Even if there wasn't much to hold onto, if the secret had achieved a life of its own, letting go may have given life to Victoria. Instead, she classically can think of nothing else. What else does she have? Women believe so much in relationships. They harbor hope. But sometimes they become hopeless, and this is worse.

Can women learn from other women? Do men have a responsibility? Or is infidelity not a secret but a social institution in our culture? I'm not one for quoting statistics, but under anonymous circumstances people apparently reveal their secrets to pollsters, and infidelity ranks high up there as a common experience.

An Update on Invisibility

In a recent Sunday *New York Times Magazine,* Sue Hubbel writes about turning 60. She gives the encouraging message that, during this decade, one is totally free to do anything and say anything. One has nothing to lose. The article is about women aging. Earlier, we talked about women becoming invisible at 50, that is, invisible to others. This *Times* writer suggests that as a woman ages, she should simply cover her mirror with construction paper. Then she doesn't have to see herself aging. Am I losing my sense of humor? I think this is so irresponsible! Women should feed at the trough of this sexist, ageist stuff? Wipe out their existence? Wipe out their appearance? How about telling a woman to put a bag over her head so her appearance could be a total secret, not

only to herself but to everyone around her? Why do I get so riled? There will always be more secrets because society is not only sexist and ageist, but homophobic as well.

LIVING IN A HOMOPHOBIC CULTURE

Carol's Secret

Carol: I'm 50 years old and I'll tell you that, for me, being a lesbian has always been a secret. It had to be. I was brought up Catholic and there was no way my family could deal with difference—and, in particular, one that was considered a mortal sin. I was condemned to hell for this. Of course the Catholic doctrine still maintains that. So my whole life in a sense contains this secret, this covering up to friends, family, and, most important, [people at] work. I have always considered my being a lesbian a job security threat. Also, within the work setting, I believe it is just easier if no one knows. So, in a sense I live a lie and pretend that I am heterosexual. Like you see here. Jean and I live together under the guise of being roommates and have two separate bedrooms, so, when friends come over, I say, this is my room and then this is Jean's room. Sometimes I wonder if we are fooling people but it still is important to me to maintain this front.

Hiding part of myself this way definitely shows a degree of fear and shame. Not all lesbians feel the same as I do. "Coming out" among the younger women is more common. However, I grew up during the times when being a lesbian was considered a form of mental illness. And God knows, there are still enough people that think something is wrong with us; that makes me secretive. I also don't have the personal courage to come out. I know Jean has let people know where she works, or at least she doesn't correct any perceptions, but I can't do it, even though I know I work with other lesbians. We just don't discuss it.

It can be very isolating. Most of the women at work talk about their husbands or boyfriends, or they talk about children, and I am very silent. If it was a choice situation, I would have chosen not to be gay; life would have been easier. I have lived most of my life feeling lonely and fearful. I "pretend to be I." Indirect messages I have received reinforces that people do not want to know [about] or deal with my being gay. It is a hell of a way to live. To deny who I am. To pretend I'm someone else. Never to be accepted by my family except under false pretenses. Jean and I could not spend holidays together. We went our own ways. Just lately we decided to stay together during these periods and have been socializing mostly with other people who are gay. In a regular community like this, being a lesbian can still be considered perverted. This is a label I still hear. We are treated differently. I still feel shame, I can't help it, no matter how much intellectualizing I do. So I keep it a secret and consider that I live a secret lifestyle. A covered-up one.

Carol's Predicament

There are few myths that Carol believes in. Her assessment of the culture is, for her context, probably correct. I know some lesbian couples who live quite openly but they have chosen geographical locations that allow them to do so. For all our so-called enlightenment, the prejudices, biases, and assumptions of others force many lesbians to live out their lives with a large part of their identity falsified or kept secret. Often subjected to cruelty and isolation, many lesbians feel a lifelong sense of needing to hide. Some feel shame, and sex is often couched in thoughts of abnormality. However, many lesbians, even if they keep their lesbianism secret, are extremely positive about woman–woman relationships. Who could understand a woman better? Who knows what a woman needs more? This helps, yet great conflict can often be heard. The pain of being different, of being the subject of jokes; the stereotyping; the energy needed to keep one's sexuality secret—all these take their toll. We have reviewed the destructive nature of secrets. When many lesbians

must keep this as a lifelong secret, I think it is very sad. Again, what can we do as women? Straight or gay, are we divided on this issue or supportive? Is this an instance where women harm one another?

Closets, Closets, and Closets

What else do women believe that cannot be given voice? What other life events and situations must be hidden and never shared, keep women in fear, and rob them of their energy, self-esteem, and spirit? What are other sources of pain, some so tortuous, that show themselves only in dis-ease and self-destructive behavior?

Each secret of the women described in this chapter has its own story. The common denominators are pain, shame, self-blame, humiliation, and fear. The unconscious secret is somewhere "being shown," and the conscious secret is depleting the woman and disempowering her. The belief that these secrets are "bad," and that is why they must be kept secret, isolates a woman in her shame.

Also in the closet are secrets of specific illnesses, mental illness, convulsive disorders, substance abuse illnesses, sexually transmitted diseases, and past surgeries. How does one reveal these? One woman asked me, "How do I tell a man I'm HIV positive? I can't even tell people I work with, other women."

"I'm single and have a mastectomy. You have no idea what that is like. The rejection I have experienced," another woman tells me. Some secrets are harder to hide than others. I don't know which is worse. "I have a child but I have never been married. That goes over like a lead balloon," says another woman.

The wish to appear "normal" motivates keeping a secret. Some secrets may not be evident; no matter, they tend only to isolate the woman in different ways. Depression, to remain undetected, calls for constant performance. Compulsions keep many women from leaving their homes. Abortions, giving children up for adoption, family secrets, "illegitimate birth": on and on goes the list.

Another Pause, This One about Women

While many women's secrets tend to have something to do with men, or with men's abusing power, one thing, or maybe two, has

become clear to me. One has to do with the connection women feel to other women and the other has to do with the continuation of the feminist discourse. Perhaps they are the same.

I will tell you a little about myself. I have secrets but I cannot have a pseudonym; suffice it to say I know the pain. Most women do. However, I am in one hell of a privileged position. I am educated to treat women who come to me with secrets. In other words, I have a role where I can, I hope, be there for them: a listener, a safe person, a non-judgmental person.

I have shared with women their brave and courageous exploration into their symptoms or behaviors and their pain, only to find that a secret has been guarded for years and often will be for more years. My work has demonstrated to me the power of secrets for women. Women tend to feel shame and humiliation in ways that cause enormous suffering to them as persons. *And,* although something was done to them, they excuse people, they forgive people, and they blame themselves.

The feminist discourse, which has led to tremendous reconstruction of some of our culture, has just begun to open up the closets of incest, battered women, and date rape. How seriously this is all being taken, or at what risk for women who come forward, is not entirely understood. Women are still blamed.

WHAT CAN WE DO?

Women must provide places for the unsaid to be said. And women must feel safe. Many times that safety is found with a therapist and in group therapy. But in their everyday existence, women should not have to be burdened with keeping secrets from other women, for fear of shame and humiliation. There must be public language, places for secrets to be revealed and kept and shared and the teller supported. I worry because we have made advances, yet we don't always see ourselves as a group. Perhaps the individual woman is at the forefront. We need to look at each other. We are connected and need one another. If we continue with focusing on individual stuff and not on the web of connectedness, some very serious political machinations are going to occur and force our secrets further underground.

How could a woman lose custody of her daughter because she had placed her child in day care while she attended classes? The political agenda being supported by many as a return to "family values" opens the way again to family loyalty and the ensuing secrets. All sorts of repetitions of the past are possible with any *return* to something. We know that. Our current situation is very complex. We are women, and the men who share our concerns must be ever vigilant.

THE PRETENDING "I"

Women must be vigilant as well toward their public performances. Performing is extremely energy-draining if the performance is to mask something. A defense of silence or "unspeaking" builds up anger and depression. Denying ourselves the relief that comes with telling a secret and working on healing means yielding to the stranglehold of the secret, the suffocation, the loss of identity, the transformation into another condition, the pain. To keep the secret is to walk around with a bag over our heads. To keep the secret is to give others power. If there is a grain of truth to the idea that we are only as sick as our secrets, it is time for us to devote part of women's experience in the effort of healing one another.

ANOTHER CONCEALMENT

Anger was explored in last year's volume (Munhall, 1994). This is all connected. Heidegger (1926) spoke of the appearance of things and then the concealment behind the appearance—the covered-up-ness. A suggestion: Be careful. Choose very carefully whom you share your secrets with; they are extremely tender areas. A woman might need therapy to learn to trust enough to tell a secret. Another woman who is able to trust may find a friend or some type of support group. We are often concealed enough because of the myriad expectations placed on us before we even get to makeup, dressing up, or media exhortations to "turn ourselves around." Consider this sales pitch for Clinique's new cream:

When skin persists in showing lines, . . . poor texture, muddiness, dullness, Clinique pronounces it perfect.

PERFECT! Perhaps; but if the cream doesn't work, in any cosmetic department they have a variety of "concealers" to choose from. Conceal lines if you wish, but please make an effort not to conceal pain. Speak aloud the unspeakable. Give voice to the unspoken. Slowly let go. Let go of the "pretending." Be "I" with other, truthful words.

REFERENCES

Blume, E. S. (1990). *Secret survivors: Uncovering incest and its aftereffects in women.* New York: John Wiley & Sons.

Butler, S. (1978). *Conspiracy of silence: The trauma of incest.* San Francisco, CA: New Glide.

Greer, G. (1992). *The change: Women aging and the menopause.* New York: Alfred A. Knopf.

Heidegger, M. (1926). *Being and time.* Macquarrie and Robinson (Trans.). San Francisco: Harper and Row.

Hubbel, S. (1995, February 19). A gift decade: Sixty something. *New York Times Magazine.*

MacFarlane, K., & Korbin, J. (1983). Confronting the incest secret long after the fact: A family study of multiple victimization with strategies for intervention. *Child Abuse & Neglect, 7,* 225–237.

Miller, D. (1994). *Women who hurt themselves: A book of hope and understanding.* New York: Basic Books.

Miller, J. B. (1976). *Toward a new psychology of women.* Boston: Beacon Press.

Munhall, P. (1994). *Revisioning phenomenology.* New York: NLN.

Richardson, L. (1988). Secrecy and status: The social construction of forbidden relationship. *American Sociological Review, 53,* 209–219.

Skolnick, A. (1991). *Embattled paradise: The American family in an age of uncertainty.* New York: Basic Books.

van Manen, M. *Researching lived experience.* New York: State University of New York.

ABOUT THE AUTHOR

Many of us are engaged in pretending. "The Pretending I" is not something to always be avoided, in fact, all too often, it is the only way to survive. However, a plea herein is not to disguise pain or circumstances that can make us sick and to find avenues where we speak aloud the "unsaid."

I have mentioned the great privilege I have to be a part of women's secret worlds as part of the psychotherapeutic process and I know of the burdens of secrets for them and also for myself. Freedom comes eventually to those who persevere and take the leap to revealing what most threatens them.

I still have an excellent dean, Judith Balcerski, and this year through a growing friendship, a wonderful colleague in the associate dean of the undergraduate program, Vicki Schoolcraft, and a warm and loving secretary, Karol Geimer. We are all at Barry University, where I have found an exceptional faculty, students, and staff.

When I first moved to Miami, because of its vacation associations, it was difficult to work. Then something happened, perhaps summed up best in this verse by Yeats:

> *. . . had she done so who can say*
> *What would have shaken from the sieve?*
> *I might have thrown poor words away*
> *And been content to live.*

Allowing in my case for Miami to be "she," I understand this better. And those who choose to write.

Being a Grandmother

Dula F. Pacquiao

. . . I'd feared that I wouldn't be able to balance the casket and that it would tilt and my grandmother's body would fall out at my feet. But, really she was so light, held by the six of us. I had no idea it would feel like this to be a pallbearer: Gentle, Cradling, Maternal. . . . Carrying now was a responsibility given over to me. It was completion and connection. . . .

The Hebrew phrase associated with pallbearing is hesel shel emeth, *an act of truthful and pure loving kindness. It is pure because the giver can have no expectation of reciprocity.*
(*Hershman, 1992, pp. 18, 20*)

Marcie Hershman's final tribute to her grandmother reminds me of a family anecdote about my mother-in-law, the only living

grandmother of my children. My 10-year-old son has developed great fondness for her despite her once-a-year visit from the Philippines, when she spends a few months at a time with us. Being a retired elementary school principal, she naturally takes over supervision of my son's homework after school. After one of these productive evening sessions, I declared proudly to my son, "You are so smart. You know why you're smart?" David, who was then 8 years old, responded, "Yes, 'cause Maya [Grandma] makes me smart!" I was stunned by his reply. Here I was, working with him every evening and he gave full credit to his grandmother who visits once a year. My mother-in-law was clearly pleased, and chuckled at the compliment. Grudgingly, I agreed and dropped the subject.

Indeed, when my mother-in-law is around, my son does his schoolwork without any fuss. He gets full attention, and his grandmother adjusts to his after-school television program schedule. He gets to bed on time and is always prepared for school the following morning. However, this short hiatus creates havoc when she leaves. Then reality begins when I have to introduce the same old routine that has worked smoothly in the past. I always dread to be the bitch, but someone has to reestablish a workable schedule. Because of these post-honeymoon aftershocks following her visits, I am ambivalent about the nature and meaning of grandmotherhood. On one hand, I value the emotional closeness and sheer joy that my son experiences with his grandmother. On the other hand, I dread the task of restoring a convenient lifestyle without appearing unreasonable to my son.

New grandmothers among my friends and colleagues have endless tales and pictures of their grandchildren, giving an impression that grandmotherhood is more exciting than parenthood. When stories are tinged with worries and difficulties, these are always balanced by positivism and affectional ties with their grandchildren. Speaking of her two grandsons, one grandmother happily states:

You can not love them enough. You can not spoil them enough. And the best part of it all is that they go home when you have had enough.

Similar views are expressed by these two grandmothers (Cherlin & Furstenberg, 1986, p. 55):

Well, I'll tell you about grandparents. They do some extra loving. Especially when you don't have to just do everything and aren't busy with children—you know, spanking them and getting them off to school, or whatever. You don't have that responsibility, so you have more love to spare; when you have grandchildren, you have more love to spare. . . .

The best part of being grandmother is just that you can say, "Come here" and then, "Go over there, go, go." And they go and I mean, you can love them and then say, "Here, take them now, go on home." You know, something like that. See, the responsibility, all that responsibility, is not there. So you can take them whenever you feel that, you babysit when you feel like it, and then you can go. It's nice.

Earlier studies have documented cross-cultural evidence that, in societies where decision making and economic power reside with the old, relations between grandparents and members of other generations are described as formal and authoritarian. Conversely, in cultures in which the old are removed from functional authority, grandparents are described as having warmer and indulgent relationships with their grandchildren (Neugarten & Weinstein, 1964). Apple (1956) noted that as urban, middle-class grandparents relinquish parental authority over their children, they experience freedom from concerns that may have competed with their enjoyment of their children. This freedom from responsibility seems to enable them to experience their grandchildren with individually determined degrees of identification, indulgence, and delight with the pleasure of the child.

THE NUMBERS

The U.S. Census Bureau (1991) estimates that 3.2 million children under 18 years of age live with their grandparents or other rela-

tives, representing an increase of close to 40% over the past decade. Approximately 12% of all African American children today live with their grandparents, compared to 5.8% of Hispanic and 3.6% of White children.

About 70% of middle-aged and older people become grandparents. Because the average age of becoming a grandparent in western societies is approximately 50 years for women and a couple of years older for men, they are likely to remain grandparents for some 25 years or more, or about one-third of their life span (Smith, 1991). Grandparenthood is thus an important segment of the life cycle for most people.

My purpose in studying the experience of grandmothers is a highly personal one. By moving into their world, I hope to understand the nature, meaning, and function of grandmotherhood as lived by these women. My own experience as a mother with two children and a mother-in-law depicts a different and limited dimension of the phenomenon of grandmotherhood. I wish to gain insight into their own perspective—the subjective, very personal, and experiential interpretation of grandmotherhood. Such conversations will capture the holistic, contextualized, and authentic meanings of being a grandmother. As I approach grandmotherhood, I will have been instructed by the experiences of genuine, real people who are living through the event before my time.

THE GRANDMOTHERS

The ten grandmothers who participated in the interviews included both working and retired women between 50 and 84 years of age. Eight women are married and living with their spouses, one is divorced, and another is a widow. One-third of the participants possess college and/or graduate degrees. Only one-third live in the household of an adult child who has children; the majority maintain separate residences. One working grandmother is the adoptive parent of her 12-year-old grandson. The women have multiple grandchildren, most of whom are teenagers and adults. Only one grandmother has two grandsons below 4 years of age.

GRANDMOTHERS' TALES

Transcending One's Mortality

Several authors have recognized the role of grandmothers as family biographers, ensuring the survival of valued traditions, rituals, and legacies through many generations. Retirement, for most grandmothers in this group, has permitted time and patience for imparting the wisdom gained from a lifetime of experience with the young. They are an important resource as teachers and role models for the young generations.

Margaret, grandmother of two young grandsons, comments:

When I see my daughter . . . how good a mother she is to her own sons, keeping those values that my parents have taught me and which I hoped I was able to transmit to my own children—this is my biggest achievement in life. It surpasses any other successes I've had. And when her husband tells me that he really likes being part of our family, I couldn't ask for more. As an only child, I was always close to my parents and they have helped me in raising my own daughters. My father lives with me and has been very close with my daughters.

On her application for college admission, Margaret's youngest daughter wrote about the parallels between her 90-year-old grandfather and herself. Both of them were seeking autonomy. She was seeking her identity through higher education and physically moving out of her parents' home, and her grandfather's day-to-day existence has been a continuing saga of his maintaining his independence at home. Margaret was astonished by the profound influence her father had had on her then teenage daughter, whose experience in living with her grandfather enriched her perceptions of her present and future life.

Andrea, who is in her 80s, laments the gradual disappearance of traditional values in her grandchildren:

My son is always too busy with work and my daughter-in-law does not inculcate the same values of respect for elders,

generosity toward others, most especially toward your own family, and basic family rituals such as eating together in the evening. My husband and I took care of the youngest and you can see how different he is from his two older siblings. He is thoughtful, respectful, and giving. It upsets me sometimes to see that he is being taken for granted by his brother and sister. Do you know that my son told me one day after we attended a school [Middle School] program and David [grandson] received many honors and awards..., "Ma, you brought him up well."

As a retired school teacher and author of many elementary school textbooks, Andrea has retained much of her knack for teaching others. She proudly mentions:

He [grandson] learned how to read before he was in kindergarten. Reading is the most important skill ... you can not solve math problems if you can't read. I used to take him to the library and the bookstores every weekend. The love for books must be stressed early.

Becoming a grandparent is a deeply meaningful event in these women's lives. The birth of one's grandchildren provides a great sense of completion of being, of immortality through the chain of generations. It is an affirmation of the value of one's life, and, at the same time, an insurance against death. For these grandmothers, grandchildren are a great source of personal pleasure and achievement.

In comparing her two teenage grandchildren, Mary describes her granddaughter Debbie:

[She has a] fresh mouth but [she's] an achiever. She gets good grades and will succeed since she knows how to take care of herself. She won't allow people to step on her.

On the other hand, Debbie's older brother, Robert, is "loving, sweet and thoughtful. He is not as successful in getting decent grades and his potential at playing soccer has been dampened by a severe knee injury." Although Mary and her husband are closer to Robert, they worry about his future. He has not had an easy

time in school, despite being a star player in high school soccer. Now that his physical capability is limited, they feel his pathway toward success in later life has been minimized.

Mary's conceptualization of success in life is consistent with her assessment of her adult children. She admires her son, who had a college degree and a house before he got married. Her daughter, who quit college to get married at a young age, is not as admirable as her husband, who persevered to become a Certified Public Accountant despite being orphaned as a young man. Mary went back to work after her two children went to college. She has continued to work as a secretary in a local college even after her husband's early retirement.

Grandparents can influence their grandchildren both directly and indirectly. An example of indirect influence is the role modeling of child-rearing patterns in their own children. Huesmann, Eron, Lefkowitz, and Walder (1984) have found evidence of the predictive value of grandparental forms of discipline many years earlier on the level of aggression in their young grandchildren. Direct influence includes acting as surrogate parent or as a caregiver when both parents are at work. Grandparents can also pass on information and values directly to grandchildren, as well as act directly as role models (Neugarten & Weinstein, 1964).

With a growing awareness that time is running out (de Beauvoir, 1973), the elders are moved toward transcending mortality by making life more secure and meaningful for others who will go on after them (Peck, 1968). Age is not only a threat to one's identity but also offers an opportunity to consolidate one's life (Reichard, Livson, & Peterson, 1962). Leaving a legacy to future generations is rewarding to one's personal well-being (Pincus, 1967).

Maintaining Linkages with Others

Grandmothers, especially African American grandmothers, have been identified as "kinkeepers" and "keepers of the clan" (Ovrebo & Minkler, 1993). They have the extended responsibility to nurture and care for all who come under the roof. The central role of women as caretakers of family and kin members has been documented cross-culturally.

One daughter describes her mother:

[the] telephone directory of the family. . . . She knows every relative and friends who migrated from the Philippines to this country. We receive calls from relatives from other states asking for an address or phone number.

Speaking of his 82-year-old wife, Josephine, Bill O'Brien states:

She always makes sure that we call every child, grandchild, and great grandchild on their birthdays. And we have grandchildren living as far as Paris.

Josephine admits that the best time she has is with her family. Highly incapacitated by a cardiac condition and progressive visual and hearing loss, she still enjoys running after her young great-grandchildren even if it means physical exhaustion after their visit. Pictures of their grandchildren and great-grandchildren abound on every wall of their living room.

Madeleine, aged 62, describes her home as the center for all family gatherings. The literature provides support for rituals as instruments in linking generations of families.

My two children and four grandchildren are here for Mother's Day, Thanksgiving, Christmas, New Year, and Easter. I know exactly what to prepare for them. I usually bake this friendship bread as a family tradition. . . . I keep in touch with my side of the family and Rich's [her husband] side of the family. In fact, I visited my mother every day after she was institutionalized. I am also the guardian of my mentally retarded sister who is institutionalized and we visit her every week. I have no doubt at all that my daughter, Ellen, will continue to do so after me. She was always with me when we visited my mom up to the day she passed away, and she is very much involved with my sister.

Grandparents in all ethnic groups tend to play the role of a "family watchdog," a latent source of support, a contingency caretaker, ready to provide assistance if a family crisis occurs (Troll, 1983; Werner, 1991).

Diane related her concern for her young grandson, who was delayed in talking and is hyperactive. She suspected that he was being abused. Her son, daughter-in-law, and grandson were living in California.

I visit them whenever I can. I was disturbed by her inability to provide attention to her young son ... She talked when my grandson wanted to talk ... she did not listen nor looked at him when he needed attention. When my son was assigned in Korea, they came to live with me and we really had a good relationship. She was very naive but willing to learn. We shared similar views about many things and she listened to most of what I had to say.

When her son and daughter-in-law divorced, Diane became the adoptive parent of her grandson after he was literally thrust upon her by her son. She became the most logical and natural caregiver for her grandson.

My daughter-in-law did not want to have anything to do with him anymore. Up to this day, I keep contact with my grandson's maternal grandmother. He needs to have connections with the other side of his family.

A grandparent can act as a companion and be an important part of the child's social network. Many enjoy conversations with their grandchildren and can be a source of emotional support, acting as a buffer when the child has a conflict with his or her parents or when parents are in conflict with each other.

The high rate of divorce has underscored the plight of grandparents whose relationships with their grandchildren are cut off or severely restricted by post-divorce custodial arrangements. More commonly, maternal grandparents maintain access to their grandchildren as a result of maternal custody of young children. In contrast, noncustodial grandparents' relationships with their grandchildren are contingent on their relationships with their ex-daughter-in-law. Remarriage by their ex-daughter-in-law often leads to further isolation from their grandchildren.

Minkler and Roe's (1993) study illustrates the significant role of grandmothers in the care and survival of their grandchildren

among African American families with crack-addicted parents. Grandmothers moved into active parenting roles when their adult children and the social institutions failed in protecting their grandchildren.

In his eulogy for his mother, Rose, Senator Edward Kennedy described her as the "glue that kept the family together." Indeed, grandmothers are at the core of family togetherness. They provide reasons for visits from extended family. Their presence ensures conversations about the past, keeping memories and ties alive for younger generations.

Grandmothers' role as family historians is aptly described by one granddaughter (Gill, 1990):

When I was a teenager, I talked a lot about family memories with my grandmother, my mother's mother, who was in her late 80s (she was born in 1886 and died in 1975). She remembered talking to her grandmother (who was born in 1821 and died in 1899) about her grandmother, who had been an emigrée from the French Revolution. My grandmother's grandmother remembered her grandmother, who had been a very old lady in the 1770s and had been to Versailles either in the last years of Louis XIV or the early years of the regency of Louis XV! (p. 10)

The developmental tasks of late life have been described by many authors; for example, Erikson (1959, 1977) posits that the core task of aging is that of "ego integrity vs. despair." He defines ego integrity as the stage where all phases of previous life come together. The elder's task is one of acceptance of her one and only life cycle. Failure to accept one's past life predisposes the elder to "despair," a state of oblivion and meaninglessness without linkage with significant others. Facing the inevitability of death, the aged person is absorbed in personalizing death and creating a sense of connectedness with those left behind.

Butler (1963) refers to the elder's obsession in transcending mortality as the *process of life review:*

[It is] a naturally occurring universal mental process characterized by progressive return to consciousness of

*past experiences and particularly the resurgence of unre-
solved conflicts; simultaneously and normally these re-
vived experiences and conflicts can be surveyed and
reintegrated. Presumably, this process is prompted by the
realization of approaching dissolution and death and the
inability to maintain one's sense of personal invulnerabil-
ity. (p. 66)*

A Second Chance at Parenting

Grandmothers in Minkler and Roe's (1993) study spoke of their
great personal sacrifice and denial of self-interests and ambition
when they took on active parenting roles for their grandchildren.
For these women, there was no other choice to make. Some gave
up their occupational careers, others lost their spouses because
of conflicts that arose, and a great majority were thrust into a
state of poverty. Grandmothers described their isolation from
previous support—especially from their church, which failed to
understand their inability to create significant changes in their
drug-addicted children's lives.

Assumption of grandmothering roles for these women entailed
a long process of disillusionment from two fronts: first, with a
crack-addicted child who is unwilling or unable to kick the habit
and care for his or her children, and second, from their interac-
tion with a social service bureaucracy whose rules often hurt the
very people they are supposed to protect.

Grandmothers experienced conflicting emotions—relief and
happiness that they were able to help their grandchildren, and
anger and despair that they had been placed in this position.
Their mixed emotions were complicated by a great sense of guilt
associated with their failure in bringing up their own children.

Most of them had expected and looked forward to babysitting
and helping out with the grandchildren in a peripheral rather
than central caregiving capacity. As one grandmother stated:

*I'd just like to be in the sidelines and, if needed, to be able
to help out not because I have to but because I want to.
There's a difference between doing things because you
want to and doing things because you have to. When you*

do things because you want to, you can appreciate them
more. But when you're doing things because you have to,
you get some pretty bad thoughts sometimes." (Minkler &
Roe, 1993, p. 31)

Diane initially was resentful for having had no control over decisions regarding where her grandson, John, should live after her son's divorce. They came to visit her, left him with her, and refused to take him back. If she did not take him, he would have surely ended up in a foster home. Taking on additional responsibility late in her life was a better choice than sending him to a stranger's home.

John was six years old when he moved in with Diane. As an administrator of a college program, Diane was active in her professional organizations, traveling most of the time to meetings and networking activities. Diane had to find a reliable babysitter. She had to resume activities that most parents with young children were expected to do. She attended parent–teacher meetings, special counseling sessions, and the usual childhood health checkups with dentists and physicians. She also had to find suitable after-school activities for John. He needed a special school because he was delayed in talking and was suspected to be learning disabled.

Like others in similar situations, Diane sought comfort from a support group composed of grandmothers who found themselves actively parenting young grandchildren. The cathartic value of such groups was reiterated by many grandmothers (Minkler & Roe, 1993, p. 109):

The grandparents really open up and let it out. They cry,
they really explode. You sit there with them and they're
crying and you cry with 'em, and they're wipin' their eyes
and you're wipin' yours. It just all sort of comes out.

I think that's what we go for—to holler and scream and
cry.

Being among people with similar problems relieves a lot
of stress because they can understand and relate to what

you're saying and you don't feel bad or embarrassed about it.

Diane tearfully relates the first incident when John was able to inform her about a previous incident at home:

He was able to make me understand what happened to him ... how he fell downstairs, hurt himself, and was frightened by the experience. He was able to let me know, when all along no one could follow what he was saying. He needed to connect, and I was able to do that for him.

At 12 years of age, John is in the academically talented group. Diane states:

Now, I can say that I was able to make a difference. Part of the reason is that I have learned from my past. I feel I am able to become a better parent to John since I have learned from previous mistakes in myself and my parents. Essentially, he has given me a second chance to be a better parent. As I become older, I am wiser and more ready to accept my mistakes.

Grandparents are repaid by their grandchildren in sentimental currency—love and affection (Cherlin & Furstenberg, 1986). Some women state that taking in a drug-exposed grandchild was finally something positive that they could do for their drug-addicted child, which brought them peace and satisfaction. One grandmother describes this feeling when speaking about her troubled daughter and granddaughter (Minkler & Roe, 1993, p. 175):

She knows that this is a safe place for her baby. She knows that my home is gentle. She remembers that she felt love in this house, that we touch a lot, that we carry our little traditions. She's beyond help now but it's not too late for the baby ... she needs a lot of help and my daughter knows she can't give it to her.

Grandmothers reiterate their comfort at having had a second chance at parenting and doing it right this time around. Inherent in growing older is the wisdom from past experience. For these grandmothers, history is reconstructed and reexamined with positivism and altruism. This process allows for integrating previous life into the present with increased self-acceptance, self-tolerance, and self-affirmation.

Studies of family caregivers for the elderly have found that many report satisfactions and rewards in their new role, including a feeling that one grew as a result of the caregiving experience, a general satisfaction at having helped someone in need, and a discovery of new personal strengths and capacities as a result of caregiving (Henrichsen & Hernandez, 1991). Similarly, grandmothers describe a process of self-transformation that imperceptibly occurs as they grow into their roles as parents, the second time around. They begin to redefine themselves by reframing their present life in a way that allows stretching its boundaries to highlight the positive.

Transmitting the Culture of Caring

Grandmother caregivers share other important similarities with women caregivers for the elderly. They are typically middle-aged and may have chronic health conditions that are exacerbated by frequent lifting and carrying, emotional stress, and the many demands associated with caregiving. The low socioeconomic status of many grandparent caregivers and the well-documented relationship between social class and illness suggest the likelihood of significant health problems in this population (Brody, 1985; Kaplan, Haan, Sime, Minkler, & Mysinski, 1987; Stone, Cafferata, & Sangl, 1987).

Among Black American grandmother caregivers, stress-related conditions emerged after they became active parents for their grandchildren. These symptoms included broken clinic appointments, insomnia, and sudden flare-ups of previously controlled conditions such as asthma, hypertension, and arthritis (Miller, 1991).

Stack (1974) wrote of the highly adaptive, extended network of family support systems among low-income Black communities. Some authors protested the glorification of Black motherhood as

being richly endowed with devotion, self-sacrifice, and unconditional love, by Black male scholars who thereby created a burden of expectation of Black women in general (Dance, 1979; Weems, 1984). Collins (1990) argued that Black motherhood is a contradictory institution. It can be rewarding, but it can also extract high personal costs. In fact, the assumption of full-time caregiving for one's grandchildren, and doing so under the circumstances of the crack-cocaine epidemic, was, for many, a far more difficult experience.

Yet, many of the grandmothers in Minkler and Roe's (1993) study articulated the pluses of caregiving despite all the hardships involved. Fifty-four-year old Sarah, whose own children "didn't turn out very well," stated that raising a young granddaughter, and being able to help her overcome the emotional scars of early abuse and neglect, provided an important sense of pride and accomplishment. Her perceptions were echoed by another grandmother:

> *I've changed my way of thinking. Sitting down eating a lot of greasy food like you did at those senior centers, that is not getting you anywhere. I like raising my grandson because I can educate him, make available numbers and things. (p. 63)*

These grandmothers develop highly individualized coping strategies to redefine their life. One such strategy is *comparing.* They find tremendous strength in relating their present situation to other events in their own lives, to the situations of others around them, or to their image of how much worse things could be. Comparing changes their perspective on the problem and helps them manage the meaning of the situation, so that the threat it poses is reduced (Pearlin & Aneshensel, 1986). Grandmothers in their support group have become their primary reference group, isolating them and cushioning the dissonant reality of their lives from mainstream society. As one grandmother stated:

> *I can't complain or feel sorry for myself when I see how bad it is for others. It makes me want to try and help them in some way, which is sort of comical since I can hardly*

help myself! But you have to wonder how they're going to make it. (Minkler & Roe, 1993, p. 125)

McAdoo (1982) has reported that a most frequent response to a problem by upwardly mobile African American families was "to think about it myself, stay calm, and do what was needed" (p. 485). Grandmothers mention calling upon their own resources, reaching deep inside, and finding an inner peace or focus. As 65-year-old Nell states:

I've had a place inside me that no one has ever found. It's there waiting for me, whenever I need it. All I have to do is find me a few quiet moments and I can go there in a minute. Sometimes in the bath, even doing the dishes or standing over the rice on the stove. If I didn't have that little place, I couldn't get through some of the days I'm facing. (Minkler & Roe, 1993, p. 38)

Another coping strategy mentioned by these grandmothers was focusing and thinking about the grandchildren. Its underlying theme is explained by these two grandmothers (*ibid.*, p. 122):

I think about them [four grandchildren]. That keeps me going.

I'm learning to cope. You can have a pity party for 15 minutes, then you solve the problem. You look at this girl who can't take care of herself and say, "What happens to her if you commit suicide or run away?" Little kids are so helpless.

The philosopher Nel Noddings (1984) explicates the cognitive aspects of caring as: having the knowledge of another's perspective (empathy) and a motivational displacement, which is the ability to displace one's own interests and motives for those of the person for whom one cares. According to the author, "mental engrossment is on the cared-for, not on ourselves" (p. 24).

Gilligan (1982) theorizes that the capacity to care responsibly for very specific others evolves through three types of caring.

One type is the inclination to care for oneself, to protect the self from more powerful others. A second type of caring focuses on conventional social views of being good, tactful, not hurting others, and winning the approval of others. In the third type, there is an attempt to balance nurturing others and caring for oneself so that both persons are honored. This type of caring, according to the author, represents the height of moral maturity in women, reflecting the strength of caring and women's ways of relating to others. Women at this level recognize both their desire to be responsive to others and their latitude and freedom within others' expectations of themselves.

Feminist literature, on the other hand, opposes this view of caring. Wood (1994) argues that caring necessarily involves self-denial and loss of an autonomous self. Whereas others are empowered by caring, it has extracted high costs from women who are placed in the position of caregivers by social and cultural forces beyond their control. Preoccupation with giving and the larger tendency to displace one's own motives have the potential to induce caregivers to deny, distort, and devalue, or otherwise repress their own impulses, goals, needs, and desires. Several authors protest the societal devaluation of caring in the public sphere, which upholds masculine, instrumental, and achievement orientation (Goodman, 1991; Hare-Mustin & Marecek, 1990; Janeway, 1971; Okin, 1989; Rowbotham, 1973). Rhode (1990) points out that the cultural tendency to extol women's tendency to care is entirely predictable because it serves the purposes of those who generally benefit from women's care. The author finds irony in defining caring for others as power: care relationships are necessarily asymmetrical because caring gives power over to the other.

Research on the family suggests that the roles of men and women are distinct (Hagestad, 1985). Ties between mothers and daughters are said to be the strongest links; married daughters and their mothers supposedly do much of the work of keeping families in touch. Women are said to be the "kinkeepers" or "lineage bridges" whose efforts hold kin groups together. Men are found to specialize in task-oriented, instrumental family roles; women specialize in nurturant, emotion-laden, expressive roles such as rearing children and comforting adults. Grandmothers do

more of the kinkeeping and have warmer, more expressive relationships with their grandchildren.

Studies of grandparental caregiving reveal great variability in terms of intensity, meaning, and occurrence. Cherlin and Furstenberg (1986) find differential effects on grandparental roles conditioned by changes in many fronts: fertility, longevity, technology, social security, and standards of living in old age. The authors describe the existence of different styles of grandparenting. Many grandparents prefer the *companionate style* of caregiving, which is characterized by leisurely, easygoing, friendly interactions with their grandchildren. Where little contact exists between generations, a *remote style* emerges; this is a purely symbolic and ritualistic type of relationship. In the *involved style* of grandparenting, such as the one described by grandmother caregivers in the crack-cocaine affected families, parental authority and control over grandchildren occur. This type of grandparenting is precipitated by a crisis or disruptive event.

Grandparenthood is a contingent process whose playing out is influenced by a host of variables (Troll, 1985). Caregiving by grandmothers is contingent on many factors: their own health, economic status, and age; ethnicity; geographical distance from their children and grandchildren; ages and gender of their grandchildren; and situational events in their extended family (Bengtson & Robertson, 1985). Caregiving for young grandchildren is different from caregiving for adolescent grandchildren. Divorce creates both opportunities and dilemmas for grandparents. The opportunities arise from the need parents and children have for assistance after divorce. Grandparents, especially on the custodial side, can maintain or even deepen their relationships with their children and grandchildren by providing material assistance, a place to live, help in child rearing, guidance, or advice. The dilemmas arise from constraints imposed on grandparents, particularly on the noncustodial side, by the actions of the middle generation. Another dilemma occurs when a grandparent assumes full-time caregiving of young grandchildren during dissolution of an adult child's family.

The type of caregiving that emerges in grandparenting is shaped by contingency needs. As nurturers, grandmothers are the second line of defense. They serve as a safety net for children

whose parents are unable to provide care (Kornhaber, 1985). Grandmotherhood is not a continuation of the parenting role. Grandparents help, but only when needed, and the type of help extended is contingent on the need (Wilson, 1984).

Family linkage to the elderly person is of critical importance. It has extreme influence on his or her relationship with nonfamily individuals and outside organizations (Sussman, 1976). Research strongly supports grandparents' desire to have intimate and close contact with their grandchildren. This closeness in turn appears to create positive feelings in the elders. Many indicate that they were glad they could be there for their grandchildren, and that the new caregiving role was well worth the costs—an indication that the negative effects of caregiving are viewed as less impor- tant and troubling than might otherwise be the case (Young & Kahana, 1991). For most grandparents, caregiving for their grand- children has created a positive life change.

Caring by grandmothers is not a uniform phenomenon. Among middle-class families, defining the roles of grandmotherhood has been difficult. It tends to be ideological rather than real; it is not based on normative rights and obligations. By contrast, among lower classes, grandparenting roles are more defined in terms of functions, and grandmothers tend to occupy central positions within the family (Smith, 1991).

The meaning of grandmotherhood may be described as "cen- trality," the perceived importance of grandmotherhood to the individual (Kivnick, 1982). One of the formal dimensions of grandmotherhood is its centrality in biological renewal and con- tinuity by surviving through one's offspring (Benedek, 1970). In a symbolic sense, it ensures social continuity through social con- struction of biography by grandmothers acting as reservoirs of family wisdom (Bengtson, 1985; Neugarten & Weinstein, 1964). One of the symbolic features of grandmotherhood is being there to act as an arbitrator for the young generations (Bengtson, 1985).

It is evident that, regardless of the context in which grand- mothers provide care, the positive transformation in themselves and the opportunities for linkages and connectedness with signif- icant others remain consistent. In the process of caring for oth- ers, grandmothers experience growth in themselves and ensure

their legacy for the future. As they care for others, grandmothers empower their significant others by modeling and demonstrating a process that will, in turn, ensure continuity and survival of these young generations into their own old age. Grandmothering is living a type of caring and love, with no expectations of reciprocity. Reciprocal gains are highly introspective. They are measured by their meaning, which only grandmothers and their care recipients appreciate as they live through the experience.

Grandmothers' care should be recognized and allowed to flourish. Politicizing the issue of caring as it pertains to these grandmothers negates their natural prowess for caregiving and prevents enactment of their protective impulses to hedge against meaninglessness and oblivion. Debate should focus on the assistance and support that society must provide to nurture this caring tendency that exists among grandmothers.

ABOUT THE STUDY

Phenomenology was chosen as the vehicle to unfold the mystical, transformational, and relational aura associated with grandmotherhood. By eliciting the personalized, subjective descriptions of grandmothering by women as they live through the experience, the emic emphasis of the experience is brought into focus. Grandmothers' tales have been the starting point from which patterns of themes are drawn about the subject.

Findings from the review of literature have been bracketed and their applications initially suspended to underline the supremacy of grandmothers' conversations as the salient, organizing themes for data analysis and presentation.

REFERENCES

Apple, D. (1956). The social structure of grandparenthood. *American Anthropologist, 58*(4): 656–663.
Benedek, T. (1970). Parenthood during the life cycle. In E. J. Anthony & T. Benedek (Eds.), *Parenthood: Its psychology and psychopathology*. Boston: Little, Brown.

Bengtson, V. L. (1985). Diversity and symbolism in the grandparental role. In V. L. Bengtson & J. F. Robertson (Eds.), *Grandparenthood: Research and policy perspectives*. Beverly Hills, CA: Sage.

Bengtson, V. L., & Robertson, J. F. (Eds.) (1985). *Grandparenthood: Research and policy perspectives*. Beverly Hills, CA: Sage.

Brody, E. M. (1985). Parent care as a normative family stress. *The Gerontologist, 25*(1): 19–28.

Butler, R. (1963). The life review: An interpretation of reminiscence in the aged. *Psychiatry, 26*(1): 65–76.

Cherlin, A. J., & Furstenberg, F. F. (1986). *The new American grandparent: A place in the family, a life apart*. New York: Basic Books.

Collins, P. H. (1990). *Black feminist thought: Knowledge, consciousness, and the politics of empowerment*. London: Harper Collins Academic.

Dance. D. (1979). Black Eve or Madonna? A study of the antithetical views of the mother in Black American literature. In R. Bell, B. Parker, & B. Guy-Sheftall (Eds.), *Sturdy Black bridges: Visions of Black women in literature* (pp. 123–132). Garden City, NY: Anchor Books.

de Beauvoir, S. (1973). *A very easy death*. New York: Warner Paperback Library.

Erikson, E. (1959). *Childhood and society* (2nd ed.). New York: Norton.

Erikson, E. (1977). *Toys and reasons: Stages in the ritualization of experience*. New York: Norton.

Gill, A. (1990). Personal communication (p. 10). Quoted in Smith, P. (1991). *The psychology of grandparenthood: An international perspective* (ch. 1). London: Routledge.

Gilligan, C. (1982). *In a different voice: Psychological theory and women's development*. Cambridge, MA: Harvard University Press.

Goodman, E. (1991, July 26). Judge Thomas' latest self-made star. *Raleigh News and Observer*, p. 13-A.

Hagestad, G. O. (1985). Continuity and connectedness. In V. L. Bengtson & J. F. Robertson (Eds.), *Grandparenthood*. Beverly Hills, CA: Sage.

Hare-Mustin, R. T., & Marecek, J. (1990). Gender and the meaning of difference. In R. T. Hare-Mustin & J. Marecek (Eds.), *Making a difference: Psychology and the construction of gender* (pp. 22–64). New Haven, CT: Yale University Press.

Henrichsen, G. A., & Hernandez, N. (1991, November). *Problems and rewards in the care of depressed older adults.* Paper presented at the annual meeting of the Gerontological Society of America, San Francisco.

Hershman, M. (1992, October 4). No burden to bear. *The New York Times,* pp. 18, 20.

Huesmann, L. R., Eron, L. D., Lefkowitz, M. M., & Walder, L. O. (1984). Stability of aggression over time and generations. *Developmental Psychology, 20,* 1120-1134.

Janeway, E. (1971). *Man's world, woman's place: A study in social mythology.* New York: Delta.

Kaplan, G. A., Haan, M. N., Sime, S. L., Minkler, M., & Mysinski, M. (1987). Socioeconomic position and health. In R. W. Amber & H. B. Dull (Eds.), *Closing the gap: The burden of unnecessary illness* (pp. 125-129). New York: Oxford University Press.

Kivnick, H. Q. (1982). *The meaning of grandparenthood.* Ann Arbor, MI: UMI Research Press.

Kornhaber, A. (1985). Grandparenthood and the "new social contract." In V. L. Bengtson & J. F. Robertson (Eds.), *Grandparenthood* (pp. 159-172). Beverly Hills, CA: Sage.

McAdoo, H. P. (1982). Stress-absorbing systems in Black families. *Family Relations, 31*(4): 479-488.

Miller, D. (1991, November 24). *The "grandparents who care" support project of San Francisco.* Paper presented at the annual meeting of the Gerontological Society of America, San Francisco.

Minkler, M., & Roe, K. (1993). *Grandmothers as caregivers: Raising children of the crack-cocaine epidemic.* Newbury Park, CA: Sage.

Neugarten, B. L., & Weinstein, K. J. (1964). The changing American grandparent. *Journal of Marriage and the Family, 26:* 199-204.

Noddings, N. (1984). *Caring: A feminine approach to ethics and moral education.* Berkeley: University of California Press.

Okin, S. M. (1989). *Justice, gender, and the family.* New York: Basic Books.

Ovrebo, B., & Minkler, M. (1993). The lives of older women: Perspectives from political economy and the humanities. In T. Cole, A. Achenbaum, P. Jakobi, & R. Kastenbaum (Eds.), *Voices and visions: Toward a critical gerontology* (pp. 289-308). New York: Springer.

Pearlin, L. I., & Aneshensel, C. (1986). Coping and social supports: Their functions and applications. In L. H. Aiken & D. Mechanic

(Eds.), *Applications of social science to clinical medicine and health*. New Brunswick, NJ: Rutgers University Press.

Peck, R. (1968). Psychological developments in the second half. In B. Neugarten (Ed.), *Middle-age and aging* (pp. 88–92). Chicago: University of Chicago Press.

Pincus, A. (1967). Toward a developmental view of aging for social work. *Social Work, 12*(3), 33–41.

Reichard, S., Livson, F., & Peterson, P. G. (1962). *Aging and personality: A study of eighty-seven-year-old men*. New York: Arno Press.

Rhode, D. L. (1990). Theoretical perspectives on sexual difference. In D. L. Rhode (Ed.), *Theoretical perspectives on sexual difference* (pp. 1–9). New Haven, CT: Yale University Press.

Rowbotham, S. (1973). *Women's consciousness, man's world*. Harmondsworth, England: Penguin.

Smith, P. K. (Ed.), (1991). *The psychology of grandparenthood: An international perspective*. London: Routledge.

Stack, C. (1974). *All our kin: Strategies for survival in a Black community*. New York: Harper & Row.

Stone, R., Cafferata, G. L., & Sangl, J. (1987). Caregivers of the frail elderly: A national profile. *The Gerontologist, 27*(5): 616–626.

Sussman, M. B. (1976). The family life of old people. In R. H. Binstock & E. Shanas (Eds.), *Handbook of aging and the social sciences*. New York: Van Nostrand Reinhold.

Troll, L. E. (1983). *Grandparents: The family watchdogs*. In T. H. Brubaker (Ed.), Family relations in later life. Beverly Hills, CA: Sage.

Troll, L. E. (1985). The contingencies of grandparenting. In V. L. Bengtson & J. F. Robertson (Eds.), *Grandparenthood* (pp. 135–150). Beverly Hills, CA: Sage.

U.S. Bureau of the Census. (1991). *Current population reports: Marital status and living arrangements: March 1990*. (Series P-20 No. 450.) Washington, DC: Government Printing Office.

Weems, R. (1984). Hish, Mama's gotta go bye-bye: A personal narrative. *Sage: A Scholarly Journal on Black Women, 1*(2): 25–28.

Werner, E. E. (1991). Grandparent-grandchild relationships among US ethnic groups. In P. K. Smith (Ed.), *The psychology of grandparenthood: An international perspective* (pp. 68–82). London: Routledge.

Wilson, M. N. (1984). Mothers' and grandmothers' perceptions of parental behavior in three-generational Black families. *Child Development, 55*, 1333–39.

Wood, J. T. (1994). *Who cares? Women, care, and culture.* Carbondale: Southern Illinois University.

Young, R. F., & Kahana, E. (1991, November). *Racial dimensions of caregiving.* Paper presented at the annual meeting of the American Public Health Association, Atlanta, Georgia.

9

On Being Different: In Women's Experience

Vickie Schoolcraft, Sheila Hopkins, Joan Davis, and Jessie Colin

BEING BORN DIFFERENT

*F*rom the moment of birth, a female may be considered different from the norm, which is frequently defined as being male. The English language has few generic words to include both men and women. Even words that are intended to be inclusive usually have a male concept imbedded within them: hu*man*, huma*ni*ty,

All the contributors to this chapter are nurse educators who work together in a school of nursing in Florida. They are in their 40s and 50s. Subjective material discussed in the first person, unless otherwise attributed, may have originated from any one or more of the contributors.

*man*kind, *homo* sapiens, or per*son.* The word wo*man* inevitably implies that women are somehow modified men.

This bias can even turn up in concerns that seem to be completely mathematical. I was startled, while reading a book on research methodology, to find this very thing. In a discussion of coding data, the writer said that, in dealing with only two possible manifestations of a variable, a 1 would signify the presence of the variable and a 0 would denote the absence of the variable. As an example, he used gender: a 1 would be for male, and a 0 would be for female. The author was not describing the use of these codings in a specific study; being male or female had nothing to do with the study itself. His frame of reference seemed to be that male was the norm and female would always be 0 on the gender scale.

I don't want to seem naive about how men and women are different, but why are so many of the differences that women manifest seen as weaknesses or less desirable traits in comparison to characteristics attributed to men? Why should girls and women start out with a self-concept that depicts them as being different in a somewhat negative way? Using this narrow definition, women are then supposed to be not only different from men, but like one another! Their difference from men is immediately apparent, but differences within the gender are more easily concealed. As a girl or woman becomes aware of ways in which she may differ from the societally acceptable concept of being a woman, she may become uncertain or frightened of the consequences of her differentness. Or, she may glory in being the individual she perceives herself to be.

Both fear of difference and joy in difference emerged in the women we studied in exploring this phenomenon. Sometimes a particular sense of difference caused the same woman to sequentially or simultaneously feel fear and joy. Stories about women from literature and cinema; our own stories and those of our acquaintances—all abound with awareness of and struggles with being or feeling different.

VOICES OF WOMEN IN LITERATURE AND FILM

Conflict arises in the inner negotiations between being the same and being different: "If I can understand, accept, and

respond to what someone else needs, why then am I so different in wanting some part of me to be acknowledged and reaffirmed also?" Forty-odd years ago, Anne Morrow Lindbergh, in *Gift from the Sea*, spoke of women's need to give: "I believe that what woman resents is not so much giving herself . . . [but that] woman's creation is so often invisible" (p. 46). She seems to have been saying that women often lose their identities not only by being different from men but also by being too much like what women are expected to be. Anne Lindbergh spoke about the conflict of inner convictions with the outer pressures on women. She said this conflict causes women to seek an inner stillness amid the many social demands placed on them. Lindbergh found inner stillness: "the still axis within the revolving wheel of relationships, obligations, and activities" (p. 51). This solitude of inner reflection helps women to value their differences and find their true individuality.

Lindbergh described her process of beginning to write down her thoughts and feelings in a journal as a way to reflect on her life. She expressed the idea, "I had the feeling, when the thoughts first clarified on paper, that my experience was very different from other people's" (p. 9). She also wondered parenthetically, "Are we all under this illusion?" It seems that when she considered her own life, she found more similarities and harmony in the responses of others to what she had written than she ever expected.

One of my conversations with a gay woman reminded me of the book, *I Wonder Why Some People Don't Like Me,* written by Shirley Burden in 1963. The book shows lovely pictures of raindrops, the sea, babies, puppies, and other wonderful things, each with a caption that says, "I like rain," or "I like the ocean," or "I like puppies," and so on throughout the book. The last page shows a sad little African American girl; the caption is, "I wonder why some people don't like me." This book makes a powerful statement about what it feels like to be different!

Women's feelings of difference can be found in many books by and about women. One classic, Charlotte Brontë's *Jane Eyre,* is a typical example. Jane saw herself as frail, small, and homely, yet capable of willing herself to do whatever she chose to do. She had been orphaned, left with an uncle, who died, and then sent to an orphanage school by her aunt, who did not like her. She spent ten years at the school and earned her qualification to teach. At 18,

she left the orphanage to become a governess. Although Jane was satisfied in her employment, she felt a stronger yearning to see and go beyond the closed gates and hills around the estate. She obviously believed that women were equal to men but were treated differently because of their gender. According to her, societal rules made by men dictated that women should be generally calm and confine themselves to things of the home, such as cooking or sewing. During her employment, she fell in love with her employer, Rochester, who came to love her for her differences from other women. In the vein of the melodramatic literature of the era, on their wedding day, Jane learned that her love was already married to another woman, who had gone mad and was sequestered in a secret part of the house. Jane ran away but returned after several months to find that the first Mrs. Rochester had set the house on fire and burned to death. Jane was then free to marry Rochester. Readers today wonder whether Brontë intended some irony in her plot: the woman who tried to fulfill social and cultural expectations went mad and ultimately destroyed herself. The way was then open for a more unconventional woman to replace her and find a deeper happiness.

In *The Miracle Worker,* two women who were different became allies: one helped the other to become a full-fledged person. Helen Keller was quite different, being afflicted with multiple physical challenges of being blind, deaf, and mute. With no real frame of reference because of her sensory isolation, Helen may not have felt different, as would people who are more aware of their separateness from others. Helen's teacher, Annie Sullivan, was aware of her own differences from others. She was grappling with a progressive loss of sight and an abrasive demeanor that distanced her from others. Annie was a determined, strong-willed person who struggled to communicate with Helen, sometimes in conflict with Helen's parents. Ultimately, Annie's defiance and strength, so different from the accepted characteristics for women of the time, elevated Helen from an animallike existence to an awareness of herself as a human being. In another touch of irony, Helen then began to perceive and deal with her awareness of her differences from other human beings.

My first "favorite" book was *The Secret Garden* by Frances Hodgson Burnett. I discovered it in a small library in my sixth-

grade classroom. I was captivated by the touching story of two cousins who were unwanted by their parents. The central character, Mary Lennox, is described in the opening passage:

> ... *everybody said she was the most disagreeable-looking child ever seen. It was true, too. She had a little thin face and a little thin body, thin light hair and a sour expression. Her hair was yellow, and her face was yellow because she had been born in India and had always been ill in one way or another. (Burnett, p. 1)*

After Mary's parents died from cholera, she was discovered alone in their house in India. Everyone who knew of her existence had forgotten her. She was shipped to England to live with her uncle, a widower who refused to see his young son because the boy reminded him of his wife, who had died giving birth to the child. Mary discovered her cousin, who was treated as an invalid. He was cross and given to fits of temper. Accustomed to having her own way, Mary exerted control over him by threatening to withdraw the only thing she had that was important to him: her companionship. Both children felt different because they tended to be sickly and because they were unwanted. Mary, her cousin, and a neighbor boy found a secret garden that had been locked away, also unwanted and nearly forgotten. As the children toiled together to bring the garden to flower, they found themselves coming alive and gaining a feeling of belonging, being wanted, and no longer feeling different.

The other day, while roaming through the library, I picked up an audiocassette of *Sing to Me of Dreams,* by Kathryn Lynn Davis. I was so entertained with the audio version, I found and purchased the book, in order to better absorb the elements of this fascinating story. Tanu, a young Salish woman born of a white father and an Indian mother, illustrates the dichotomy of the specialness accorded being different and the sense of alienation from others. Tanu's birth was the beginning of her differentness:

> *The child was born on a night of moon and thunder and a wind that sang high, sweet and clear, naming this a night of miracles.... The People crouched outside the hut of*

woven mats, silent, expectant, for they felt the chill of magic in the air. . . . Koleili turned in the golden light, hands on her swollen belly, weary from the ebb and flow of pain, thinking of the Stranger who had given her this child. . . . The girl-child came so quickly that the women were without speech. . . . Outside the People murmured songs of gratitude and worship. . . . Thus she was born and blessed, the Child, the Prophet, who would bring the People to thrive among the Many Flowering Waters on the Island of the Raven in the light of the misted sun. So it was promised, so it had come to be. (Davis, pp. 1–3)

Far from being happy with this attribution of near-deity for her difference, Tanu felt her father had "poisoned" her blood by making her so different from her people. She was expected only to care for the needs of her people, and to have none of her own. She was forbidden to marry within her own tribe because of the power she was believed to possess. To satisfy her own needs, she had to leave her tribe to go among others who were also different from one another.

Finally, in a different genre of literature, I found an interesting account of the relationship between Hans Christian Andersen, the writer of children's stories, and his "sisterly" friend, Henriette Wulff. This interesting account was woven into a mystery story by M. D. Lake. One of the characters in Lake's story was a college student doing a senior thesis on Wulff, and she periodically shared parts of it with the protagonist, a woman who was a campus cop. Andersen, the illegitimate son of a prostitute, was from the lower classes. When his stories became popular, he was accepted in a conditional way by the upper class. He met Wulff and they became friends, maintaining a long and rich correspondence as they both traveled. The relationship never progressed from a friendship, it was thought, because Wulff was small, hunchbacked, and not at all pretty. Because of her inability to attract a husband, she had no children, and her life was very different from that of most women of her time. She seemed always to regret the absence of children, and conveyed a feeling of being different by being incomplete. At one point, the character who was writing about Wulff said, "So being different was what made both Andersen and her [Wulff] human. . . ."

Perhaps that last statement is too tidy a formula, but this mood seems to suffuse other accounts of being different. In the film *Working Girl,* Melanie Griffith played Tess, a young, talented woman who was different from her friends because she desired to be successful in the male-dominated business world. By setting goals different from those of her peers and her lover, she puzzled her friends and gave her lover an excuse to have an affair with another woman. She tried to be successful by duplicating the appearance and the ruthless behaviors of the successful woman she was emulating, but she wasn't comfortable in that guise. The model businesswoman portrayed in the film was selfish, exploitive, and devious, and she identified with traditionally male values. Tess was not like that. She triumphed by using her differences: her honesty, creativeness, and respect for other talented people, including women.

The film *The Ballad of Little Jo* is purportedly based on a true story. An unmarried woman in the 1800s was thrown out of her home because she bore a child. This was the initial difference of the film's title character, Josephine. As an unwed mother, she was unacceptable in her society and to most of her family. She went West to try to make a new life, but found that even though the society there was rugged and quite different, women were still seen as either "nice" or as whores. After several unpleasant incidents, she scarred her own face, chopped off her hair, and donned the clothing of a man (illegal at that time). She finally found a community where she was able to live, work, and delude her neighbors. She managed to succeed with her deception by avoiding intimate relationships and by isolating herself for much of her life.

After saving a Chinese man from being killed by some of the townspeople, she was expected to take care of him by letting him work on her ranch. He saw through her disguise after only a few days of close contact. They became lovers, but they could not make her true identity public and have an open relationship because of his race. He made her realize that she could never recover her public identity as a woman or she would be in even more danger than ever before. She had to permanently adopt her difference as a woman who seemed to be a man. She was respected within the community, although always on the outskirts of the group. She was a peacemaker and a defender of the values

of the sheep ranchers, of which she was one. She integrated the style of a woman for dealing with conflict and had the power to do so because she seemed to be a man. She managed to perpetuate the myth of her identity for the rest of her life, living with and surviving her lover. When Jo died and her true gender was discovered, a woman who had known her for many years was overcome with laughing, but the man who had been closest to being her friend was enraged. He had always told her she was different, but had never guessed the source of that differentness.

One common theme seems to run through all of the books and movies we reviewed. Even though the actual differences may vary, they all appear in some way related to women's seeking a destiny of sorts, whether in the love of some person or the love of some thing. These women's experiences of feeling different were similar to self-assigned goals or struggles other women have felt in meeting or fulfilling their own destiny. Life seems to be a constant struggle with feelings of difference for all women. Perhaps the feelings are calmed or resolved periodically, but they frequently reemerge at the most vulnerable times in women's live.

WOMEN TALK ABOUT THEIR OWN EXPERIENCES AS WOMEN

Sheila

When I was about 19 years old and had known little of the world, my girlfriends and I talked for hours about life and religion and goodness and evil and love and hate. We had decided that we would create a new world—a world that would be a great age for women; when there would be women of honesty, strength, wisdom, and power, who would not lie awake troubled by bad dreams of loneliness and manipulation by men. We would be dedicated to caring for each other as women and we would help other people. We would always be honest and share our most private thoughts and feelings. We would be nurses and wives and mothers. We just knew that caring for others would bring us happiness and fulfillment. We swore our loyalty to each

other and to all women. We were open and honest with each other.

We no longer live together in a comfortable dorm sharing our joys and heartaches. Many of us have lost contact with each other, but a few of us have continued to "keep in touch." All of us have gained and lost relationships with many other women and men throughout the years. We are in our late 50s now. Each has tried to hang on to her own fairy tale. We now share our successes, our "similarities."

Often, the stories we tell are jaded. Although the glimpses we get of each other's troubles (reading between the lines or hearing remarks) may provide vicarious insights into our own problems, we have learned through our travels in life that everyone covets the attention of a winner, and that when a hand is extended we may expect a slap instead of a pat for being different. We have become wary and fear that each of us is more different than similar. Somewhere deep inside, we long to relinquish the banal half-truths and the safety of conformity. Perhaps we saw similarities more than differences. Perhaps that is what has led to misunderstanding as we tried to maintain our friendships. We thought we thought alike. There was comfort in that, but now we wish to reveal our "true selves," to have differences acknowledged and accepted. We wish to be able to find honest kinship. We believe that public confession and group support can persuade women to accept themselves and other women (after all, that's how the women's movement was revitalized in the 1960s, with consciousness-raising groups). This honest sharing of experiences was and can be an effective means for women to explore and expand. We women can continue to enhance our human potential. Instead of the consciousness-raising groups that spoke to similarities, now maybe it's time for women to revel in their differences and create a new world that allows women to gain in knowing their differences.

Describing oneself is a difficult task. Describing feelings about being different is even more uncomfortable. I feel I am different in what I want, more than anything, to be kind and good and fair, and I wish to be experienced in

that way. I assure myself that I will not allow differences that are, after all, minor and external to create conflict in relationships that I covet. Yet, at times, other people seem actually to want me to be otherwise, and conflict develops. They want me to be kind, good, and fair to them, but they don't want me to be as honest and direct as I can, in my relationship to them.

It has taken me several years and many wakeful nights to understand that being different has something to do with being alone. No matter how similar we may be to others, each of us is ultimately alone because of our physical separateness and psychological uniqueness. The unpleasant side of being different and alone is the fear of growing old alone, of making choices alone, of taking a stand for what I need, want, believe in, and am willing to share, because it might mean isolation; I know that my actions that support my opinions may antagonize others and jeopardize my connection to them. The satisfying side of being different and alone is that I can rejoice in living my values; I can cherish my solitude in my home, at the beach, in a chapel—wherever I feel a sense of belonging, wholeness, and peacefulness; I can embrace the differences that define me as ME.

Joan

As a woman, I would venture to say that we all feel different at various times in our lives. These feelings of difference may be buried in our subconscious and not surface until we come face-to-face with them through communication with another person, a newspaper article, a book, a movie, or another stirring source. Then we say, "Oh! I remember feeling like that." That is not to imply that all women experience the same feelings of being different. In fact, we seem to experience the same differences in different ways.

There are times in my life when I feel like I am experiencing what I call the "Sybil Syndrome." In other words, I feel like I have multiple personalities. I struggle with balancing all the roles I have to play, as well as deciding when

to be different and when to fit in. There are days when I wake up wondering which personality is called for. Am I a mother doing things with my children, a grandmother babysitting, a housewife cooking, cleaning, or shopping, a nurse caring for someone, or an educator teaching? After I have decided who I am, then I must decide what role I am to play. For instance, am I the leader, the follower, or just an observer today? My role may determine my apparel for the day: black, navy, or red for power; yellow or blue for the happy follower; gray or brown for the quiet observer who blends into the woodwork unnoticed.

Next, when must this role be performed? I have to know the time of day for whatever it is I'm supposed to be and do. Time of day not only determines what I wear but also how I will function. Next I come to the where of the role. Being the leader on home turf is comfortable and familiar, but being the leader in a strange place surrounded by strangers requires more time, thought, and energy. Lastly, I must consider the why of the role. Why am I involved in this particular role? Did I choose this role, or have I merely accepted it?

I feel like my existence is in trying to harmonize my many personalities. I think this is all part of my sense of feeling like a woman: juggling the need to be different with the need to fit in.

I wondered how and when these feelings of difference began. I remember feeling different when I first started grade school. I was probably a head taller than all the other children. In fact, I was as tall as my teacher. In my school picture, the teacher is at one end and I'm at the other end, with all my short schoolmates sandwiched in be-tween us. I do not recall my height as being a "bad" differ-ence though, because I was always the teacher's pet or assistant. When the teacher left the room, I got to sit at her desk and take names of those who misbehaved. All the way through grade school, I was the tallest student and, usually, the teacher's pet. Now that I think about it, perhaps all of my teachers were quite aware of my uncomfortableness about my size and made it better for me by allowing me to be their assistant.

When I began to develop breasts at age 10 and not one of my friends was developing, I really felt different. I would wear very large sweaters and shirts and would walk kind of stooped over, hoping no one would notice my blooming figure. Finally, around age 12, I stopped growing and most of my friends caught up with me in height and development. What a relief to no longer be different in that way.

I don't recall ever feeling pretty, so I guess I tried to excel in other ways, such as schoolwork, singing, and anything I thought I could win approval for. My mother was not really good at giving praise or instilling confidence, so in my early years I think I really worked hard for her approval, which never came. Even in my family I was different. I somehow didn't measure up to some unspoken criteria.

Not being different once I was a young woman meant that I needed to have a husband. At age 18 I met a boy of the same age. He was very nice looking, which made me feel that perhaps I was a worthy person. Unfortunately, his looks were about all he had, and the marriage lasted only five years. We were both immature and shallow in our awareness of how to be life partners. I was again different. I had failed at marriage and was a divorced woman. A few years after the marriage ended, I met the man who was to become my second husband. It was through his love and belief in me that I finally realized that I did not need anyone's approval but my own. He gave me confidence and made me feel that I could accomplish anything I wanted to. After 26 years of a wonderful marriage, he died in 1989. It was then that I really felt alone and different. It was like I was in an abyss. I literally felt like my heart was breaking. Twenty-six years to me was my whole life, or so it seemed. Even in a crowd, I felt so alone, as if half of me was missing. I guess I isolated myself by withdrawing from my family and others and pouring my heart and soul into my work. As I look back on that time, I was very productive; I published two articles and went through a very time-consuming promotional process.

Perhaps what I had experienced was only the "normal" grieving process, but I know for at least a year, internally I

was floundering to stay afloat. It took a long time and a brand new marriage to overcome those lonely feelings of difference. There are still times when I feel similar feelings of separation and loneliness resurfacing. For me, involvement with another special person and satisfying work seem to be the answer to staving off those uncomfortable feelings.

Jessie

One day I listened to the members of the group who had come together to examine the meaning of feeling different. As I listened, glimmers of my own youth flashed into my mind. My dad was 20 years older than my mom. He hired maids to attend to her every need, and all she had to do was to stay home and wait for him. I have been told that, as the only child, I was cared for like a precious diamond, always sparkling and never lacking for anything. This must have been wonderful, but I have no recollection of this time. This life was not rosy for my mom. People in the family have said that he was very jealous of his young wife and made her life miserable by keeping a constant watch on her. When I was three years old, she ran away from my dad. She left Haiti to migrate to the United States, leaving me with my great aunt, my grandfather's sister.

My aunt was well educated and was a teacher. She took wonderful care of me. I attended the best schools, socialized in high society, and expressed myself only in French—no Creole was permitted for a child in my social stratum. I was content with my life. When I was five, we moved in with my mom's brother. His wife had also gone to the United States, leaving him with six children. My aunt had also taken in another child from another family member. Suddenly, there were eight children in the family. My world had changed from my being the center of all attention to being just one of an enlarged family. My cousins and I accepted each other readily, and we got along for the most part. My aunt still saw to it that I wore the best clothes, was always neat, received a lot of praise, and was treated as

special by everyone. I felt like I held a special place in my aunt's heart. My differences made me special. Still, I began to be aware of being different from the other children. They referred to me as my aunt's "pet," and sometimes called me the "princess." At times they teased me about being an "orphan" since not only was my mom gone, my dad rarely came to see me. I really felt different and it was painful.

When I was six, my mom sent for me. I was delighted! Not only was I not going to be an orphan any more, but I was going to be with my mother in the United States of America. What a shock when I actually arrived. My differences no longer made me special. I didn't have any friends. I couldn't speak the language. My mom was always working, and my grandmother who cared for me wanted to go back to Haiti. My happy world had vanished, and I cried every day of my six months in the States. Finally, my mom decided to send me back. What a relief! Back in Haiti, my home life was the same as what I had left six months earlier. Although I was still aware of being different from others, I also felt I belonged there.

My world was again disturbed when I was 13. My mom decided it was again time for us to try being together. I felt I was being pulled apart: being forced to join a mother I didn't know in a totally unfamiliar environment with strange people and a completely different language; and feeling the need to be with my loving aunt and my friends in my own comfortable world. I knew my mom resented my aunt because she felt it was my aunt's fault that I didn't feel comfortable with her. As a result, I didn't mention my aunt unless I had to. My world felt empty. Most of my social life was with my mom, who was constantly trying to be my friend and my mother, and succeeding with neither role. Three years later, my aunt joined us. I felt like my world was whole again, and I blossomed.

Looking back, I see clearly that my evolution as a human being occurred because I alternately lived in two different worlds during different stages of my life. I feel angry with my mother sometimes because I feel this

experience robbed me of a more carefree youth and some of the most joyful aspects of adolescence. However, my intensive loving relationship with my aunt made me responsible, trusting, caring, and able to engage in meaningful interaction with others. Although the counterplay of these two relationships sometimes caused me to be miserable, I am, in fact, happy for it. This experience made me different in a way I appreciate. I think I am more patient than most people, and I always look for the best and the most positive in others. I have a very keen sense of responsibility toward children, and believe in being caring, supportive, open, and authentically present with them. I believe I understand what is involved in being a real parent regardless of the biological connections involved. My becoming has come from the tools given by my aunt and the challenge from the relationship with my mother, which helped me to find my identity. The content of my character is a kaleidoscope: it is colorful, ever-changing, comforting, serene, and exciting.

Vickie

When we embarked on this process of examining the meaning of feeling different, Tricia Munhall told us we should start by keeping a journal of our thoughts and other things we encountered which were pertinent. The first thing I thought of was very literal. I started by listing the synonyms I could think of for "different." Here are some of the words I came up with:

> *not the same*
> *unusual*
> *unique*
> *separate*
> *not alike*
> *special*
> *exceptional*
> *odd*
> *greater than one standard deviation from the mean*

abnormal
strange
stand-out
queer
weird

These words and phrases seem to vary from the mundane ("not the same") to the technical ("greater than one standard deviation from the mean"). When I look back at the list, I note that I did not think "bad" was a synonym for "different," although some of the terms might be seen as negative by some people. In general, I felt that most of the words were either neutral or positive.

In my own experience, feeling different has often been extremely negative, even when I have simultaneously sensed some positive aspects of the same experience. The biggest (pun intended) way in which I feel different is my size. Since I was an adolescent, I have always been overweight. I'm usually the largest woman in any group, and often the largest person, regardless of gender. Many people have ignored or harassed me because of my size. However, sometimes it's an asset.

Because of my unusual size, it is easier for some people to recognize me and remember me. Other people sometimes confuse me with other large women of their acquaintance. This is a typical situation for anyone who is part of a group containing stereotypes that are externally accepted by others. As with many people who are stereotyped, it is sometimes difficult for me to figure out whether I am being treated a certain way because I am large, or whether there are other explanations that have nothing to do with me.

I have never felt very attractive, and I haven't attracted the amorous interest of many men. This makes me feel different from most women, because I have had fewer dates in my life than I imagine most women have, and have never attracted a man who became my life partner. Although I know there are any number of reasons that any given man may not find any particular woman attractive,

I feel that I am the least attractive woman in any group of which I am a part. It doesn't surprise me one bit when a man isn't attracted to me, and I have difficulty figuring out what's going on if a man does seem attracted to me. Surprisingly, I have managed to have some wonderful intimate relationships with a few fine men. In each case, I felt my size had nothing to do with the ultimate end of the relationship, but I always end each relationship feeling there will never be anyone else like that in my life. Since I long for what women seem to have who have life partners, this is a tremendously painful way of feeling different.

Another way in which I am different is that I am a cancer survivor. This is certainly a good way of being different as compared to those whose lives are quickly curtailed by the diagnosis of cancer. When I was diagnosed with Stage IV ovarian cancer in 1987, it had already metasticized to my pleural cavity. At that time, the prognosis for such extremely advanced disease wasn't very promising. Less than five percent of such women were still alive after five years. In this case, I needed to be different by more than three standard deviations from the mean! I didn't feel too optimistic about it, but one of my friends said, "Well, someone's got to make up the statistics. Why shouldn't it be you?" My sister also pointed out that five is my favorite number, so how could I not be in that five percent in five years. I have now more than made that goal, having survived for seven and a half years since the original diagnosis. Part of that difference, though, is that I have endured four recurrences, so I have had the cancer active in my body five times! There's that five again. Maybe this one will be the last one!

So far, I have noted several ironies in dealing with difference. In my situation, the irony has been that being overweight while being treated for cancer has usually been somewhat helpful, since the cancer and the treatments for it can be so debilitating. I feel my life has been a struggle— sometimes keenly felt, sometimes only an undertone to the rest—to accept my differences and to make them work for me and not against me.

Well, that's us. We know some of the meaning of feeling different just be examining our own lives and listening to one another. To further enrich our perceptions, we listened to other women.

WOMEN TALKING TO US

Two forms of interaction constitute what we learned from other women. With some women, one question was posed after describing the purpose of the interview: "Can you tell me whether you have ever felt different and, if so, what was that like for you?" The communication was one-sided thereafter. Words spilled eagerly from these respondents. It was almost as though they had been waiting for an opportunity to speak much-rehearsed thoughts aloud. Other interactions took place within the context of conversations with friends or acquaintances.

The women themselves seemed very different from one another. They differed in age, physical appearance, lifestyle, demeanor, ideology, and vocation. However, there were several striking similarities among their responses about their experiences of feeling different. Apparently, over time, regardless of the nature of the perceived differences, the women had come to accept and value their different characteristics. They said such things as: "I felt lonely and sad [about being different] but I'm OK about it now;" and "I'm glad I have been 'different.' Now it feels special."

Jane

Jane is a 32-year-old dental hygienist. She appeared to feel that she earned other people's respect by being true to herself. She was pleased with who she is, and her perceptions of herself had changed over time.

Because I was taller than most in junior high and thought very differently than my peers—my parents always encouraged open expression of feelings and thoughts—I never was quite comfortable with the kids in school. And now,

I'm so busy with my job, my husband, my house, seeing the rest of the family and planning to have children of our own, that I don't have time for many friends. I guess many women my age are in similar circumstances. I'm happy that my parents brought me up the way they did. I like being open and honest. The few friends I have are very close. Now I'm envied for being tall and thin. I'm OK and everyone respects my difference. It feels good to talk to someone about being different. I didn't realize that I had even thought about it.

Joyce

Joyce is a 35-year-old woman who had married a man 20 years her senior. She is still mourning the loss of her dad, who died when she was 12. She describes herself as a homemaker, wife, and mom. She felt she was different from her friends because she "did what she wanted to as long as it didn't hurt anyone."

My friends feel as though they have to do what everyone else expects. I like to travel. I take my kids with me most of the time. My husband doesn't mind. I think [my friends] are jealous. Life is too short not to do what you want. I'm happy.

Joyce seemed to understand and accept the exchange she has made to give up some of the approval of her friends in order to find happiness in her own way. Her travels with her children are a greater source of satisfaction than peer approval. Her demeanor during the interview was prideful, almost brash. She spoke firmly, sat upright, made consistent and firm eye contact, and smiled frequently.

Hope

Hope is a 40-year-old, twice-divorced mother of two children. In her interview, she sounded apologetic. She spoke hesitantly, had a frown most of the time, looked down at her hands frequently,

and, when she looked at me, there was always a question on her face and in her words. Hope works for her mother, and she is currently in a relationship with a man who her mom (unknown to Hope) thinks is a jerk. The following is a paraphrased account of what she shared.

My mom is my best friend. I cannot imagine going without seeing her for more than a day or two. I'm different because I learned very young to put others before myself. Having been the oldest of three children in a blended family, I was expected to care for the younger children. I think the rules and regulations were more stringent for me than they were for my younger brother and my sister, "the baby." I feel that having placed others before myself growing up made me feel good then. But now I feel as though I missed a great deal. Now, people tell me that I need to learn to do things for myself—spend time and money for my own enjoyment. I feel confused and don't know how to make myself happy.

Hope's perception of being different, "putting others before herself," has changed. That used to give her satisfaction but, as time passes, she is "unhappy" about being different in this way and confused about how to meet her own needs.

Rheba

Rheba is a 59-year-old woman. She said that her feeling different was basically due to her cultural heritage of being Jewish. One incident she recalled occurred when she was seven years old and someone called her a "dirty Jew." Fortunately, she had a very supportive mother and even though she did not like hearing the words, after talking to her mother about it, she felt better. She still states that she feels uncomfortable and different when she hears people talking about her culture in derogatory terms.

She also recalled feeling different during her first marriage, for an entirely different reason. She so wanted a marriage like she saw others experiencing, but instead she felt sad, alone, and hopeless at times. Her husband was not loving or supportive as

she so needed him to be. The good that came of years of enduring a bad marriage were her three children.

Laura

Laura responded bluntly with the following:

> *What's it like to feel different from a woman's viewpoint? It's being "used," "abused," and "confused." Women are used by their families and loved ones, abused by their bosses and colleagues, and confused by the world in general.*

What an unfortunate perception, but for her it was true.

Grace

Grace is a 77-year-old woman who said she grew up during hard times.

> *Because money was scarce and children were plentiful in my family, being the oldest, my parents sent me to live with my aunt and uncle when I was 12. I felt like a servant, not a daughter or even a niece for that matter.*

Grace stated that she practically ran their boarding house because they were too old to manage. She never had time for friends or play like other children her age. When she was 17, she met a boy at school whom she really cared for, but her aunt "chased" him away in a hurry and forbade her to see him. One summer she met an older man who was renting from her aunt. He was very kind to her and her aunt did not seem to object to her spending time with him after her chores were done. The following summer, the man returned again on a business trip. This time he asked her to marry him, so she eloped. Shortly after their marriage, her husband lost his job so she began to work in a store as a bookkeeper.

> *I had the same feeling of being a servant. I worked eight hours and then had to come home and cook and clean. He*

never helped me and continuously complained about everything I did. My whole 50 years of marriage was the same story. So yes, I do feel different, cheated!

Mary

Mary recalled her whole 35 years as feeling different.

I was born short and fat and have never been able to overcome the envy I feel for tall, thin women. I remember asking my mother to put me on diets so many times, but I could never stick to them, especially when I saw all my friends eating whatever they wanted. Thank God my parents were always loving and supportive or I probably would not have an ounce of self-confidence today. Fortunately, when I was 17, I did lose most of my weight but it's a constant struggle, up and down. My husband loves me, but I know he would like me to be thinner. That's my only feeling of difference, but for me it's an age-old story.

Jody

Jody talked about being gay and feeling different.

I don't want to be pigeonholed—you know, stereotyped. I don't want someone to not say or do something with or for me because he or she thinks I would be offended or not like something because of being gay. I don't want to miss out on things because people make assumptions about my being different because I'm gay. I don't want to be introduced to someone and say, "Hi, I'm gay Jody." But I also don't want people to learn about it from others instead of my telling them. I feel if it does happen that way it's embarrassing to both of us. With people I really care about, I'm afraid they'll be offended learning about my being gay from someone else. I wouldn't want to hurt their feelings—my being gay makes me different, just in one way really. Why should I have to be concerned about it with everything I do and with everyone I meet? It's so hard to be different.

Berte

Berte, a corporate consultant, had this to say:

It's embarrassing, but I've always felt different—smarter, you know; even in high school, I didn't know whether to hide it or show it.

This was a new slant, feeling different about something good but also feeling that it had to be concealed because it wasn't acceptable.

Destine

Destine said she grew up in "the Islands," meaning the Caribbean islands. She talked about the impact of moving to the United States as a teenager. What she said is paraphrased.

I wasn't different at home. I was just me, but when I moved here, I was something else. I mean, all of a sudden I was "black." I never thought about my skin saying who I was. I was me, that's all. But here, in the U.S., I'm different, and I'm black. I still don't feel different inside, really, I don't like it though, being summed up by the color of my skin.

Anne

Anne is a 34-year-old administrative secretary. Her perceptions were philosophical and pertinent to more than a specific aspect of her life.

I was brought up with what I call old-fashioned values. I've picked up that everybody feels different and thinks different. Sometimes that leads to confrontation. But it's part of being an individual. Being different is part of who I am and it's important. I don't mean that I'm eccentric. I don't need to have everyone turn their heads when I walk into a room and say, "Oh, wow, there she is." I can look like everyone else, but still just be me. I want to be appreciated

*for what I am and not be put down for being different.
I'm trying to convey to my 11-year-old that it's OK for him
to be different.... It's important not to be so influenced
by other people that you lose your individuality and your
being different. Nowadays, I think there's a trend in peo-
ple going back to being different, so different that it's
"me," all "me," but I'm not so self-centered in that respect.
The world wouldn't be the way it is if we didn't have dif-
ferent people....*

*I like to know how people are different and what sets
them out as different. I'm not always good at everything,
but I like to do it my way.*

MOVING THROUGH COMMON FEELINGS

What did we realize about the meaning of feeling different? We
have found that there is comfort in being different and alone.
Being alone is less enervating than the struggle of explaining one-
self and seeking explanations from others. Our feelings about
being different are becoming less conflicted as we grow older.
When the end of one's life starts to come into view, we become
more intense about grasping the lovely things in life and in being
true to self. As we age, it appears we have begun a new game with
a subtle opponent: the person each of us would like to be now. Al-
though it may at times be frightening to think of being alone be-
cause of being different, the time spent by oneself has become
increasingly precious. One woman said, "I hope I can be faithful
to that which exists nowhere but in myself, regardless of how dif-
ferent from others that feels."

One of the predominating ways in which women said they felt
different was in not fulfilling identified roles assigned by soci-
ety (probably originally by men) and adopted by women in
order to survive. When we don't match the expected criteria,
we feel different. The younger we are, the more intensely this
difference is felt. It is always surprising when we reminisce
about high school to find that almost everyone had the same
sense of being *the* different one, the outsider. We were all feel-
ing that way, but we didn't want to admit it. Even though similar

feelings may be experienced by other women around us, we fear sharing our vulnerability, thinking the other women possess the secret of fitting in.

Although it wasn't true with each woman, several of them eventually focused on one personal difference that they perceived altered many situations over an extended period of time in their lives. This occurred frequently without any prompting and regardless of the length of the interview or the number of experiences of feeling different cited by the respondent. Feeling different seemed to be one of those issues which these women focused on as significant in the stories of their lives.

Although several women felt cheated or abused by assuming the roles that were supposed to keep them from feeling different, others felt gratified as they learned to appreciate their own differences. Some spoke entirely or almost entirely of the positive nature of that feeling.

Many of them felt differences seemed to be only internally verified. Things that made some women feel they were different were not things necessarily seen that way by others. Some women experienced a difference as being negative when they first perceived it, but grew to view it as a positive asset. Others had the opposite experience.

It may be that "feeling different" isn't *different* at all. Many people feel different in one or more ways. However, that experience of the feeling is perhaps what differentiates us most from one another.

REFERENCES

Bronte, C. (1946). *Jane Eyre.* New York: World Publishing.

Burden, S. (1963). *I wonder why people don't like me.* New York: Doubleday.

Burnett, F. H. (1994). *The secret garden.* Boston: David R. Godine.

Davis, K. L. (1990). *Sing to me of dreams.* New York: Pocket Books.

Gibson, W. (1957). *The miracle worker.* New York: Knoph.

Lake, M. D. (1995). *Once upon a time.* New York: Avon.

Lindbergh, A. M. (1975, 20th Anniversary Edition). *Gift from the sea.* New York: Random House.

ABOUT THE AUTHORS

Victoria Schoolcraft

When I was a child, I wished that I was a boy. The boys I knew, even those younger than I, seemed to have more fun and much more freedom than I did. I was big for my age and found that I could physically exert my desire to be included and do the things the boys did. I remember once when I wanted to play "Army," the boys said I could only play if I was the nurse. After I beat them all up, I got to be a soldier.

Nowadays, I feel that I am a different kind of soldier. I am now pleased and comfortable about being a woman, but I feel it is my duty to be a soldier in the fight to equalize fun and freedom without gender restrictions. Ironically, given my youthful attitude, I am now proud to be a nurse. In that role, I have been a good soldier by earning three degrees, including a Ph.D. Rather than beating people up to get my points across, I now serve as an educator and an Associate Dean in the Barry University School of Nursing. I use bigger words and gentler actions to get to play where I want to play, but the fight goes on.

Joan Davis

I believe that the things that I have accomplished in my life can all be attributed to the fact that I was born different. The feelings of never being quite good enough made me work harder to try to prove myself to others. It took me years to realize that the only person I had to prove anything to was myself. Today when I look back on my life struggles for achievement, I am glad that I felt challenged. I did not begin my educational journey until I was 32, so I was quite proud when I received my Nursing Diploma along with 29 18- to 20-year-old students. After that, with the support of my family, there was no stopping me. My goal was to teach and that meant getting a bachelor's degree. As fate would have it, just about the time I finished my degree and applied for a teaching position, I was told that if I wanted the position, I would have to get my master's degree, which I did. I was quite content and convinced that my life was complete until my husband's health warranted a move to a warmer climate. When I began applying for teaching positions

in the South, I was told that I would have to get my doctoral degree. Boy did those old feelings of having to prove myself to others again begin to resurface. I have had my doctoral degree for six years now. Would I have come this far if I had not continually been challenged? Who's to say! Remember, I was born different.

Jessie M. Colin

I am Jessie M. Colin, M.S.N., R.N., a Haitian-American. I am an Assistant Professor of Nursing at Barry University, I also practice nursing as a home health nurse and I am a doctoral student at Adelphi University. The dichotomy of the specialness accorded to being different and the sense of alienation one experiences has always been of interest because I lived in two different worlds. Being different is to me a blessing, a challenge, and an opportunity. But, concealing being different would have impeded my becoming. I am evolving.

My research interests are in women's issues, cultural diversity, history of nursing, and collective bargaining.

Sheila Hopkins

I am almost 60 years old, and I've done much of what I had hoped to. I never was able to learn how to play the piano and I never will be pretty. But, I've relished my own uniqueness after many struggles with being different. Having been divorced when all my friends remained married, going to college in my forties when all my classmates were teenagers, finding the love of my life in middle age, and then being widowed at an age younger than most, but old enough to be too enmeshed in my own purposes to negotiate a new relationship, I find myself taking more and more comfort in just being me.

I have been instrumental in developing educational programs and national certification for geriatric care managers. Most of my research and publications are in the field of geriatrics. I am an assistant professor of nursing at Barry University in Florida. My BSN was from Central Connecticut University and my MSN was from the University of Connecticut. I am an advanced practitioner in geriatrics. I teach community health nursing and geriatrics.

Index

Other Books of Interest from NLN Press

You may order NLN books by • TELEPHONE 800-NOW-9NLN, ext. 138
• Fax 212-989-3710 • MAIL Simply use the order form below

Book Title	Pub. No.	Price	NLN Member Price
☐ **In Women's Experience, Volume I** *Edited by Patricia Munhall*	14-2612	$35.95	$34.35
☐ **African American Voices** *Edited by Ruth Johnson*	14-2631	32.95	29.95
☐ **Peace and Power: A Handbook of Feminist Process, 3rd Edition** *Edited by Charlene Wheeler & Peggy Chinn*	15-2404	16.95	14.95
☐ **Annual Review of Women's Health, Volume I** *Edited by Beverly McElmurry & Randy Spreen Parker*	19-2546	37.95	34.35
☐ **Annual Review of Women's Health, Volume II** *Edited by Beverly McElmurry & Randy Spreen Parker*	19-2669	37.95	34.35
☐ **The Path We Tread, Blacks in Nursing Worldwide, 1854–1994, 3rd edition** *M. Elizabeth Carnegie*	14-2678	30.95	27.95

PHOTOCOPY THIS FORM TO ORDER BY MAIL OR FAX

Photocopy this coupon and send with 1) a check payable to NLN, 2) credit card information, or 3) a purchase order number to: **NLN Publications Order Unit, 350 Hudson Street, New York, NY 10014 (FAX: 212-989-3710).**

Shipping & Handling Schedule	
Order Amount	Charges
Up to $24.99	$ 3.75
25.00-49.99	5.25
50.00-74.99	6.50
75.00-99.99	7.75
100.00 and up	10.00

Subtotal: $ _____

Shipping & Handling (see chart): _____

Total: $ _____

☐ Check enclosed ☐ P.O. # _____ NLN Member # (if appl.): _____

Charge the above total to ☐ Visa ☐ MasterCard ☐ American Express

Acct. #: _____ Exp. Date: _____

Authorized Signature: _____

Name _____ Title _____

Institution _____

Address _____

City, State, Zip

Daytime Telephone (_____) _____ Ext. _____

IN WOMEN'S EXPERIENCE, VOLUME I, also edited by Patricia Munhall, features explorations of these areas of concern to women:

- Caring: In Women's Experience
 Cathy Appleton

- Power for Midlife Women: Written on the Breeze
 Carolyn L. Brown

- Surviving
 Diane Cope

- Fifty-Something: A Phenomenological Study of the Experience of Menopause
 Geri L. Dickson

- Mothercare
 Ellen Goldschmidt Ehrlich

- See My Abuse—The Shelter Transition of Battered Women
 Carol P. Germain

- In Another World: "Essences" of Mothers' Mourning Experience
 Sarah Steen Lauterbach

- The Transformation of Anger into Pathology
 Patricia L. Munhall

- Motherhood and Women's Development
 Dula F. Pacquiao

- Seeking Harmony: Chronic Physical Illness and Its Meaning for Women
 Zane Robinson Wolf